RIFT

RIFT

A MEMOIR OF BREAKING AWAY FROM CHRISTIAN PATRIARCHY

CAIT WEST

WILLIAM B. EERDMANS PUBLISHING COMPANY
GRAND RAPIDS, MICHIGAN

Wm. B. Eerdmans Publishing Co.
4035 Park East Court SE, Grand Rapids, Michigan 49546
www.eerdmans.com

Book design by Lydia Hall

Printed in the United States of America

30 29 28 27 26 25 24 1 2 3 4 5 6 7

ISBN 978-0-8028-8358-2

Library of Congress Cataloging-in-Publication Data

A catalog record for this book is available from the Library
of Congress.

An earlier version of the chapter "Work" was first published as "Going
Dutch" in *Dunes Review* 25, no. 1 (Spring 2021). Material that now ap-
pears in the chapters "Colorado," "Fire," "Daughter," "Graduate," "Essay,"
and "Engagement" first appeared in "Metaphoric" in *The 3288 Review* 5,
no. 2 (October 2019).

For those who have seen the cracks beneath their feet
and are looking for the other side

For those who have lost friends, family, and community
even as they have found themselves

For the little girl who needed to hear this story long ago

AUTHOR'S NOTE

In writing this book, I am crafting a narrative of my life, as we all do when we tell ourselves stories of who we are and where we came from. My memory is not perfect, and my perspective is limited, although I have spoken with others who were there to confirm details where possible.

Except for public figures, I have changed names, including those of my siblings, to protect privacy. I have reimagined dialogue. I am speaking my truth based on my experiences. At the same time, I am determined to present my story in all its complexity, understanding that each of us has the potential to cause both harm and good. I myself have been complicit in upholding patriarchy. Even when I call out problems, I strive to do so with compassion and empathy.

This book talks about abuse, suicidal ideation, infertility, and religious trauma, among other sensitive topics. I have tried to write my story with your physical, emotional, and mental well-being in mind, but please take care.

RESOURCES

National Domestic Violence Hotline:
1-800-799-SAFE (7233), TTY 1-800-787-3224,
text "START" to 88788,
www.thehotline.org

Tears of Eden: Nonprofit serving survivors who have experienced
spiritual abuse in the evangelical community,
www.tearsofeden.org

Center for Trauma Resolution and Recovery:
www.traumaresolutionandrecovery.com

Coalition for Responsible Home Education:
www.responsiblehomeschooling.org

The tectonic layers of our lives rest so tightly one on top of the other that we always come up against earlier events in later ones, not as matter that has been fully formed and pushed aside, but absolutely present and alive. I understand this. Nevertheless, I sometimes find it hard to bear. Maybe I did write our story to be free of it, even if I never can be.

— Bernhard Schlink, *The Reader*

BIRTH

Snow often falls on January evenings in Michigan. I've lived here longer than in any other state, yet I still dread the loss of light every winter, the darkest time of year. The air freezes and shrinks, the snow and dark disappear sound. Sitting at my window, if I close my eyes and dream of spring, the whispers of cars on the highway in the distance become a soft breeze in my hair. I can almost feel the velvet of new grass, the damp of a watered garden at dusk, the glow of lightning bugs hovering on the outskirts of a bonfire. My body remembers a thousand warm days.

I try not to linger long on the past though; there are shadows waiting there too. But as I open my eyes and look out into the January night, I can't help but wonder if the color of frost is more like silver or more like ash. And the memories grind along like a snowplow, scraping up gravel with the ice.

If I am alone enough or scared enough, I try to collect the memories, weave them together like lace, like snowflakes. But with the fragility and instability of barely frozen water, they fall apart, run together, melt into tiny lakes. Other times, I pick them up one at a time, place them gently on the table, watch them glitter, and see how they look next to each other in a line or stacked into a mountain. No matter what I do, they vex me. They keep me up at night. They haunt me.

Out beyond the snow, I am surrounded by Great Lakes: Superior, Michigan, Erie, Huron. They are deep, grandfatherly, never-forgetting. They freeze over in the winter, burying shipwrecks, hiding fish and fossilized coral, blurring the boundary of land and sea. All becomes ice.

These lakes have an ancient memory — the basalt rock on the bottom of Superior tells of old lava flows, fault lines in the Earth's crust, fire where there is now cold water. The volcanic rupturing more than a billion years ago caused a deep rift that started to pull apart, almost splitting the continent in half.[1]

But then the rifting stopped, and the continent held together. Some geologists have speculated that pressure from another tectonic plate of Earth stopped pulling in another direction, causing the fracturing to halt before the continent broke completely.

When the lava hardened, the years froze into an age of frost. An ice sheet — two thousand miles long and one mile thick — spread over the newly shaped land, carving deep into the rock and creating the basins for the lakes in recurrent glaciations. Almost as if the ice knew what it was doing, what it was shaping.

Eventually, the ice retreated, and the lakes filled with fresh water in the melting. The volcanic rocks had been eroded, making room for complex life, and what had been broken was healed, the Earth here stronger than it was before.[2]

And now I am here for a speck of time, trying to understand the immensity of a past that has irrevocably shaped my present. I have not yet learned to trust the ground beneath my feet. The Earth continues to shift.

I did not notice the fissures or how unstable my footing was until it was too late, until my own life rifted apart. What once seemed solid and unbreakable suddenly split, revealing a crevice where I once stood. The two sides of a rift evolve separately, erode in weather, rebuild themselves until they are nothing like the whole they once formed together. But buried deep, they are made from the same elements, even if they are severed by an ocean.

My mother tells me the day I was born was a rare snowy morning in mid-March 1988. The hospital in downtown Wilmington, Delaware, should have been surrounded by drizzly skies and dirty streets not yet cleaned by spring rain, but instead it was a cozy place slowly enveloped by gently falling snow. My mother speaks of it as a good omen, a signifier that sets the day apart from every other.

I like to imagine her joy, almost as if I hadn't been there. A mother and father welcome their third child, this one by C-section. The baby has a cone-shaped head because of the suction the doctor used, but her parents love her anyway. It is the day before St. Patrick's Day, and the Irish nurse suggests a Gaelic name: *Caitlin,* meaning "purity," like snow maybe.

I look at photographs of me as a rosy-cheeked toddler and wonder what was making her laugh so hard. She is ecstatic with existence. I try not to hold it against myself. I wonder when it happened: When did I become the quiet, submissive child who never dared break the rules? I barely recognize this girl in the high chair who is clearly enthralled with Ritz Crackers; she is not yet tame.

Pictures shape memories. We assemble albums of the times we remembered to photograph. But we rarely take pictures when we are at our happiest, when we are so fully in the moment that we don't think to capture it for the future. And we almost never commit to film — or pixels — the times we were hurt, or ashamed, or lonely.

* * *

I have long attempted to find the words to accurately describe what happened to me, and the short version is always too short: I was born into a strict, religious family, homeschooled, and ruled by authoritarian discipline and a literal interpretation of the Bible. We eventually stumbled into the Christian patriarchy movement, but I was told it was God's plan all along. Chance or luck was nonexistent in our world. Now that I've left the movement, I see how my father led us deeper into an environment where he could control every as-

pect of our lives — my life. Where he would be rewarded and praised for his narrow views and inflexible rules.

I am calling this a *movement* because Christian patriarchy is an ideology that cuts across many Protestant denominations. Some might call it a cult, a high-control group ruled by hierarchy and oppression. In the case of Christian (or biblical) patriarchy, the cult leader is each family's father, deemed prophet, priest, and king of the household — a Christ figure. The mother's purpose is to support her husband in raising the children and taking care of the home. And the children are considered arrows in the quiver of their parents, weapons to wage a spiritual war on the secular culture, Satan, and all manner of evil in the ultimate fight for good. Because of this metaphor, taken from the Psalms, some call this belief system *Quiverfull*.

I became a stay-at-home daughter because I had no other choice. I lived at home under submission to my father long after I turned eighteen, waiting for my future husband — waiting for my *future*. I tried to follow all the rules, obey my father in all things, and put to death my sinful self as I sacrificed for the greater purpose, and for many years, I succeeded. And then I did the impossible: I left.

I did not leave in a day but over a long time of gathering strength and resources. In some sense, I am still leaving, even though it's been more than a decade now since I boarded a plane to start my life over. I like to think that the farther I get away from the damage, the closer I get to myself. That even though my life rifted apart, my body, mind, and spirit can finally heal. That I can be free.

But always I am reminded that deep down, I am made of the materials gathered from my past. The best I can do is return to the trauma, acknowledge the truth, and make space for who I am becoming.

This is a story of loss and separation. This is a story of chaos, of fragmentation, hidden beneath the facade of a happy family. This is a story of escape and risk and making it all worth it. This is a story of psychological, emotional, financial, and spiritual abuse.

This is my story of survival.

BUT FIRST . . .

My parents always told their story like it was the plot of a romantic comedy:

A man and a woman meet in South Florida. They work in the same office building. He asks her out; she says yes. At the restaurant she peels his boiled shrimp for him, and he knows right away she's the one. After dinner, he proposes; she says yes. They marry seven weeks later. She holds a bouquet of violets. They honeymoon in the Bahamas. God saves their lives. And they live happily ever after.

But as I grew older, I heard more of the details, read more between the lines:

Two lonely people meet in South Florida. They work in the same office building. He is only twenty years old. She has a six-month-old baby girl and is struggling to make ends meet. He asks her out; she says yes. At the restaurant she peels his boiled shrimp for him, and he knows right away she's the one. They marry seven weeks later. She holds a bouquet of imitation violets. The minister pronounces her name wrong. They sell one of their cars so they can honeymoon in the Bahamas where they go to the beach every day, sharing a two-liter bottle of Diet Coke. After

they return, they want to go to church, but she's a lapsed Baptist and he's a halfway Catholic, so they compromise and visit a Presbyterian church. Next thing they know, the church's Evangelism Explosion team visits their home, and he becomes a born-again Christian. The rest is history, as they say.

Both versions can be true; neither of them is fully true. What matters is the meaning you make of the narrative. In my family, stories of the past created the mythology of who we were, where we came from, and what we could do with our lives. I wonder now whether my parents' origin story is more of a "just so story" in the tradition of Kipling: half fantasy, half truth. Maybe the accuracy didn't matter so much as the retelling of it, the tradition, the grounding, the sense of stability. As if the earth beneath our feet doesn't move.

RULES

"I baptize you in the name of the Father, and of the Son, and of the Holy Spirit."

The pastor probably said this somberly, sprinkling cold tap water on my head from the baptismal font. The stained-glass window above us cast a jewel-toned light over the white walls and Puritan pews.

Presbyterian baptisms follow the same script. Parents bring their newborns to the front of the sanctuary next to the pulpit and promise to raise them "in the nurture and admonition of the Lord." The congregation watches with soft smiles and nodding heads — another soul for God, another baby in a frilly white gown. The pastor drips the water three times for the Trinity, and the baby usually cries. I didn't cry though. My parents say I was a good baby.

* * *

If I were to tell a story about how an innocent girl grew up in an idyllic family, only to be blindsided by cruelty when she got older, I would start here: a little girl searching for buttercups in the grass. I would begin with how the girl liked to fold printer paper together and write nature books about the creatures and flowers and trees she played among. How she dreamed of becoming a ballerina or

someone who owned a horse. How she rode bikes and roller-skated and drew with sidewalk chalk and tried really hard to be good at origami. I would begin with an image of a perfect childhood, just to show the contrast of what came after.

But the truth is trauma doesn't always happen like a car accident, suddenly, out of nowhere. Often suffering sets in like the fading of day in high summer, like the slow disappearance of buttercups as autumn creeps up on you.

And even though all these things happened, from the roller skates to the origami, they weren't all that happened. And maybe I wasn't all that innocent.

Sometimes when I look back at that girl, I see the parts of me I hate. The tattletale. The people pleaser. I see a mean big sister, an obnoxious little sister, a friend who is quick to judge. I see my sanctimonious insecurities.

I was told I was set apart, holy. A child of the covenant, I belonged in the family of God. This was taught to me from infancy, in the words of the baptism, in the water that signified and sealed me into the hands of the everlasting. In my mind, I was blessed. I had conservative Presbyterian parents who understood covenant theology and who faithfully catechized me in Reformed doctrine. I memorized the hymns of the church; I could sing the books of the Bible without missing a beat. I was destined for heaven. Nothing fills the need for belonging more than a promise that you are God's child and will live forever in paradise. Belief in this promise is a foundation that does not easily crack.

I assumed this belonging was provided without any payment on my part. I was born into it, so I didn't have anything to worry about. It wasn't until later that I discovered the rules I had been abiding by all along to keep my place.

* * *

There's a photograph of me when I was around four years old, out at the summer cottage we used to rent on Star Lake in Upstate New York. I'm wearing a pastel two-piece swimsuit. I have blunt

bangs that curtain past my eyebrows, and I'm holding a fishing rod with a small fish dangling from the end. I'm squinting into the sun and smiling.

I don't remember this moment, but I do remember the rough planks of the dock under my feet, the sun on the cold water of the lake, and that bathing suit.

I also remember another moment, perhaps the following year, finding the swimsuit in my dresser and coming down to the lake ready to swim or fish or jump in the canoe.

"Tell her to go upstairs and change. She can't wear that," my father said. His hair was darker then, absent gray hairs. He wore the mustache and short shorts popular in the early nineties.

I don't know if he was angry with me then, not in a loud way, not in the way he would be as I grew older and less compliant. I felt only his disappointment with me, with how I looked.

My mother told me to change into the other swimsuit I had — a one-piece. "Go on, honey," she said softly, her oversized glasses and tight perm shielding her deep-brown eyes.

I didn't know what *modesty* meant then. I only knew I had done something wrong, that something must be wrong with the small band of skin showing at my middle. Most of all, I remember feeling ashamed. I remember trying to put the guilt into the swimsuit, as if it were evil somehow, as if it had tainted me, those flimsy pieces of stretchy fabric.

Cover up. This was one of the first rules I learned.

When I was around eleven years old, and on the hot pavement of Disney World, I was clumsy, already grown taller than the average for my age group. I had pulled my hair into an unbrushed ponytail. My skin was thick with sweat and sunscreen, and I'd already tripped Pluto in my attempt to get an autograph, to the laughter of my family. I carried a little drawstring purse with me that held a few crumpled dollars and chewing gum. I had been carrying it around for days, and I was surprised when I heard my father say to stop wearing it like that. *Don't wear it across your body like that.* He meant that the string was outlining my chest, the small bumps I hadn't

9

even noticed developing early. I felt ashamed of my body being seen in its curves, its outline so clear, even through an oversized T-shirt. I wondered who had noticed — the cashiers at the store? Was my whole family embarrassed of me? I wanted to throw the purse away, but I had to continue balancing it awkwardly on one shoulder.

<p style="text-align:center">* * *</p>

I spent my early years in a small suburb in southeastern Pennsylvania, between Lancaster County and the Delaware border. A small creek wandered at the back of our row of houses, along with thickets and monkey brain trees. There was just enough danger to make life seem exciting.

We lived on a street with lots of other children my age, and I remember summer afternoons spent roller-skating together or playing hopscotch in the driveway. During the school year, the other kids would all be gone during the day, and the streets were quiet. I was the only homeschooled kid on the block — my older siblings, Allison and Kyle, went to a Christian school run by our church, and my little brother, Christopher, was still too young for school. During my lunchtime break, I would wander in the yard alone, picking dandelions, talking to trees.

One afternoon when I was around seven, my neighbor friends finally came home from school, and we sat together in my driveway, drawing with chalk on the asphalt. I was very proud of a brand-new bucket of chalk I had been given, and I only let my friends play with the old batch of broken sticks. One of my friends decided she wanted to use one of my new colors, and instead of sharing, I got up, picked up my bucket, and brought it into the garage. As I turned around, I could see my father pulling into the driveway, home from work in the city. I knew even before he got out of the car that I was in trouble.

He took me inside and sat me down on a chair in the school room. This room had once been a play area for Chris and me, but when my father decided to try homeschooling out, he and my mother had converted it into a classroom.

A white dry-erase board stretched across one wall; in the upper right corner my mother had written the date in her curly script (she updated it every morning). Facing the board was my desk — wooden but unstained — that my father had gotten for cheap from one of his work connections. In the drawers were my spelling workbook, penmanship paper, an introductory logic textbook ordered from Canon Press. In the corner next to the whiteboard was my mother's desk, similar to mine, but with more drawers and cubby holes to hold her ballpoint pens and yellow-and-green steno pads.

"Why did you take the chalk away from your friends?" my father asked. He knelt down so he could look me in the face. His tone was stern, serious.

"I wanted to get out of the way of your car," I said. I tucked my hands under my legs until they burned from the pressure.

"I think you're lying to me."

"No, I'm not." I could feel his eyes boring into my thoughts. I'm not a good liar.

"I want you to sit here by yourself until you're ready to confess." He left me there and went into his office across the foyer. I could hear his computer booting up, his fingers tapping the keyboard.

I felt like I was sitting on that wooden chair for hours, dwelling on my sin and feeling like it was the end of the world. I felt sick and feverish and nauseous. I was worried that if I told him the truth, if I admitted to lying, I would be spanked. Old paint stirrers and paddles were collected for the purpose. I clenched my bottom tighter at the thought.

I'm not sure if it was only minutes or an hour before I could no longer stand the guilt and knocked on the office door to confess. My face was burning, and I started to cry.

"I'm sorry for lying and for not sharing my chalk. Will you forgive me?" Apologies in our home were never enough unless we asked for forgiveness at the end, showing a repentant heart.

Instead of spanking me, he hugged me and thanked me for telling him the truth.

"I think you've suffered enough by sitting there thinking about how God hates your sin. I can tell you're really repentant," he said. He smiled down at me. Mercy, this time.

<center>* * *</center>

I was often reminded that all human beings are born depraved and deserving of hell.

My dad had a call and response we practiced during family worship, our daily devotional time of Bible reading and prayer:

"What are people who aren't saved?" he would say.

"Dead," we'd respond with confidence.

"And what do dead people do?"

"They rot."

He would tell me and my siblings that all our actions, whether we saw them as good or bad, were like "filthy rags" before our perfect God. We didn't deserve to be saved from hell, but those who were chosen by God would be considered clean because of Jesus Christ's death on the cross and his resurrection.

Anytime I lied or didn't share or was mean to my little brother was proof of how evil I really was. There was a clear line of obedience, and I needed to toe it or risk eternal damnation. I wanted to be a good girl, and good girls don't disobey their fathers. Even though the threat of spanking hung over me, I hated more the feeling of disappointing my dad. After disciplining me, he always said he loved me, but during family worship, he taught me I was unlovable because of my fallen nature. I was, and always would be, a sinner. I needed to strive constantly to be better.

All other rules hinged on this one: *be good.* Dad was always watching, which meant God was always watching.

<center>* * *</center>

In October in Pennsylvania, ancient oaks cast long shadows, and the dark fell early. Fog in the early mornings hid the shape of the hills, and the mushroom farm across the road seeped out an earthy smell that ran over our neighborhood like a fine mist.

Every year on Halloween night, we turned off the lights and hid in the basement, or we attended the Reformation Day party at church, where we celebrated the heritage of Martin Luther and John Calvin, leaders of the Protestant Reformation. The candy made it seem like we weren't being deprived of trick-or-treating, but the church would also pass out pamphlets printed on orange paper describing the pagan roots of All Hallows' Eve.

The following week, the neighbor kids would talk about what kinds of candy they got and how much. And I would say proudly, "My family doesn't celebrate Halloween because it's Satan's holiday."

Like most children my age, I saw the world in black and white, good and bad. And because I was being raised in a religious fundamentalist home, this framework was only ever reinforced. I was never encouraged to recognize nuance.

I was good at following the rules, and I was quick to judge the neighbors for their heathen behavior, like celebrating Halloween and believing in the Easter Bunny, for staying home from church on Sundays and being disrespectful to their parents. I struggled with making friends, but at home I was taught it was a good sign to be hated, to be different from the outside world.

I was intrigued by all the kids on my block who went to public school, but I also felt sorry for them because I had learned they were being taught lies that would send them to hell. I would ask them leading questions, using tactics I had learned at an event for home-schoolers featuring creationist Ken Ham: "Do you *really* believe we evolved from monkeys? How do you know? *Were you there?*"

Girls in the neighborhood started calling me a Goody Two-Shoes, and I had to ask my parents what that meant. I pretended their words didn't hurt me. I knew the truth, after all, because I was in the covenant. I wanted to be good.

Even though I didn't understand this tension of wanting to be good and wanting to be liked, I tried my best to make friends. I played most afternoons with my neighbor Kim, who lived a few houses down. She had a *Titanic* poster in her room — a movie I had heard was immoral. She also had unsupervised access to a family

computer, where we would look up the websites from cereal boxes and play games before my parents found out and told me not to do that anymore.

One night, I was invited to Kim's house for dinner. Her family was Roman Catholic, but they didn't seem as religious as my family. Kim's mom said they didn't pray before dinner and that since I was their guest, I didn't have to either. I felt how easy it would be to nod my head and dig right into the spaghetti I had been served. This was how Satan tempted you when you interacted with the world. Drop one small thing like praying before a meal, and just like that he'd pull you down the slippery slope with all the other sinners.

Kim's family seemed very nonchalant about the whole matter. They said I didn't need to pray in their house and that my parents wouldn't mind, but I knew that wasn't true. I had to abide by the rules of my parents' house no matter where I went, even if they would never find out. Because disobeying my parents was disobeying God. And God would know. He could see everything, even my thoughts. I could never escape him.

I bowed my head and prayed silently, alone. Later, I confessed my temptation to my parents. They praised me for doing the right thing and berated my friend's mom for suggesting that I sin. Even though the neighbors were Catholic, my father said they weren't "real" Christians. Kim went to public school. Her mom had a career. Her dad mowed the lawn on Sundays. Their family was lost. And I had brought light into their home, even if they couldn't see it.

I had learned another rule: *be a witness*, even when it hurts, even when you're rejected. *Especially* when you're rejected.

* * *

One of the most important rules is *stay quiet*. This one applies only to girls, and I learned it everywhere, before I can even remember.

Adults smiled at me when I sat still and pretty. Women at church chastised me if I raised my voice. My parents dressed me in tights and Mary Janes so that it was difficult to run around and yell in the church parking lot like the boys did.

I was good at being quiet, so good that sometimes I was forgotten. Once, my parents forgot me at church when they left to go home. I had been playing on the swing set, and when I looked around, I couldn't see any of my siblings. I walked over to the parking lot but didn't see our faux-wood-paneled Dodge Caravan.

Thirty minutes passed and I had already jumped in the back of a friend's minivan, hoping to spend an afternoon at her house, when my parents finally remembered me and returned to pick me up.

I might have been so good at being quiet because I had seen what happened when my sister, Allison, spoke up.

She was nine years older than me — the oldest of the four of us. When I was elementary age, she was in high school. I felt like she was the opposite of me. She had a lot of friends from school, and she always seemed to be inviting them over to hang out with her in her bedroom. She had posters of Wyland ocean scenes stuck to her walls with blue putty, dozens of silver hoop earrings and necklaces organized in recycled plastic seedling trays. She played DC Talk tapes on her boom box. She laughed a lot, and I could always tell when she was home.

But Allison would also get into trouble with Dad often. She wasn't easily controlled like I was. Sometimes she would talk back to him, or make sarcastic remarks, or roll her eyes, all tantamount to yelling in our father's opinion. And then she would get grounded for weeks. No friends were allowed to come over, and she'd disappear into her room after school, silent, isolated.

I learned that avoiding trouble meant being quiet, accepting Dad's instructions with a whispered, "Yes, sir." It meant keeping my thoughts to myself, saying only what was allowed.

Over time, I would realize that having a smaller voice was not the only rule. Having no voice at all was better.

* * *

I've always been good at following the rules. Give me a fifteen-step recipe with twenty-seven ingredients and I will follow it meticulously. I color inside the lines. As a kid, I made my family follow the after-Thanksgiving rule for Christmas music.

So when I was told the way to heaven, I was willing to take any steps necessary. I said the prayer, I practiced repentance, I believed the promises of the Bible. When I was eventually given the church membership vows, I pledged my soul to God and to the elders.

I knew deep down that if I disobeyed, I would be cast out forever.

STARTER

So how do we go about bucking the cultural currents of a whole civilization? How do we resist the further erosion of family and community and actually begin to rebuild society from these foundations up?

—Philip H. Lancaster[3]

I went to a private Christian school for a few months in kindergarten, so my first understanding of school was a large room with two teachers and two dozen five-year-olds — it was always a little bit chaotic.

The alphabet wrapped around the room just below the ceiling in large, colorful letters. I learned to read my first word, *green*, in the list of colors on the wall. School meant memorizing my phone number and home address. Recess was wide-open pavement and a basketball hoop with no basketball. It was a boy stepping on a rusty nail in the fringe of grass. It was two girls, both named Hannah, one who was mean and one who was nice until she paired off with her namesake. It was the assistant kindergarten teacher who drew the shape of a heart in the air with her hands and then pointed at me.

After school, I would ride the bus home with my brother Kyle. He was six years older than me, and he usually kept to himself. But on the bus, he let me rest my head against him so I could close my

eyes and try to ignore the other kids on the bus throwing crumpled-up paper at each other. Their shouts and scuffling hurt my ears and made me want to shrink into an imaginary solitude.

I was small enough to fit into a brown-paper grocery bag that my mom had cut with holes for my head and arms and fringe at the bottom. We were celebrating the first Thanksgiving, and I was dressed up as a Native American. My hair was too short to braid. No one said it was strange for me to play an Indian as a white girl living on colonized land. My teacher, Mrs. V, called me a new name to go with my outfit: Gentle Rain. My parents liked this because they thought it fit my soft-spoken personality.

After Christmas, my parents decided to homeschool me. Before we had a school room, I would sit at the kitchen table and study flashcards with animal pictures and words on them. My mom practiced phonics with me, teaching me the sound of *t* plus *h*, showing me how you can't say *ring* or *king* if you're pinching your nose. She read to me from nature books, teaching me to love wildlife, to appreciate the intricate details of flower petals, to imagine the lives of ants and praying mantises, opossums and raccoons. I thrived in the one-on-one attention, the quiet of our home.

Homeschooling in the nineties was a Laura Ingalls, Oregon Trail, make-your-own-corncob-doll vortex. And my mother leaned in as primary educator in our home. The outside world — the realm of public schoolers and teen pregnancy and marijuana — was a depraved place, and family values were the only thing that would save us from the darkness of what we called "worldliness." We were survivalists of a sort.

I remember my mother sometimes participating in the sharing of Friendship Bread. It would begin with a ziplock bag of sticky dough — the starter — that she would receive as a gift from another homeschooling mom. The bread was shared in the way chain emails back then were: *Be sure to keep the fun going and send to five of your friends!* No one really knew where the first starter came from, which was a testament to the growing network of homeschoolers trying to live counterculturally.

For some reason, I don't remember ever eating Friendship Bread. I only remember the ziplock starter. Did my mother ever bake it into loaves? Did she keep the sharing train going? Or did she leave it on the counter until it fermented so much it needed to be thrown away?

In those early days, my mother did her best to connect with the other moms, take me to co-ops where I could play with other kids, and sign me up for field trips to nature centers and history tours. She still calls those some of the most enjoyable days of being a mother.

* * *

Our friends the Mitchells lived not too far away in Lancaster — what we called Amish country. Green rippled hills. The distant whiff of manure fertilizing the fields. The electrifying sounds you hear in the absence of a power grid: scissor of grass, movement of dust.

Sometimes my mother would drive us to a big white barn where Amish farmers sold produce. She'd leave us in the car and walk up the drive to where the tables were laid out with thin-skinned tomatoes and flossy cobs of corn and shoofly pies sold by clean-faced women in white bonnets. They wore modest, simple dresses with aprons, and their hair was always well tamed and pinned down. In the winter, horse-drawn buggies slid down the icy roads, and we'd watch to see if they'd crash at the bottom of the hill. The orange triangles attached below the rear windows were bright warning signs in a dead white landscape.

The Mitchells weren't Amish, but in some ways they lived like they were. They farmed the land, inhabited a tall wooden farmhouse, and lived set apart from the world in a way I didn't yet understand. Their many children seemed a little wild, running around the wooded property, even when dressed in their church-day belted jeans and plaid button-downs. They taught me how to dig potatoes out of the dirt with a giant fork, how to feed the chickens.

My mother, who once worked in offices and grocery stores and wealthy people's homes as a housekeeper and who now was a stay-at-home mom, learned to can fruits and vegetables from the Mitch-

ells, and we kids always pitched in when we could. They taught us how to preserve everything from apple butter to grape juice.

To make grape jam, we'd pick bunches of Concord grapes where they grew under the wide umbrella leaves on the vines. Then at the Mitchells' house, we'd rinse the grapes and peel the leathery skins off, boiling the pulp in a commercial-sized vat. The skins we'd process separately, then mix it all together. For the canning part, with the boiling of lids and jars, the children would be banned from the kitchen, and our mothers would finish the work.

* * *

I was supposed to be friends with Leah Mitchell, the daughter who was closest to my age. But we had almost nothing in common, and she seemed strange to me. She was older than me, for one thing: when I was eight, she was around eleven. And she seemed to have special knowledge that I didn't about how our world worked.

One time when I was playing at her house, I brought with me a tiny purse, a miniature imitation of the bottomless pocketbook my mother carried around like a suitcase. I had placed my purse on Leah's bed as we were playing, and the next thing I knew, she was dumping it inside out on the comforter and inspecting its contents. Out fell my packet of tissues, my wintergreen Tic Tacs, my candy-flavored Chap-Stick, my Fruit Stripe chewing gum with the foil wrapper wrinkled at the corner. I felt violated. Invaded. Nonexistent. Like I had died and someone was going through my things to find my identity. But Leah got away with things like that, so I didn't say anything.

Leah would tell me things — stories that now seem ridiculous and clever for a little girl to come up with. At the time, I thought Leah's maturity meant she knew better than I did. I felt like I should believe her. She told me once that her bedroom wasn't really her room and she actually lived in a tiny cabin at the back end of her family's property. And in the cabin was her secret husband. They had a baby, but I wasn't supposed to tell anyone this secret.

Something about this story sounded right. I already knew that I would grow up to be a mom someday. But the idea of a husband

was new to my imagination. I didn't quite see how husbands and babies could even be connected, even though my friends from church talked about having them as if they were a guarantee. We were talking about childbirth and how painful it would be long before we hit puberty or even knew what a menstrual cycle was.

Leah's story made me uncomfortable. She wasn't *that* much older than me. How could she have a secret family in the middle of the forest? Yet there was something romantic about it. This was what we girls were waiting for, after all, and somehow Leah had already achieved the dream, the fulfillment of our calling.

* * *

When the Mitchells came over to our house in the suburbs, we'd play games while our parents talked. After dinner, we'd watch Civil War movies in the basement. *Gettysburg* was our favorite. Our fathers liked the portrayal of Robert E. Lee as a praying man, a man of honor. We were taught to be Confederate sympathizers and to value states' rights, my father imitating the Southern accent of my mother's family when he said, "states' *rats*." He was a little proud but mostly ashamed of his own ancestor's statue, rising above the fields of western Pennsylvania — a Union general.

* * *

Anyone who met my dad would say he was charismatic. He told good stories and could make just about anyone laugh. He was passionate about what he believed, and I always admired that about him. As a child, I also trusted him. I trusted that he believed the right things and that he would help me become who I was supposed to be. People said I looked like him. We're both tall with brown hair and high arches in our feet. I thought that meant I belonged, that nothing could remove me from the love of my father.

I watched him as he had long, passionate discussions with Mr. Mitchell. My dad would get fired up after those talks, renewed into fervor again for what he believed: Calvinist theology, distinct gender roles, the boundaries that keep a family together. Or apart.

What he called family values. His talks with Mr. Mitchell were what people in our church would have called "iron sharpening iron."

The way I remember it, Mr. Mitchell introduced my father to *Patriarch* magazine.

I knew the word *patriarch* from Old Testament stories: Abraham, Isaac, Jacob. I knew it meant *fathers*. I was told it meant benevolence, protection, the God-ordained order of living. *Patriarchy* was a good word in my family.

Patriarch magazine had the tagline "Equipping Men to Be Godly Leaders in Family, Church and Society." It had the feel of a grassroots movement, a revolutionary pamphlet. It was a collection of articles that a man named Phil Lancaster published out of his home. Articles were written by Lancaster and other patriarchy leaders and had titles like

"The Remnant Will Make the Difference"
"The Loving Art of Spanking"
"My Child Does Not Belong to the State"
"Hopelessly Patriarchal"

At the back of every issue was a short letter from Pamela Lancaster, Phil's wife, who wrote "an encouragement for our wives."

But most of the magazine was for men, fathers, who were called to be leaders. *Patriarch* taught that God is masculine, the "prototypical Father of all fathers" and that "those, like the feminists, who hate biblical patriarchy hate God, whether they realize it or not, because God is the arch-patriarch, the archetype of fatherhood. He is the source, pattern, and goal of all manhood."[4] Because of this, fathers were responsible for their wives' and children's relationships with God; men had to dominate and protect their homes. Patriarchy was framed as godlike benevolence, and the writers were bringing a new era of God's blessing as fathers were turning their hearts to their children. If you wanted to be a good father who followed the Bible, then patriarchy was the only way.

I can imagine my father reading these words:

We are not writing, however, for most Christian families. We are addressing those of you who have already begun to think and act "outside the box" of contemporary lifestyles. You have already done the "unnecessary and impossible" when you chose to homeschool your own children. While most people don't see the point of home education and don't believe they can do it, you saw its value and you did it. . . . And one of the things you have come to realize is that homeschooling was just the beginning of a discovery process. It opened your eyes to the fact that many of the ways of modern family, church, and social life, are, well, insane. . . . The way you have chosen has been bearing good fruit, and you want to keep discovering the full dimensions of this path back to sanity.[5]

And I imagine this is what my father heard: *You are brave, you are special, you are a thinker, you are not crazy if you pull your children out of public schools and Sunday school and teach them everything yourself — you are following God's will. You see something few other people see.* Everyone else *is crazy.*

My father the protector. My father in charge. *Patriarch* told him, "You have a little kingdom called 'the family' over which you can take dominion today."[6]

My father believed that my siblings and I should be dominated because we were children, but also because we would grow up to be dominion takers. We were supposed to take dominion over the world for God. We were a generation of warriors bringing true religion to the world as we lived simple prescribed lives. Patriarchy gave us rules and Bible verses, enforced with spanking, and promised that we would stay on the path to godliness if our parents just followed the rules.

* * *

I hadn't given much thought to how I would end up a wife and mother until my father read an article series in *Patriarch* by John Thompson called "God's Design for Scriptural Romance." Thomp-

son answered the question "What is God's step-by-step process for bringing about a marriage the biblical way?" with very detailed instructions on a father-controlled courtship process. He had "five fundamental principles of scriptural romance (*piety, patriarchy, purity, preparedness,* and *patience*)" and a four-stage process for getting married: friendship, courtship, betrothal, wedding.[7]

The courtship process was organized and structured, backed by quotes from the Bible to support each point. My dad, who worked in the building industry, thought in straight lines and right angles, so it made sense to have a blueprint for marriage. Here was a guidebook, endorsed by God.

My father told us this new plan for our futures at the kitchen table. The previous house rule for dating had been age eighteen, and my sister was almost old enough. Dating was something she had been looking forward to. As our father talked through his convictions about father-led courtship, I watched her face fall, her fingers twine through her long black hair. Quiet.

"Allison, stop twirling your hair," Dad said.

She put her hands in her lap and blinked back tears, as if she knew this time it was pointless to protest.

MARKETPLACE

Ads appearing in *Patriarch* magazine from 2000 to 2002:[8]

WORK FROM HOME. Earn extra income part time or full time in a true home-based business.

NEW MAGAZINE FOR YOUTH, 12–25: *Peculiar People*, a magazine with articles by and for Christian youth.

CHASTENING INSTRUMENT. Flexible like Biblical rod, but also unbreakable, compact, attractive and guaranteed.

"HOME SCHOOLING ON THE THRESHOLD" . . . answers most common questions of critics, media, grandparents, etc. on socialization, academic achievement, success in adulthood/ college, population growth, reasons for home schooling, special-needs, talented-and-gifted, etc. Full-color format, charts, and photos make it a very engaging and effective booklet.

PRO-LIFE TELEPHONE SERVICE only 9.9c/min. State-to-state and 5% of your bill goes to the pro-life organization of your choice.

GET HEALTHY, LOSE WEIGHT & MAKE MONEY. I work with a proven 20 year old, billion dollar international health and nutrition company. I am looking for a few serious people who want a true home-based business. I support my family full time in this venture.

PREPARE YOUR CHILDREN for perilous times with highly acclaimed 36 week homeschool curriculum. Teaches outdoorsmanship, first aid, homesteading skills, more. Fun, positive, practical!

FREE VIDEO: THE HIDDEN CAUSE OF ILLNESS . . . This educational video gives essential information about eliminating the root cause of disease and premature aging. *Simple* program of outstanding herbal products. This has made a big difference in our family and has become a ministry/business. Distributors wanted.

ONLINE STORE — Hand-sewn dresses for little girls; capes and bonnets; educational toys from Plymouth Plantation. . . . If you don't have internet access, let us know and we'll send you a printout of our web pages.

NO ELECTRICITY NEEDED! Portable, airtight, wood/miltifuel [sic] stove keeps you warm, lets you cook and wash with hot water. . . . Call Pilgrims Products.

CHRISTIANS HELPING CHRISTIANS! Would you like to be part of a growing network of believers who are sharing one another's medical expenses (even pre-existing conditions) through a unique ministry that doesn't involve insurance?

SPARK

1996. I woke to fire in the driveway. My mother rubbed my shoulder as only she could do, whispering, "It's okay. You need to wake up now," in a calm voice, not wanting me to be scared of the alarming lights or the shriek of the fire engines she knew were coming. I leaned into her soft, fuzzy cardigan, but I wasn't afraid.

Out the window, my father's cherry-red BMW was in flames. I remember only the blurred edges of the fire: the flash and crashing of electric sparks, the gray heaving of fumes that blanketed our front yard, coating golden chrysanthemums in ash.

While I had been sleeping, my father had started the car in the driveway to warm up before his morning commute into the city, and he had gone inside to get his thermos of coffee that my mother had made. She used to get up early with him, in her nightgown, performing the housewife routine of suburban mornings. While they were in the kitchen — whispering about weekend plans, bickering over a bill, kissing goodbye? — they heard the muffled punch of tires exploding. My father thought it was one of us kids tumbling out of bed, but while he was on his way up the stairs to check on us, the lick of flame consuming his car caught his eye from the window in the foyer.

My little brother, Chris, and I huddled behind the second-story window, knees on the pristine white carpet. I was six and he was three.

Winnie-the-Pooh characters with chubby cheeks and no comprehension of the melt of fire, the heat of material things vaporized.

When the fire trucks came, turning into our usually quiet circle of houses, I felt proud that our house was the center of attention. A neighbor had rushed over earlier at the first signs of smoke, carrying his kitchen fire extinguisher, but its short-lived sprays couldn't put the fire out. Now there were lights, red and blinding white, and trucks the length of our yard and people huddling at the corners of the street, watching the car as if it were an eclipse. Later, once the skeleton wreck was removed, gaping holes were left in the driveway where the tires had melted the asphalt.

My parents let us come outside once the fire was put out. In our pajamas, we stood barefoot in the cold grass. The neighbors were going back to their homes, driving past us now on their way to work. The firefighters said it was lucky our house didn't catch fire. My father, thinking quickly, had wedged himself into the driver's seat before the fire had burned through the dashboard, yanked the shifter into reverse, and let the flaming car fall back down the driveway, far enough from the garage.

Fires need to be controlled, and he had stopped a disaster before it became a catastrophe, at least for the moment.

COLORADO

540,000,000 BCE. The Earth is silent and already four billion years old, a globe of water and ice. The land, rising above the surface of the seas, is barren, nothing but rock and sand.[9] Every day is sun rise, sun set. Every night is the quiet lapping of salt water.

250,000,000 BCE. Before there are mountains and canyons and cliffs, the flat of the Earth moves north and west. It shifts beyond the equator, this supercontinent made of multiple plates of crust, straddled by tidal flats. Cyanobacteria grow on top of one another, leaving sedimentary stromatolites behind.[10] Life trapped by new life. Eventually the continent rifts, pulls apart, letting an ocean fill in the gap.

68,000,000 BCE. The puzzle pieces of the Earth are moving, slow and fast at the same time, the way the universe expands both slowly and quickly depending on how you look at it. The pieces move with compelling pressure. A massive slab of rock from the west moves under another, like the creep of a hand under a bed sheet. Granite pushes against the crust, raising the ancient rock above ground.[11] Rust-colored sedimentary rock cracks and breaks ground at an angle, exposing its layers, which took such lifetimes to create, the red-on-red mineral sediment.[12]

28,000,000 BCE. Beneath the surface, a lake of fire boils against the boundaries of the Earth's crust and explodes, devastating the life above. The supervolcano, one of the greatest in Earth's history, pushes out four thousand times more molten rock and ash than Mount Saint Helens does millions of years later. The pit that resulted from the expulsion of rock is La Garita Caldera, a broken hollow in the ground.

18,000,000 BCE. The Rocky Mountains are made of recycled material. Ancient stone and grit, a metamorphosis of rock re-forming rock. Iron upon iron. They curve like a spine down North America. They rise from their roots in the Earth, a miracle of slow tectonic movement. They rise like ripples in a tablecloth. They break out of their skin like shards of bone. They form the Great Divide, a ridge line that spans a continent, directing the traffic of water. To the east of the divide, rivers fall to the Atlantic; to the west, the Pacific. Ice forms on the peaks. Snow falls. Glaciers sink into ridges like grandmothers into armchairs. The winter erodes the rock, makes it jagged, makes it sharp.[13]

FIRE

1998. Maybe moving to Colorado was a risk. My father wanted to start his own business. He said out west our lives would be better; he would be less stressed and would be able to work from home, which meant he could help more with homeschooling me and Chris, as well as Kyle, who could finish high school at home. Allison had graduated from the church school, but she would come with us to work on homemaking skills while she waited for her eventual marriage. I had been homeschooled for years now, so I didn't have many friends that I was leaving behind. I thought maybe moving to Colorado would mean I could get a horse.

It took us three days to drive there. We crossed the cornfields of Kansas and the eastern plains of Colorado, and finally I could see a mountain rising up out of the hazy distance like a storm gathering clouds. Steely blue, a darker shade than the sky, Pikes Peak was the very definition of a landmark. It seemed like the pushpin on our map, our final destination. We were like miners, heading west in search of gold.

The first people of this land, the Ute people, call it *Tavá Kaa-vi*, Sun Mountain, the place where Creator placed them, the "chosen ones."[14] The Ute climbed the ridges of these mountains hunting

eagles for feathers, tracking the moments of each day until the sun set behind the snowy peak.[15] Sun gold on ice.

* * *

My father imagined for us a newly built home: a wooden house in a tinder forest on the other side of the mountain, the shadow side. He and my mother picked out a five-acre lot in Divide, Colorado, near the national forest.

First, the builders dug into granite, laid cement. Then, the frame went up, meeting the scraggly pines in their altitude. They sided the house with cedar planks and laid forest-green tiles for the roof. It looked almost like a tree, and woodpeckers used to hammer the sides looking for insects.

* * *

1999. I would wear a different fleece pullover every day, not bothering to match my argyle socks. It was cold and quiet in the basement school room, and my desk was now made of metal with a top that could flip for storage. My parents had scavenged it from a local public school's remodel. Inside, I kept my literature book, a book about the Constitution, a Saxon Math textbook, and erasable pens. A glass door led out to the backyard, or more accurately, the back-forest. Sometimes a doe would step through the snow to peek inside. I would often sit and watch the chickadees and flickers, the occasional magpie, and tassel-eared squirrels fight over birdseed my mother had scattered over the crust of the ice-coated ground. Back in Pennsylvania, she had taught me how to call birds with a special chirping device made from a screw and a whittled piece of wood. She had taught me to sit quietly near the sassafras trees, my field guide in my lap, and keep a record of each finch and sparrow that fluttered near enough to see. Those birds never seemed to fight over anything.

On warm days, when it was sunny enough to make the winter feel more like spring, I would take a sketchbook and a set of charcoal pencils outside. I tried to duplicate the forest on my paper in thick black

strokes: the ridges and valleys that ruffled together before rushing down into the gully; pines pointing like arrows, ever upward; broken granite ground with wisps of mountain wheatgrass breaking through, stiff with winter; puddles of snow. The result was a shadow version of the emerald and silver and topaz that surrounded me. I could walk five hundred feet from the back door, and no one would be able to see me. I could sit for hours in the stillness of high altitude and hear no one. Only the call of jays, only the ghosts of trees.

Another homeschooled girl lived two lots down the road. Heather was a couple of years older than me, but she still liked to watch cartoons at lunchtime. Sometimes her mother would call mine to invite me over, and after we ate soup and watched *Arthur* on PBS, Heather and I would wander the wilderness. She took me to the mining cabin at the bottom of the hill. Its walls had sunk inward like a collapsed card house. One day, we trespassed on some acreage that felt miles from home, but Heather always knew her way back. This house looked abandoned, so we peered in the windows, pretending to look for a way inside. I could see empty beer bottles everywhere: on the sills, on the floor, in the middle of the dusty table. But we left before we could find a door inside.

* * *

2000. Homeschooling was a choice my parents made, a practice in religious commitment. I had been homeschooled for more than six years now, and I understood more the reasons why. Being home meant my parents could teach me what they thought was best, could protect me from drugs and sex and the teaching of evolution.

Homeschool was not chaos or noise or distraction as kindergarten had been at the Christian school. Homeschool was a notebook full of lists of assignments for each day, with encouraging notes and smiley faces in my mother's curly handwriting. It was reading my Bible every morning. It was learning to skip count with Bible-story songs: Noah and his animals, two by two; Moses and his Ten Commandments. It was learning about science and math and history and literature and spelling and health. It was grading my own tests.

It was playing soccer for the parks and recreation club in the next town over. It was taking piano lessons once a week. It was lying by the wood stove on chilly afternoons, listening to the pine crackle and reading Louisa May Alcott.

I got lonely studying in the afternoons after Chris had rushed through his work so he could play video games — we had limited time on the PlayStation, but more on educational computer games. I mostly didn't mind being alone, and I didn't let myself wonder about how it could be different. Math would take me hours to do. My father used to teach me algebra, writing examples on the white-board: his fours that looked like pointy nines, his upright hand-writing in all caps. But he'd grown too busy with his home business for full lessons. If I got stuck on a math problem, I would stand outside his office door, listen to the muffled music of John Denver, and think about knocking for help.

About once a month, my mom took me and Chris on field trips. The places we went had fairy-tale names: Cave of the Winds, Garden of the Gods. We met up with a homeschool co-op group down in Colorado Springs; sometimes I would know the other kids, some-times I wouldn't. On one trip to the gift store at the Manitou Cliff Dwellings, a girl I'd never met and would never see again taught me that ankle bracelets with beads were cool; she showed me how to try sunglasses on by seeing how they looked pushed to the top of my head. I tried to imitate her, but I felt awkward in my own body, unsure of myself.

* * *

2001. Being homeschooled in the mountains meant sleepovers were a rare occurrence. But another girl homeschooled nearby, Sophie, was turning fifteen, and Heather's mom, who seemed to be always looking for ways to get me out of the house, somehow got me in-vited. Sophie rode horses bareback, a fact that I was jealous of since I had realized that moving to Colorado does not guarantee getting your own horse. She hadn't cut her hair in years, and it fell down her back in a sandy-colored waterfall. She told me about how she was

dyslexic, something I'd never heard of, and how she was already engaged to a boy. They would get married in a few years, and although I didn't want to be married so young myself, I wasn't surprised by it. The idea of getting engaged and married young was familiar.

The morning after we slept in tents in Sophie's backyard, we went on a scavenger hunt. With each house sitting on its own five- or seven- or twenty-acre lot, it took a long time to walk between clues, gathering prizes from each neighbor. My team had given me the hand-drawn map, designating me navigator, but I must have been reading it backward because we soon got lost. The forest disappeared, and we wandered on a dirt road between two open fields for what felt like hours. I was starving and it was all my fault, but I held my panic inside. If we just kept walking, we'd find our way. But as it was growing dark, Sophie's mother found us and brought us home in her car. It hadn't occurred to me that someone would come looking for us.

* * *

For Christmas, my parents bought me a Singer sewing machine, just like my sister's. I was barely a teenager, but my parents thought of me as a young woman. My eventual marriage was a frequent topic of conversation, as if it was a party we were planning. It was expected, something to look forward to. Allison helped me learn how to use the machine. She showed me how to plan a quilt on graph paper, to count squares, to calculate enough fabric width for the shrink of seams. I cut up my old dresses, favorites I'd grown out of, into little squares: the burgundy corduroy that matched my face when I blushed, the floral with the lace collar for church, the brown poplin embroidered with white horses, forever running. I knew sewing was a skill valued in a woman, but I didn't see the point in making my own clothes when they were cheaper to buy in the store. Instead, I created costumes, gowns I could never wear out in public: a Civil War gown with black buttons and a ribbon-edged hem; a medieval princess dress, magenta with sheer baby-pink sleeves; a blue-and-white plaid Highlands dress. I played at who I was, or could have been, if I had only been born in an earlier century.

35

Cooking seemed like a more practical skill to learn. Food was the best way to attract a man, I'd been told. My mother told me how she had first hooked my father by peeling his shrimp for him at a restaurant. My parents paid for a subscription to *Cooking Light* magazine, and I copied recipes I liked into a spiral-bound notebook: ricotta-stuffed pasta shells, strawberries with balsamic dressing, apple pie decorated with pieces of crust shaped into leaves, candied cranberries coated with crystallized sugar, brown bread flavored with beer and chocolate and sour cherries.

I was learning how to be a homemaker, but I wasn't sure if I felt educated. I knew how to cook and sew and clean. I knew how to plan a surprise anniversary party for my parents. I knew how to diagram sentences. I knew how to make boys think I was uninterested (or uninteresting). I knew how to be a bridesmaid. I knew how to scrapbook and keep a diary and hold a newborn and dance the Virginia Reel.

But there were many things I had yet to learn: how to use a tampon, how sex works, how to set up my own email account. I'd never heard the f-word. I didn't know what kind of music I really loved to listen to or if I actually wanted to get married and have children. I had no idea what I was supposed to do with the knowledge I had and didn't have.

* * *

2002. In June, the Hayman Fire burned over 130,000 acres northwest of Colorado Springs, sparked from a match thrown by a forest service employee. Later, she said she was burning a letter from her estranged husband in a moment of rage.[16] But some people thought she was playing hero: if she started a fire, she could be the first to report, the first on the scene, the first to put it out. Almost as if she didn't know that fire doesn't respond well to human attempts to constrain it.

* * *

We could see the mushroom cloud if we hiked into the national forest to the top of the abandoned quartz quarry. Two ridges away, the bottom of the cloud glimmered orange, mirroring the flames that from a distance seemed small and silent. The morning the call came for us to evacuate, ash filled the open sky, smelling like a battlefield. A blood-red sun lurked behind the haze. We had an hour to collect our valuables and escape before the firefighters blocked off the roads and started their evaluation of which houses could be saved. I stuffed my pockets with plastic-bead jewelry and filled my backpack with letters from pen pals. I slipped in my Bible because it seemed like the right thing to do, as if what I brought with me would symbolize where I was going.

"We can't bring the dogs," my father said. "There's no room."

Our wolf-husky hybrids lived outside tied on running lines between towering pine trees. We unhooked their collars, set out a pile of dog food, and left them to fend for themselves. Chris kept asking if they would be all right, alone in the woods, but my dad replied in his calm, commanding voice that the dogs would stick close to the house, that they knew how to survive. They still had wilderness in their blood. Somehow that made sense. My father had a way of handling our emotions, imposing a sense of safety on us. The dogs hated being tied up anyway.

Our car crammed with family picture albums and my dad's work computer, we drove leisurely down the mountain pass, and my parents took us to the zoo in the city. The air was clear of smoke but noisy, and the zoo animals were all locked up. The zoo felt like a controlled atmosphere, danger just on the other side of the fence. My siblings and I were happy to be on an outing with both of our parents at the same time. We would probably be eating out for dinner and sleeping in a hotel even though we weren't on vacation. Meanwhile, the fire blazed above us on the other side of the pass.

Years later I look at photos of the fire, Colorado's largest at the time, the beast that obliterated over a hundred homes, turned trees into matchsticks, and melted soil into crusty soot. In one nighttime photograph, a mountain ridge glows with flame and cinder as if it's

an image of the ancient Hadean Earth. I never saw this side of the fire up close: all I knew was the scent of combusting wood, the sight of a nuclear cloud of smoke breaking the sky, and my mother's face crumpled under the weight of anticipated grief.

Two weeks after the evacuation, my family returned home. The sky was open and empty again, and our house, still standing, had been marked savable with an orange ribbon on a tree. The fire had stopped two miles away, leaving our house free of smoke damage.

We eventually found the dogs, their faces and paws swollen with porcupine quills. They were never quite the same after that. Something wild had been sparked in them. I don't know what they saw in those two weeks wandering the abandoned land as the fire advanced: the glory of freedom mixed with the fear of a self-destructing world. One of the dogs got sick from drinking creek water, and she had to be put down. The other became so lonely without her sister that we gave her to a wolf rescue.

After that, our house in the woods didn't feel quite as safe as it had before. I realized how difficult the fire had been to control, how destruction is not something that can be managed. And I began to wonder about the potential for devastation everywhere: If a forest could combust, what else was prone to explode? What if my parents couldn't protect me?

I started to agonize over my future death and the afterlife. I had been taught about hell, how it was an eternal furnace, and how easy it was to go there.

My father would read to us from the Gospel of Matthew in a somber voice: "Enter by the narrow gate. For the gate is wide and the way is easy that leads to destruction, and those who enter by it are many. For the gate is narrow, and the way is hard that leads to life, and those who find it are few" (Matt. 7:13–14 ESV).

But I had also been taught that God is sovereign, that he "reigns over" everything, that those he saves are those he has chosen. So death as a gateway to hell became an obsession — something I knew I couldn't control but something I needed to understand. Was I destined for the lake of fire or for the living waters of heaven? I imag-

ined car accidents and plane crashes, slept as much as I could because my daydreams were worse than my nightmares. I wondered if God existed, and if he did, would he give up on me? I saw my own end as inevitable and imminent. Fire was always on the other side of safety. And *fire* is just another word for *loss*.

READER

Elsie Dinsmore
by Martha Finley

> *"Dear papa, I love you so much!" she replied, twining her arms*
> *around his neck. "I love you all the better for never letting*
> *me have my own way, but always making me obey and keep*
> *to rules."* [17]

Synopsis: Elsie Dinsmore is a good Christian girl growing up in the American South before the Civil War, and ever since her mother died in childbirth, she has been mostly estranged from her father, who (when he is around) is usually cruel and bitter. One day, her father asks her to play a secular song on the piano on a Sunday for his house guests, and conscientious Elsie refuses. Her abusive father's discipline style includes restricting her diet and condemning her to isolation in her bedroom. When she appears to almost die from a nervous breakdown, her father sees the error of his ways, becomes a Christian, and suddenly adapts his cruelty to a Sunday-school-teacher flavor of authoritarianism. Elsie loves having a father whose rules follow the Bible.

* * *

When I was eleven years old, I picked this book out of a Christmas-edition Vision Forum catalog, probably because it was the only book that looked vaguely interesting in the gender-designated "Beautiful Girlhood" section. For subsequent Christmases, my parents bought me all twenty-seven sequels because they knew I loved to read. Vision Forum's marketing implied their books would produce meek, godly, submissive daughters. My parents didn't read the Elsie books themselves, so they never knew about the scenes of Elsie being whipped by her father, of her sitting on her "daddy's" lap or of him kissing her on the lips when she is an adult, of the Mammy character, of the fumbled dialect of the enslaved characters, of Elsie's future husband being an adult friend of her father when she is eight years old.

Elsie's perfect attitude and her pretentious ideas about reading only religious books on Sundays (a rule I followed for many years) appealed to my own obsessive scrupulosity in obeying God through my father. I thought imitating her unquestioning obedience would bring me love, so I tried to emulate her. I was shown perfection, and I believed anything less would bring hate from my father, from God.

* * *

The True Confessions of Charlotte Doyle
by Avi

"A sailor chooses the wind that takes the ship from a safe port. Ah, yes, but once you're abroad, as you have seen, winds have a mind of their own. Be careful, Charlotte, careful of the wind you choose."[18]

Synopsis: Young Charlotte Doyle at first seems like a proper young lady in the making. Thirteen years old and fresh out of the Barrington School for Better Girls, Charlotte is the only female passenger on a tall ship crossing the Atlantic. It is the year 1832, and Charlotte is supposed to behave herself. But soon enough, she's wearing sailor pants, climbing rigging, and getting a suntan.

The rules that dictate Charlotte's life were familiar to me. If my father could send me to a School for Better Girls where I would learn never to question authority and always to obey the will of the male head of the household, he might have considered it. Charlotte's father says she should stick to her "station in life";[19] my father called it my "role as a young woman."

Secretly, I felt destined for a life like Charlotte's, full of adventure — setting sail and letting the wind take me away. I fantasized about living on a ship surrounded by the ocean, far away from my landlocked home in the mountains. Charlotte gave me the idea that sometimes girls don't obey their fathers, that sometimes girls don't have to be good to be happy.

* * *

Sense and Sensibility
by Jane Austen

> *"Know your own happiness. You want nothing but patience—or give it a more fascinating name, call it hope."*[20]

Synopsis: Marianne Dashwood says everything and feels everything and experiences everything I wished I could say and feel and experience. She's a sister, a reader, and a hopeless romantic. She thinks she knows what she wants but quickly learns that trusting the wrong man with her heart is a big mistake. This isn't the story of a damsel in distress. This is a story of women wanting things they can't have. This is a story of women waiting for men. This is a story of men screwing things up.

* * *

I stole Allison's copy of this book because I had wanted to read it ever since one rainy afternoon when I had been alone in the house and watched the movie, crying over the idea of unrequited love,

a loss I had yet to experience. I didn't know how to talk to my church friends about my growing attraction to boys, about the feelings I was told were sinful. But when I read this story, I could think about this secret desire for a boy to like me.

I hid the book in my bedroom so no one in my family would realize I had moved on from playing with American Girl dolls and was now interested in "real" romance. When I read about Willoughby and Marianne, I imagined the scene from the movie, his fingers brushing her cheek, her smiling without reluctance, and I felt a new hope that maybe I would have a love story one day. I knew that marriage was my destiny; it was a promise I was given every day by my father and the leaders of the church. But I hoped that whoever he was, he would be special. Even if he eventually jilted me like Willoughby does Marianne, at least he would have loved me.

These thoughts were not safe. If I dared say them out loud, I would either be laughed at or scolded for letting these feelings out too soon. My father reminded me over and over that I must keep myself emotionally pure until I was betrothed to be married. So, I hid my desires in the book that was tattered and wrinkled and bent.

I was good at hiding things like thoughts like menstrual pads like diaries like anxiety like crushes like depression like songs like rage like pain.

VISION

I'm twelve. My mother is on the phone with my father. She's quiet,
listening. My father is on the other side, passionate and hopeful.
He's with Chris at one of the father-son retreats hosted by Vision
Forum in San Antonio, Texas, one of their many events meant to
inspire family unity and a radical return to defined gender roles.
I imagine them doing the manly activities the retreat advertised:
hiking, making potato guns, playing capture the flag and tug-of-
war. Later, Chris will tell me about how some of the leaders gut a
deer in front of the boys, make them watch as if the violence and
gore will make them men. The retreat is supposed to turn the hearts
of fathers to their sons with the goal of creating the next genera-
tion of male leadership. Vision Forum families are not supposed to
have rebellious children. Instead, the goal is an ideal family where
everyone knows their place, where children grow up to fill the roles
created for them.

When my mother hangs up, she turns to me with a worried look.
"He said things are going to change. We should be ready."

CHURCH

Imagine the exodus: the Israelites in the desert, finally freed from slavery, their eyes glazed over with dust, wandering for forty years before God lets them into the promised land. Moses has led them out of Egypt, an ungodly place, and they are hungry for home. But they will never make it. They have harbored rebellion in their hearts, and they have not trusted God to guide them. So, they are cursed to wander until they die.

But they have hope. Their children will be the ones to claim the land promised after decades of wandering. The next generation will inherit the blessing of God, the fruit of Canaan. And Joshua, God's faithful one, will lead them.

* * *

I've heard us called the Joshua Generation, the children of the patriarchy, the children of those who are returning to God and returning to the way families were created to be. Our parents were raised in the outside world, and so will never see the full harvest of their choices. But we were supposed to. We were supposed to be raised in the true doctrines of the faith, trained in our proper gender roles, shaped into soldiers for the coming kingdom.

If we were faithful, God would bless us and our children and our children's children, giving us churches of joy and a community of believers. There would be so many of us that we would inhabit whole towns, we would populate the Senate, we would change the world. We would make God's kingdom come here on Earth.

* * *

My family had been spiritually wandering for a few years after moving to Colorado. We had been attending a Reformed Presbyterian church my father refused to officially join because they allowed women to be deacons. He started to identify as an outcast of this church, often becoming the center of heated discussions during the fellowship time after services as he voiced his convictions about their incorrect doctrines. He pulled us kids out of Sunday school because he didn't want anyone else to teach us the Bible, because Vision Forum had said children shouldn't be age-segregated.

But we weren't the only ones who held to stricter beliefs. My friend Charity was the oldest daughter in a family with eight children. During church, the girls had to wear head coverings that looked to me like lace doilies. When they came over to our house once for dinner, Charity pointed out all the Disney movies we had that she wasn't allowed to watch.

I had a crush on Charity's brother, the oldest son in the family. He was tall, blond with blue eyes, and to me seemed so mature. But then he called me "four-eyes" during church fellowship time, and his mother later made him call me to apologize. I could never get over my embarrassment, not even when my mother told me boys made fun of you when they liked you. It was almost like a compliment.

Then I found out the second-oldest son had a crush on *me*. His mother told my mother that he had a photograph of me that I'd given Charity that he kept in his wallet. My mother related this to me as if I should feel special, wanted. I didn't like him — he seemed more aggressive and louder than his older brother — but the only thing that seemed to matter was that he liked me.

One Sunday, my family was sitting in church when I noticed a young man slip into the service late. I'd never seen him before, but he made eye contact with Allison as if he knew her.

After the pastor said the benediction, I went outside to talk with Charity, but soon my parents were rushing out of the sanctuary and herding me and my brothers into the car. I knew the signs of stress in my parents, so I understood I needed to be quiet. Even on "normal" days, there was often an underlying tension between my parents as they sat facing the same direction in the car or as they worked in their separate areas at home: my mother in the kitchen or the laundry room, my father in his office in the basement.

As my father drove us up the mountain pass back home in one of his silent rages, my mother wept uncontrollably in the passenger seat. She kept saying, "Allison always wanted a big wedding. She gets *Bride* magazine!"

I started to piece together what had happened with the help of my brother Kyle. Allison had a job at a bakery, and the man who had come into church late was one of her coworkers. She had stayed behind because she was planning to elope with him, with the aid of some of our friends at church. This went against everything we had been taught about Dad being the head of the household, about courtship, about purity. I understood why my father was so angry. Allison had rebelled.

I believed I would never see her again because of the way my parents were behaving, and when we arrived home, I wrote a kind of eulogy for her in my diary. But then, a few hours later, Allison called and wanted to come home. She had called the elopement off. I thought God must have changed her heart, and when she got home, she apologized and my parents welcomed her back. But we never returned to that church again.

* * *

My father decided to start a house church until we could find somewhere better to go. A few other families who had been discontented

at the church, including Charity's family, left with us and drove up to our house in the mountains on Sundays. Dad had been to seminary for a short time when Kyle was a baby, but he said that he'd had to leave over a misunderstanding, something to do with his church sponsorship. He still studied books on theology and enjoyed teaching the Bible, often recalling his favorite classes learning from R. C. Sproul, a professor he admired.

He led the group in worship in our living room. His gilt-edged Bible open on his lap, his pressed shirt, his neatly trimmed, graying beard. His authority as a man.

The rest of us listened as he preached, as he prayed or asked another man in the room to pray. It was easy for me to sit quietly, but it wasn't always easy to follow the words. To pay attention. To add more rules to my mental list of dos and don'ts.

House church was only a temporary solution, though, so when my father heard about a new church plant of the Orthodox Presbyterian Church in Parker, on the outskirts of Denver, he was willing to drive two hours to take us there to visit. And we almost never missed a Sunday at Reformation Church after that for six years.

At first, there was only a small group of us — people wanting something new, something challenging, something to make them feel like they belonged to a community. The ties that bound us together were shared beliefs about home education, separate gender roles, men leading loudly and with firm hands. And the thickest cord of all was our pastor, his words like coiling snakes.

Kevin Swanson was a homeschool advocate, executive director of Christian Home Educators of Colorado, church planter, visionary, radical. People often came to Reformation just to hear him speak. He was short, slight, unimposing. He wore glasses and formal suits that never seemed to fit him. He seemed awkward, harmless even, but when he spoke behind the pulpit, his voice could move from the hush of a river to the wail of a siren in a snap. He never stumbled over his words, and no one ever fell asleep. I remember he would say he wanted to step on our toes, get us out of our comfort zones, bring us

the word of God, which was supposed to shake us out of complacency. If we were bothered by something he said, that was a sign we weren't aligned with God. We needed to be offended, uncomfortable.

The first sermon I remember from him was just after September 11, 2001. I was thirteen years old. My parents had told me to come watch the news that morning because it was important for me to know what was happening. Even as I watched replays of the second plane hitting the tower, the horrific live videos of the flames and smoke, people dying, I didn't understand. I couldn't comprehend that kind of pain, that kind of death. I thought at first it was some kind of prank. What a terrible joke.

But soon I realized it was real: thousands of people had been killed. And on the next Sunday, I remember Kevin Swanson preaching that disasters like the terrorist attack on the Twin Towers were God's punishment for America's sins. I began to feel I must be living in a refuge protected from wickedness, that danger was always close. I was learning the language of fear and the lies of safety.

* * *

Reformation Church felt like a promised blessing. There were only a few families in the beginning. We had services in a small room in a shopping mall. Every week brought new visitors, and the space started to feel crowded. We might have compared ourselves to the early Christians, meeting in the catacombs, or to the early Reformers who hid from the Catholics. No one was chasing us, but we still felt like we were in the underground of "real" Christianity.

At our previous church, I had felt tension because of my father's differences in beliefs, because some of the women there were outspoken, wore pants to church instead of dresses. But at Reformation, I felt relief, as if we were finally home. There were girls my age who looked and dressed like me in long skirts and modest sweaters. There was no Sunday school to be pulled out of. Everyone seemed joyful, as if they could already envision heaven. It was a community where we supported each other. We took turns preparing food to share

every Sunday. The women threw bridal showers and baby showers. The weekly bulletin contained an extensive prayer list. We visited the sick in the hospital, made meals for families with newborns.

Above all, we were proud of our like-mindedness. We were all there for the same reason: the kingdom of the living God. We had a purpose, and when we were together, it felt safe to me, like nothing could hurt us.

* * *

Even though I no longer looked like an outsider, I still struggled to talk with the other girls at the church and make friends. Charity's family had come with us to Reformation, but she and I started to drift apart. At a church picnic, I went looking for her only to find her talking with one of the older girls at the church; they looked like they were huddled together, sharing secrets. I felt abandoned, ignored, unable to walk up to them. I didn't know how to maintain changing friendships or how to deal with potential conflict, so I walked away.

I was wandering through the parking lot to find my family's car — something I often did when I wanted to be alone and read a book or listen to a movie soundtrack on my Discman — when another girl waved at me and walked over.

"I've seen you a few times at church," she said. She smiled, and the sunshine highlighted her freckles.

"Yeah, I've seen you too." I'd seen her with her family — they had been one of the original church planters. They had four children, two boys and two girls, just like my family.

"My name's Jane. I was wondering if you wanted to be my pen pal. It would be nice to have someone to write to." I couldn't believe how quickly I went from feeling lonely to feeling seen. It seemed like God was providing for me when I'd least expected it.

"I — I would love that," I managed to say before getting in the van.

* * *

Jane and I wrote letters every week, and we started to refer to each other as "kindred spirits" — something we had picked up from *Anne of Green Gables*. I felt like I could be my fullest self with her, writing my inner thoughts that I didn't share with anyone else. We wrote about the books we were reading, our dreams of being writers. I could tell her how I felt most alive when I walked in the woods or along the ocean when we visited my mother's family in North Carolina. I told her about my insecurities, about my fears of not being a good enough Christian, something I didn't have the courage to tell anyone else.

Jane was a safe friend — she kept me on track, always encouraging me with Scripture verses, never failing to be sympathetic to my questions. She always seemed secure in her own faith.

Writing to friends was how I could connect with other girls my age. When I was back in Pennsylvania, I had become friends with a girl named Rebecca who had posted an ad in a homeschooling newsletter we got in the mail: PEN PAL WANTED. I never met Rebecca, but we wrote each other about our favorite colors and favorite foods. We sent stickers to each other with every note. She sent me photos of herself and of her family's farm, and she told me about her pet bunny that she took on walks with a leash.

We had kept in touch after I moved to Colorado, but as we both got older, things changed. She started to write to me about how she was cutting herself, how she had something called depression, how she didn't always feel like being alive. It scared me. I sensed unknown territory, but also something familiar. I would hit my wrists against the edges of my chair sometimes because the pain felt good somehow. But something about what Rebecca was saying seemed dangerous. Suicide was a sin, I'd been told. So I showed my father the letters.

"I don't know what to write back," I said, hoping he'd give me advice on how to help her. I felt afraid that something bad would happen to her.

After reading the letters, my dad said, "I think you need to stop writing to Rebecca." I don't remember any explanation beyond this,

but I felt a little relieved because all I had to do was trust him. He knew what was best, and that relieved my own responsibility. So I never responded, and I tried to forget.

* * *

At church, Kevin said we needed to be countercultural. He said that children were swords to be sharpened. He made jokes, and we laughed. He shouted fear, and we listened. He used tragedy to talk about God's judgment. He preached the Old Testament laws as rules we should follow today.

His words fueled this idea that we were on the cusp of a great movement. We were the beginning of change. We were a remnant taking dominion.

He said women who didn't submit to their husbands were disobeying God. He said homosexuality was an abomination. He said women's calling was to be helpers to their husbands, that self-serving careers would be sinful.[21] He said the "homosexuals" were on the march with an aggressive agenda.[22] He said it was okay for children to be bruised during spanking because bruises don't last forever.[23]

* * *

I remember the moment like I had woken up for the first time. We were driving to a church event, and I was sitting in my favorite spot, in the way back of the van, watching the seeds from the cottonwood trees float by out the window. I was always excited for church get-togethers because it meant I could see Jane and the other girls.

But then — as if struck by the devil I was taught to fear — I had a terrible thought.

What if God doesn't exist?

I had been taught there was only one unforgivable sin, a sin so great it grieved the Holy Spirit, and I wondered if this was it — if my sinful thought was so terrible to cast me into hell. But then I had a worse thought.

If I'm wicked enough to doubt God, then maybe God doesn't love me. Maybe I'm not a chosen one.

* * *

I went before the elders after a church picnic. My friends were playing games or taking walks by the creek. I sat down on a metal folding chair in the circle of elders, including my father. White middle-aged men with beards, holding leather Bibles, watching me as if I were a sheep who needed to be kept in a pen.

I've always hated being the center of attention, and I was filled with dread. I focused on the rustle of the shade trees above us to keep me on the ground.

It was obvious to everyone outside the circle what I was there for. Girls rarely talked to grown men in the church, and women were never welcomed to meetings of the elders. The only reason I was being examined was to see if I could take membership vows to join the church.

In some churches, like the Baptist one my mother grew up in, twelve years old is the age of accountability. In our church, anyone of any age could join as long as they believed Jesus saved them. I must have been around fourteen, and I was feeling the pressure that I should join. I was old enough to understand the Bible. I'd memorized the catechism and the creed. Why wasn't my faith strong enough?

The meeting quickly became about the doubts I had confessed to my father. I knew I couldn't hide them from the other church leaders, but I didn't say much. Who was I to talk, a girl in a church where the only time I was allowed to speak was to say five words that would commit me to the church for life: *yes* to believing the Bible, *yes* to believing in the Trinity, *yes* to repentance and salvation, *yes* to putting to death my sin, *yes* to obeying the church elders.

I had arrived at the picnic thankful that we hadn't died in a crash on the way; I was already worried about the drive home. I was praying compulsively, I read my Bible every morning, I panicked at the thought of burning alive forever.

But I didn't know how to say these things out loud; I didn't want them to know how weak and evil I believed I really was. I didn't have the language to describe *obsession, compulsion*. And I know now the elders wouldn't have given me the help I really needed anyway. They wouldn't have noticed my mental health struggles because in their view, psychologists existed on a spectrum between worldly and demonic. Mental health wasn't a concern to them. All problems could be solved with the Bible.

So instead, I simply demurred and said I still had a lot of questions. I didn't want to explain too much of what I was really thinking. I wanted to believe in God, but I just wasn't sure if I was believing in the right way. After listening to my short explanation, one elder read me a hymn by William Cowper to reassure me other Christians sometimes had doubts:

> I sometimes think myself inclined
> To love Thee if I could;
> But often feel another mind,
> Averse to all that's good.
>
> My best desires are faint and few,
> I fain would strive for more;
> But when I cry, "My strength renew!"
> Seem weaker than before.
>
> Thy saints are comforted, I know,
> And love Thy house of prayer;
> I therefore go where others go,
> But find no comfort there.
>
> Oh make this heart rejoice or ache;
> Decide this doubt for me;
> And if it be not broken, break —
> And heal it, if it be.[24]

Another elder recommended a devotional written by a Puritan theologian. He said to pray, to keep reading my Bible, to listen closely to the sermons in church. I was reassured that everyone had doubts sometimes, but the elders wanted me to have faith despite my doubts. And when I was ready, I could interview with them again.

I felt relieved that I didn't have to take any vows yet, but also worried knowing that I would have to meet with them again. I wouldn't be forgotten. I walked across the shady patches in the grass to where the mothers were putting away the food from lunch. I took a last piece of watermelon.

* * *

In the Orthodox Presbyterian Church, the leaders in each region gather together annually for meetings and committees and voting. One year my father was attending the meeting, which was in South Dakota that year. Chris and I went with him because my dad said we could use the opportunity to learn about church government.

We drove out of the Rockies and into the northern plains, past fields of dry grass, fenced-in buffalo and cattle. But mostly, there was nothing. I had never seen such a barren landscape. It felt like what I imagined driving on the moon to be like.

The church looked alien in the wilderness. Solitary in a land with no trees. But it was full of church leaders from all over the West. Chris and I sat with Dad through the whole day of meetings. The pews were packed with white men wearing slacks and button-downs. They all looked the same to me; they all looked like my dad. I was the only female in the room, an anomaly. My father had made an exception for me, and the other men accepted his decision that I could be there as a silent observer.

The day was scheduled with committees making reports, pastors sharing prayer requests, the men voting on initiatives and church discipline.

At the lunch break, I found out where all the women were: in the basement kitchen cooking and preparing the midday meal.

They looked like homeschool moms from our church. They wore floral-print, shin-length dresses, jumpers, cardigans. They seemed kind and joyful, their cheeks dusted with pink blush. They spoke softly.

The food was like nothing I had ever eaten. Every dish was in a bowl and called some kind of salad. Roast beef salad. Egg salad. Snickers salad. The only green food was Jell-O.

Men I didn't know sat at our table to talk with Dad. He was charismatic, easy to talk to, one of the guys. One of them turned to me and asked me some questions about the catechism. When I replied without hesitation, he said I was very mature for my age and would make a great wife one day. I felt proud and self-conscious at the same time. I was being recognized for my knowledge but also reminded that I would only be allowed to use my mind to serve my future husband.

At the end of the day, there was a worship service. Some of the women from the basement joined us, but still the male presence was overwhelming. When we sang the hymns, I could barely hear my own voice amid the baritones.

* * *

The more I thought about joining the church, the more anxious I got. I worried that God didn't want me. I thought about hell on an almost minute-by-minute basis, calculating each day what the risk of death might be if I were to leave the house, knowing I wasn't ready to face judgment. But my father seemed to have the answers. Once, he asked me questions and wrote down my responses: *Yes, I believe I'm a sinner. Yes, I think Jesus is the only way to salvation.*

But this wasn't enough to ease my anxiety. I'd been taught that even demons believe in God.

One day, my father took me on a day trip, just me and him. We ate lunch at a Mexican restaurant in downtown Colorado Springs, and then impulsively, after we had walked around a piano store, he bought me a brand-new baby grand piano, a lavish gift of love that also confirmed how well his home business was going and how

God was blessing us. After all the excitement, we sat in the park, and he used all the tools he'd learned from Evangelism Explosion to make me a true disciple. He asked me the questions I had heard him repeat to others he had tried to convert.

"If you were to die today, do you know if you would go to heaven? And if you were to meet God face-to-face, and he asked you why he should let you into his heaven, what would you say?"

I fixated on my uncertainty. How could I know *for sure*?

"I want God to love me, I just don't know if he does."

"Jesus didn't only die," he told me. "He experienced hell for every single person who believes in him. That's love."

I tried to imagine the pain of an infinite amount of torture times millions of people. I started crying at the thought of one man bleeding for so many. The anxiety now was not just for me, but for Jesus, the innocent one who shouldn't have experienced such horror.

My father did not look sad or concerned. His face was serene. He did not yell at me or rush me. I don't remember how many hours we sat on that park bench as I cried in public.

Later, my father took me to dinner and told the waitress we were celebrating my first day of being a Christian. He was more excited than I was. On the way home, he stopped at the grocery store to buy me a birthday cake. But as we ate it with the rest of my family, I couldn't stop thinking I must be faking it. I couldn't stop feeling guilty, like I must be a liar. I just wanted the day to be over, but more than that, I wanted to feel at peace.

* * *

I was sixteen when I finally joined the church. I still had doubts, and I was worried about being dishonest. I still felt maybe God wanted to punish me forever. But I wanted to believe everything I was told; I wanted to believe God loved me.

Chris had decided to take membership vows, and I didn't want to be the only one left out. That would have been embarrassing. And terrifying. I couldn't imagine any other option than to give my life to the church.

He told me once, "I have doubts too," but I think we both knew that we couldn't survive in our family if we didn't profess faith. We'd seen what happened to Kyle. He'd rebelled after we moved to Colorado, running away at night, dying his hair aqua. And we'd witnessed his punishment: spankings, shaved hair. He'd joined the army as soon as he could when he turned seventeen.

So Chris and I stood up together in front of the congregation to become members. We said the five yeses in answer to the five questions. And then we sat down.

Membership didn't change much for me. As head of the household, my father voted for me in congregational meetings. The one thing that did change for me afterward was that now I could be excommunicated. Now they had the right to cut me out if I disagreed or broke the rules.

My undiagnosed obsessive-compulsive disorder escalated under this new pressure. Every week, we took communion at church. We passed the silver serving tray around, and each week I took a cracker and a tiny cup of wine. Every week I started the ritual of repentance in my mind. I had been taught that if I took communion "unworthily," I would be cursed by God with physical pain and sickness. So I prayed over and over, *God, forgive me, forgive me, forgive me.* Then I'd have a doubting thought, and I'd start the ritual over. *Forgive, forgive, forgive.* It was difficult to concentrate as I watched the serving tray being passed down the rows, trying to get to a place mentally where I could say God had forgiven me. I imagined Herod from the Bible story, cursed by an angel, eaten alive from the inside by worms after he failed to give glory to God.

When I received the wine, I swallowed with one last prayer, taking my chances. In Jesus's name. Amen.

CAMP

As Reformation Church grew bigger, we moved to a larger space in Castle Rock, meeting Sundays in the cafeteria of a public high school. Whenever I walked down the hallway to the bathrooms, I looked at the student art on the walls, the posters for dances and sports games, and remembered how we were supposed to be light in this darkness. But what I saw there didn't seem so bad.

Kevin Swanson was growing in popularity with his radio show, *Generations*, and the books he was writing about how to be a Christian in a secular culture. He gave talks at homeschooling conferences, and it was not unusual for other homeschoolers we met to know our pastor by name.

So when Reformation started hosting a family camp every year, it was instantly popular in the homeschooling world.

Family camp was supposed to be a retreat and conference where everyone in the family could be involved, like a vacation interrupted by sermons and cafeteria-style meals. We started hosting the camp in New Mexico at a conference center where there were lodges for hundreds of people, a lake with canoes, and volleyball courts.

People from all over the country came out for a week of what we called "edification."

On the drive down, I thought about how fun it would be to spend time with my friends but also about the music I would be playing. As part of the hosting church, I had been asked to be one of the accompanying pianists. My piano instructor was teaching me how to improvise hymn chords, and I was getting better at it, but I was nervous about playing in front of so many strangers.

The first day, I was also a volunteer registering the families who were arriving. Dress code was long skirts, nothing sleeveless or showing, demure facial expressions. I had never done anything like this, but I was excited to be part of something important. I'd also been told family camp was an opportunity to meet other Christians and potential spouses. Parents at Reformation joked that there was a shortage of young men at the church, and too many girls to marry off. So mingling with other likeminded Christians could lead to future relationships.

At breakfast, I had looked at all the food options — cereal and pastries and bagels — and chosen an orange. I had started to feel self-conscious about how I looked. The other young women at Reformation mostly fit into a narrow category: slim, modest, hair perfectly curled or intricately braided, smooth eyebrows. My father had once called a woman on the news a "pig," and I had absorbed his criticism of women who didn't conform to his ideal of a biblical woman. I felt it was important to be small in order to be picked by a man. I wondered if I might meet my husband here and if I would know right away.

The room where we were checking people in was hot, windowless. It was summer, and I could feel myself sweating under my stuffy clothes. I was looking for someone's name on the list when the room suddenly started spinning. I couldn't read the letters on the paper anymore and felt myself list to the side. My dad happened to be nearby, and he caught me and led me over to a chair, where someone brought me a soda.

"What did you eat for breakfast?" my dad asked, worry in his voice.

"Some fruit."

"That's it?"

I nodded.

"That's not enough."

I had seen both of my parents cycle through diets: Weight Watchers, Atkins, South Beach. I thought restricting food would make me desirable.

But when I continued to be lightheaded that week, my parents called me into their room with concern that I wasn't eating enough.

I saw my mother's forehead wrinkle in concern and remembered all the times she had said how she needed to lose weight. I didn't stop believing that I needed to be small, but it was comforting to know my parents had noticed I was unwell. Still, it was confusing that they could give me advice they didn't take for themselves.

Family camp was as near to free rein as we kids had ever experienced. It was playing poker and spoons after our parents went to bed. It was roaming the conference grounds unsupervised because everyone there belonged to the same belief system. It was the red shame on my friend Samantha's face when she fell into the lake wearing a white shirt and her mother scolded her about being immodest. It was the awkward flirtations of homeschooled teenagers. For me, family camp was where I met Megan.

One morning, I was walking to the chapel, carrying my tote of music books when I heard a voice call out to me. I turned to see an energetic girl with a bouncy ponytail ask me if I wanted to play volleyball. Behind her I could see a few other teenagers in the sand waiting.

I hated playing sports, and I definitely did not want to exhibit my lack of hand-eye coordination in front of a bunch of strangers, especially considering my future husband might be there to witness it.

So I declined and went inside to practice my chords.

But later, she called to me again when I was walking through the lobby of one of the lodges. This time I joined her and the other kids she had collected to play Taboo. I could sense that saying no twice would be rude, and she seemed determined to get me to open up.

Megan was carefree and laughed a lot; she didn't fit the mold of many of the Reformation girls. She didn't try to be small or quiet. Her boldness in bringing together strangers to play a game with her surprised me, and I admired how easy it seemed for her.

I had gone to family camp thinking I would meet my husband, but instead it seemed I was making a new friend.

GIRL

We were called stay-at-home daughters. We had scrapbooking birthday parties. We sent each other handwritten letters, trading stickers when we were young, copying poetry as we grew older. The highlight of our year was the Civil War Ball, put on by the homeschooling community. We spent months sewing lace-and-satin gowns; we wanted to feel beautiful, feminine, like Meg in *Little Women*. We learned classical piano and memorized traditional hymns, songs with steady beats and predictable endings. We huddled together after Sunday service and shared prayer requests. We never talked about boys in particular, but we imagined future husbands, our lives fulfilled as wives and mothers.

We were sixteen. And seventeen. And eighteen. And twenty-one. And twenty-nine.

Age didn't matter as much as whether we were unmarried or married. The girls who were picked by husbands became women and moved away or became too busy to talk anymore. They became pregnant on their honeymoons. They never went to college. They didn't share the secrets of the marriage bed with the rest of us or tell us whether they were happy or whether they regretted it. We thought marriage must be like dying and going to heaven.

God was the author of my story. He had a plan for my life, and my father had control over the details.

The language of this story was simple. Girls like me weren't fragile but complacent, not stupid but submissive, not objects but weaker vessels. One day I would marry a man approved by my father, and this would be God's reward.

I always knew this story had power, but the power was never mine.

* * *

One of my father's favorite movies was *Seven Brides for Seven Brothers*, a musical from the 1950s. Set in the Oregon Territory during the 1800s, the plot is based on a Roman myth known as "The Rape of the Sabine Women."

In the film, a man named Adam proposes marriage to Milly, a woman he's only just met but who knows how to chop wood and cook delicious stew. She marries him that afternoon and drives off with him for the wilderness, wanting to be free from her work at the tavern caring for too many dirty men. Hence her surprise when she arrives at Adam's house in the mountains only to discover he lives with his six brothers, all of whom behave like animals, or as Milly calls them, "swine."

After Milly brings her angelic, womanly ways to clean up and organize the household, the brothers decide they, too, need wives to care for them. They need women who can civilize them, women who know their own place. They ride to town to find some, but the city folk don't take well to wild men trying to seduce their women.

So the brothers only have one option: kidnap their favorite women and hold them hostage until they agree to marry them. After an avalanche cuts off any means of escape, the women spend the winter with their captors. They fall in love by spring, and they hold a mass wedding, complete with a father holding a shotgun. They never leave the wilderness.

* * *

Every week or so, we used to drive down the Ute Pass from Divide to Colorado Springs and have a shopping day, mostly for groceries but sometimes for clothes or other necessities. In a department store at the mall, my mother got busy helping one of my siblings find a new outfit, so I wandered over to the juniors section. It must have been the season for high school proms because the clothing racks had transformed into a forest of glittery, silky gowns. If I were in public school, I would have been a freshman or a sophomore. Maybe I would have had a boyfriend. Maybe I would have been allowed to go to a dance.

I let my fingers slide over the taffeta and satin, but my dry hands snagged at the fabric. I looked around to see if my family was in sight. My mother didn't make purchasing decisions quickly, so I had enough time. I pulled one of the gowns off the rack and rushed into the dressing room.

In the mirror, I saw myself clothed in a midnight-blue velvet dress embroidered with silver stars. The gown's hem touched the floor, and I could see my shoulders exposed below the thin spaghetti straps. I felt beautiful, but in a different way from when I dressed up for the Civil War Ball. I felt attractive, like I wanted to be looked at. I knew it was wrong to want something I could never have, and I felt covetous. But I lingered in the dressing room, feeling the softness of the dress, imagining spinning on a ballroom floor, held in the arms of a faceless man.

* * *

On the way to church we would listen to tapes about courtship and how to raise young men and women. They had titles like "What's a Girl to Do?" The voices of Doug Phillips, Doug Wilson, and Voddie Baucham, proponents of Christian patriarchy, became voices in my head. I learned the word *flirtation* from them. I thought about the boy I had a crush on, the boy I'd tried to make conversation with. I felt ashamed as we pulled into the church parking lot, knowing that I'd been provocative. I'd tried to get the boy's attention by

joking around, being the first to speak, making eye contact. In my heart, I knew I wanted him to look at me. I'd been a temptation.

When we got home, I found the journal where I'd written about my feelings for him. It had been a relief to release those forbidden thoughts on paper. But now I only felt the need to atone. I blotted over my words with whiteout, hiding my confessions, trying to stop my feelings.

The messages I was hearing were clear: Be attractive, but not sexy. Be smart, but be quiet about it. Women can vote, but only for the men their fathers or husbands vote for. Be a leader, but only to younger women. Be pure of heart; don't feel things you aren't allowed to feel. Be pure of body; don't show it off. Be skinny, but don't idolize your body. Be kind, but not to yourself. In order for chivalry to exist, for men to be what they need to be, women must become dependent, needy, fragile.

I began to see myself through a man's perspective. I saw my body as dangerous, my skin as seductive. I saw myself as something hidden, wrapped up, waiting to be revealed, ready to be the fulfillment of a man's desire. But mostly, I saw myself as nothing, as invisible, because it was easier not to be noticed than to feel that shame of my body, the shame that was my body.

My father would make me try on clothes for him to approve, and he would often scan my body, look over my shoulder down at my top, check my hem and neckline to ensure I was covered, my curves unseen, my skin hidden.

Every time I tried on a dress, I looked down my chest to assess if a man would be able to. I would look at my profile in the mirror and imagine how it would look to a man. I needed to see if I looked like a temptress, a Jezebel.

* * *

I hid my sexual curiosity away like the dirty secret I knew it to be. I ignored the hidden parts of my body as if they didn't exist. My one vice was reading Christian movie reviews on the family computer. The reviews were written for parents, detailing all the objectionable

material so they could decide which films were appropriate for children. I read the descriptions of sexual content, trying to understand what sex was, and the blunt details shocked me. I felt guilty, but I knew that even if I were caught, I could use the pretense that I was just checking the rating on a movie.

But the descriptions gave me few concrete answers to my questions and reinforced my feeling that sex was not something girls should know much about. I remember one review that described a sex scene in which a man was aggressive to the point of near violence. The impersonal wording stayed with me: *the woman appears to enjoy rough sex.*

I had not been educated to know the difference between violent assault and consensual sex, and the website did little to differentiate the two for me. I read enough about rapes and attempted rapes in movies to understand that I should never be alone with a man.

* * *

Days in the mountains stretched long like the shadows cast by the pines and firs surrounding our house. As the dark settled in, we sat around the table after dinner: my sister flicking a strand of hair through her fingers, my little brother fidgeting in his chair, my mother hurrying the dishes into the dishwasher. We didn't acknowledge the absence of my older brother, and I wondered if he was jumping out of airplanes on some army base. My father called him the prodigal son — one day he would return.

"Are you almost done, honey? You're keeping us waiting," my father said to my mother.

"Be right there." She rushed through wiping down the kitchen counter and sat down.

"Late as usual," my father said, laughing. "You just can't seem to be on time, and everyone's always waiting on you."

He said it in a half-joking, half-cruel tone, looking at me and my siblings as if what he'd said were funny. We laughed along. My mother was easy to pick on, and her lateness was just one of the running jokes my father kept up about her. He also made fun of us

kids. Sometimes he'd end with saying he was just joking, but if we acted hurt, he'd tell us not to be so sensitive.

He used to call me "Grace" because I was clumsy, often bringing up the time I'd tripped Pluto as if it was the funniest thing he'd ever seen. Once when I was younger, he had repeated the story to a neighbor who was drinking beer on the porch with him, and I'd been so embarrassed I held a basketball over his head and let go, only thinking it would make him stop talking about me. The ball hit his head, and he dropped his beer bottle, glass shattering everywhere.

I pushed away the memory of him yelling at me, having learned my lesson. It was safer when my father was making fun of somebody else. It was safer to be on his side of the laughter.

My mother pressed her lips together, but she remained quiet, pushed her glasses up her nose, then scratched at her dry hands. My father picked up the book waiting at his side.

I wanted family worship to be over so we could watch a movie, but my dad kept reading to us from J. C. Ryle, one of his favorite Puritan writers: "Holiness is the habit of being of one mind with God, according as we find His mind described in Scripture. It is the habit of agreeing in God's judgment — hating what He hates — loving what He loves — and measuring everything in this world by the standard of His Word. He who most entirely agrees with God, he is the most holy man."[25]

I felt the burning of guilt. I didn't feel one with God. He felt like a stranger, always angry. But I wanted with everything that I was to belong to him, to feel called to something greater than myself. I wanted the panicking feeling I had every night when I went to bed, the fear I might not wake up, to go away.

Getting rid of this guilt was the motivation for everything I did. I apologized for making fingerprints on the window, for being too loud, for speaking when I shouldn't speak. I felt so bad for secretly listening to the Dixie Chicks that I gave the CD back to my sister, who was better at hiding contraband. I washed my hands over and over, but they never felt clean.

When my sister started a courtship with a man from church, I watched to see what would happen, if they would fall in love. Instead, I kept seeing tension between them. He checked off all the boxes on my father's list of qualities a man should have, but he didn't seem like someone my sister wanted to be with.

I was sitting with Chris and my parents at a table in the restaurant when he proposed to her. I watched my parents' eyes fill with happy tears as Allison became betrothed.

Everything went according to my father's plan, and my sister was kissed by her husband for the first time at the ceremony. I was her maid of honor, my first of many times being a bridesmaid at a courtship wedding.

After the reception, as my mother and I were helping Allison get changed for the honeymoon, I got my camera out to take a photo. In the picture, my sister's eyes are glossy and red from crying. She was trying to smile, but I could tell she didn't mean it. She was getting ready for a honeymoon, for a life that maybe she didn't actually want. Maybe she didn't want to get married to him. I wanted to comfort her, to help her understand that she should be happy, that she had chosen this and didn't need to cry.

I didn't want to believe that she really didn't have a choice at all.

* * *

After Allison got married, a single woman from church moved in with us. She took Allison's bed, and I had to get used to sharing my room again.

Amy had lived with several other families at church and had expressed sadness at not having a protector. Her dad had died, and she wanted to be married. Women in our church couldn't find husbands on their own.

So my dad became her surrogate father and, with her permission, sent letters to all the churches in the presbytery to see if any single

men were interested in a courtship. I felt like this was too much; I wouldn't want my father to advertise my singleness to every church elder in the whole region. I wanted to believe I would never be that desperate. That my future marriage wouldn't feel so *arranged*.

One day, Amy saw me lying listlessly on my bed. I'd been crying and I just wanted to be alone. Melancholy was a feeling that had become more common and more confusing the older I got. Amy walked over to me.

"Are you okay?"

"I'm just feeling down."

Amy paused for a moment, considering. I wondered if she would try to hug me, and I just wanted her to leave.

"I think you should tell your dad about that."

I knew better than she did that telling my father your emotions was never a good thing. But I didn't trust her enough to tell her that.

It wasn't long before my father found her a potential husband at a different church in the Midwest. He guided them in a long-distance courtship, and they got married within the year.

* * *

I was sitting in my friends' parents' living room. It felt like spring, and the sunshine outside beckoned me to leave the dim room and join the younger children running in the yard. I was sixteen, too old for games. I needed to listen quietly and model the perfect daughter.

My father, now recognized as a courtship expert, was giving a workshop on the basics of Christian romantic relationships. My friends and I were sitting around the room with our parents. Except my parent was the one up front, teaching.

I sat up straight, knees together. My parents would probably let me wear loose jeans to something like this, but because it felt like a church event, I wore a long skirt to make me feel like I fit in.

My father ran through his outline: the steps to a successful courtship. He spoke from experience, but also in expectation of

my future relationship. Now that my sister and Amy were married off, it would be my turn next.

In the middle of his presentation, my father told a story as an illustration of how I had been protected under his leadership. If my heart was the beautiful, fragrant garden that patriarchal leaders kept calling it, then the hedges of protection were three stories tall and made of iron.

He started to tell everyone about someone we knew who had gotten pregnant in high school. Dating equals sex equals teen pregnancy.

"Do you know what my daughter said when she heard? She was surprised that the girl's parents didn't know she was having sex!"

I felt the shame glue me to my seat. I didn't understand a lot about sex and didn't want to admit that in public. I was too embarrassed to understand that this illustration pointed less to patriarchal protection and more to how little education I'd received.

One year my mother had given me a book called *Sex, Love, and Romance*, from the Christian homeschool curriculum publisher Abeka, but it didn't describe any of those things in the title in detail. All I grasped was that I should say no to sex, whatever *sex* meant. I figured I'd understand all that when I got married. My husband would teach me. I prayed he would be kind.

DAYDREAMS

Once, I played a Chopin nocturne for my uncle who was visiting from North Carolina, and he said I was good enough at playing the piano to go to Juilliard. I had read enough of my piano teacher's music magazines to know that Juilliard was a school in New York City, for only the best musicians. But that was too far away for me to attend while living in my parents' home. I also knew deep down I wasn't good enough. I couldn't memorize music very well, and I knew that to succeed at a school like Juilliard I would need to have a better memory. Maybe my uncle was just trying to encourage me, not knowing the extent of my father's beliefs about women staying home. Still, here was a dream.

I imagined becoming a professional pianist, competing in the International Chopin Piano Competition in Warsaw. To apply, you needed to record a cassette of your playing. Your skills needed to be of the highest level to even get accepted to the competition. I thought about which piece I could play, where to place the recorder on the piano. In my mind, I was already in Poland, on stage with a Steinway grand. I would miraculously overcome my fear of attention and sink into the moment. It was beautiful to me: the way the music would reverberate across the auditorium, the feeling of the keys beneath my fingers, my breath following the vibration of

the strings. The winner would make a performing tour of Europe. They would be able to see Paris, Budapest, Berlin.

But when I brought up the competition to my parents, I already knew they wouldn't take it seriously. Me, travel to Europe? How would staying in hotel rooms and performing for audiences make me a better wife one day? How would I even meet my husband if I was out gallivanting in the secular world?

NIGHTDREAMS

I had dreams I was too afraid to talk about.

I'd dream I was in a plane crashing into the ocean. Or I'd dream I was getting married. At the wedding, I walked along the shore of a lake after dark. Three men moved toward me from the shadows. I dreamed they were going to rape me, even though I didn't understand the logistics of sexual assault. I couldn't imagine anything beyond the word — *rape* — beyond the feeling of hot terror closing in.

More than once, I dreamed about killing myself.

GRADUATE

2006. My parents decided I needed to get high school senior photos. My mom took me to the mall to get my makeup done for the first time. I watched my face transform as the cosmetologist at J. C. Penney's layered gray-purple shadow with a hint of glitter on my eyelids. Then my mom's hairstylist curled my hair: long, sleek waves that made my hair seem shinier. I picked out a new outfit: an embroidered linen skirt with a bright red top. I felt different. Not older, but changed.

My father wanted the pictures done in Old Colorado City, where the houses look Victorian and decorative. He came along on the photo shoot, and while I was posing for the photographer, a college-aged boy walked by and whistled. I didn't even hear it, but my dad laughed and said he was going to beat him up if he did that again.

* * *

Many of the Christian homeschoolers in the state would go to Denver to have a collective commencement ceremony together. My parents joined the Christian Home Educators of Colorado just so I could have a cap and gown and a diploma. I understood homeschooling to be anti-tradition, but for some reason the navy robes and gold cords were a tradition difficult to let go.

Each student had a turn on the stage with their parents. In the program, we had each picked out our favorite Bible verse with a short description of "what's next?" I had one of the shortest: "During the twelve and a half years of homeschooling Caitlin has enjoyed literature, playing the piano, sewing, and cooking. After graduation she plans to glorify God by preparing to be a wife and mother." I was the only one of the twenty-two graduates who didn't have any plans to continue education.

The verse I'd chosen was from Isaiah: "Yet those who wait for the Lord will gain new strength; they will mount up with wings like eagles, they will run and not get tired, they will walk and not become weary" (Isa. 40:31 NASB).

I felt like I'd already been waiting, but I didn't know how long it would be before I would get the promised wings. College wasn't an option presented to me by my parents. Both of them had dropped out of college, and neither of them had shared good memories of their time there. My mom, who had grown up Baptist, had said her professors had taught her things that had made her question her faith, and that she'd never gone back. On the sermon tapes we listened to, I'd heard college called the city of Babylon, a place of danger and utter depravity. The presence of women only implied the probability of male assault. Without fathers around, daughters were at risk, were risky. But I liked to imagine a university like a library that never ends; I liked to picture myself in the safety of books. Old professors rambling off-topic. C. S. Lewis and J. R. R. Tolkien smoking pipes in a pub.

When it was my turn to go on stage, I followed all the instructions. Gave a red rose to my mother, hugged both my parents, said a short thank-you into the microphone for all their hard work, watched them cry a little as they passed me the diploma they'd signed.

PRACTICE

So Much More
by Anna Sofia Botkin and Elizabeth Botkin

> *Every woman is, by nature, a man's helper. You are a helper, no matter what your age or marital status. The choice before you and every other young woman isn't, "to help or not to help?" It's who to help. Can you imagine a man more deserving of your devotion and assistance, someone whom you love and trust more than your own father?*[26]

Synopsis: Two teenage sisters, champions of the Feminist Resistance, wrote this manual for unmarried women based on their "many years" observing the world. Their battle cry is painfully clear: women, stay home. They go into great detail calling out the secular culture, arguing against Marxism and the evils of the feminist movement. And they specifically talk about adult daughters. Daughters should stay home and serve their fathers rather than go to the "Babylonian" university or get jobs or rent their own apartments. They shouldn't date but should wait until father-approved eligible men come along to marry them and make them mothers.

* * *

Kevin Swanson gave me this book at my graduation. I imagined that graduates from public school probably received *Oh, the Places You'll Go!* or money in a card. I would have liked those more, but I didn't have the words to express that. This book didn't inspire me so much as keep my horizon small. I had heard it all before: in Kevin's sermons, in my father's prayers, in the church ladies' encouragement about waiting and waiting and waiting for my life to begin. I accepted all of it, this instruction on how to be a good stay-at-home daughter. It was all I'd ever heard, the only story.

For my friends who came from families with many children, being a stay-at-home daughter meant being an extra mother to younger siblings. I watched as other girls in church became consumed by childcare when they were still practically children themselves. But Chris was old enough to take care of himself, and so I didn't have an immediate role to fall into.

My graduation didn't mean a transition into adulthood, or the next chapter in my life, or the stepping stone to college. It meant nothing. It meant less than nothing. It meant staying at home but not having homework to complete. It meant being a "helpmeet" to my father as a practice for being a wife one day. I did not understand that turning eighteen meant I had a right to leave. I had never been taught that I had individual rights at all.

HAWAI'I

Pele — goddess of fire. Legend says she was banished from Tahiti for her temper. She was a master of creation. She used fire and rock to build her home in the Pacific, the Hawaiian Islands, but her sister Namakaokaha'i, goddess of the sea, kept pushing her away. Pele created Kaua'i, then O'ahu, then Moloka'i, then Maui, always running from her sister. There, on Maui, Namakaokaha'i murdered Pele, and her spirit moved to the volcano Kilauea on the Big Island, where she lives in the fiery mountain to this day.[27]

The water will always fight fire, her sister, but the fire will never go out.

* * *

Pele sends out lava in rivers looking for the sea. But the journey takes time, and the lava starts to harden on the surface, forming a dark layer of crust. Underneath, the river still searches for the water, and the glow is all but hidden to those on the outside. And so it forms a lava tube, creating cave formations as the lava passes through. When the lava runs out, we can see the hollow it left behind, large enough to walk through. We can pass through the cool darkness, only separated by time from the heat of molten rock. We touch our hands to the curved walls, intestinal remnants of hidden fire.

Speaking on the lava flow of Kilauea, Kumu Micah Kamohaliʻi, hula and cultural practitioner, said, "If you lose something to this lava flow, it wasn't yours to begin with anyway. This land belongs to our kupuna, it belongs to our ancestors. We are the product of our geography, and we are the way we are because of our landscape and what's on it. And if you canna handle, then I guess you have to go."[28]

ISLAND

I had just turned eighteen when my parents sat me and Chris down for a talk. We were in the living room, with its wall of windows, and I looked out the sliding glass door where the back deck had still not been built. The sun felt warm even though there was still snow on the ground.

Mom sat quietly as Dad began to speak. "You know how I passed out work samples to businesses on Kaua'i? Well, one of them has offered me a job. They're going to move us all out there this summer! What do you think?"

We'd been there the previous summer because my dad had picked up some contract business there. He and my mom had fallen in love with the slow pace of life and the beauty of the islands. I imagined living there: lazy beach days, tropical flowers, sunshine all year. The ocean.

Then I remembered Matthew, and I wondered what it would mean if I left. He took piano lessons from my teacher, and I would see him twice a year for recitals. We were the same age but hardly spoke to each other as I'd been trained not to make friends with boys. He'd been doing some work for my dad and had recently asked if he could write me letters to get to know me better. He was heading to the Air Force Academy and had been clear that he

wasn't ready for a courtship but was still interested in a potential future with me. Matthew was clean-cut, mature, well-spoken, and a conservative Christian — everything my father wanted for me in a husband. So he said yes. I wondered if he was the one God had chosen for me and how we would have a relationship if we lived so far away from each other.

"Maybe it will be an adventure," I said.

* * *

Before we left, Allison threw us a going-away party at her house in Colorado Springs, passing out plastic leis and canned pineapple to friends from church. I cooked a pork loin in tinfoil in the oven, doused with liquid smoke, the closest I could get to a pig roast. We were playing at being Hawaiians before we even arrived.

* * *

When we got off the plane on Kauaʻi, the humidity swept through the airport breezeway and wrapped around me. Ukulele music filtered through speakers in the ceiling, and tourists bustled around wearing loose Aloha shirts and shell necklaces. When I visited here the first time, it had all felt surreal, so different from the culture I was used to in the homeschooling community of Colorado. Moving here felt like an opportunity I wasn't sure I wanted.

Our first house we rented was a geodesic dome built in the 1980s. It looked alien in the high country of Kalaheo in the dense tropical forest and rolling hills, a brown semisphere set on a hillside like a tumor. Inside it felt like an oven. The hot air built up, with little room to escape through the small windows at the top of the dome. Like most homes in Hawaiʻi, it didn't have air conditioning.

During the hottest part of the day, I lay on my bed reading Jane Austen or writing angsty poetry. It occurred to me that stories like *Pride and Prejudice* were appealing because they mirrored my life in a way that modern-day books couldn't. Like the female characters in Austen's books, I was a woman in her father's home, waiting for marriage, waiting for destiny. I had no money, no education, no prospects. There was little I could do to change my life.

I didn't have a car or a driver's license, but I didn't have anywhere to go. I didn't have a phone, but I didn't know who I would call. I didn't have friends on the island because I didn't have a way to meet any.

I thought about Matthew back in Colorado. He was in basic training and had already started writing me letters. I tried to picture him in his Air Force uniform: crisp navy blue with the patch that looked like wings on his arm. But I could only see the quiet tall boy who tucked his flannel shirt into his Western jeans.

He seemed kind, and I liked the feeling of being liked. I was friends with his older sister from piano lessons, and his mother had always been nice to me. Our fathers were good friends. In my head, I did the tally. We would write letters for a year while he was in training, then he would ask my dad for an official courtship, then I would visit him for the special ring dance at the Academy, and perhaps he would ask me to marry him. We'd have the wedding in the Cadet Chapel the same year he'd graduate, him in his uniform, me in a pure white dress.

I was only eighteen, but this seemed like a reasonable timeline to me. Even though I could look at the potential milestones ahead of us, I couldn't be sure of God's plan, and I knew that any affectionate feelings I might have for Matthew would be sinful. I felt like I was doing a good job at guarding my heart: Matthew didn't feel like anything more than a friend.

* * *

My father's new job was for a development company that built multimillion-dollar plantation-style homes overlooking the ocean. They were undeniably beautiful, their blueprints labeled with luxury: pocket doors, open-air lanai, outdoor lava-rock shower, bamboo floors.

Construction started slowly. There were delays due to a rare species of wolf spiders living in the lava tubes underground needing protection. Sacred land blessings given by Indigenous spiritual leaders. Care to be taken not to break ground on protected land. Things my father wasn't used to, things that he seemed to find irritating, unnecessary.

* * *

Someone in a truck drove by and shouted, "Get off, you fucking *haole*." I felt the shame resonate through my body before I could fully process the words.

I was with friends who were visiting us from Reformation Church, and they had wanted to see the bellstone in Wailua. We had wandered down to a grassy field bordered with stacked lava rocks. I wasn't looking for anything, just wandering, but I also hadn't taken the time to read the plaques, to understand that this was sacred burial ground. And I had trampled it in ignorance, but also with a privileged sense that I was welcome anywhere. I hurried back to the other side of the lava-rock border, stepping again on the ground in the process.

* * *

When Matthew's letters came in the mail, my father would open them and read them first, to make sure there was nothing inappropriate or overly emotional in them. I was always hoping for something just a little scandalous, but Matthew only wrote about training, rifle drills, and a Bible study he joined. His family had given me a devotional book by Oswald Chambers for graduation, and he wanted to talk about that, about the things of God.

Before I sent him my replies, I gave them to my father, so he could make sure I wasn't having any romantic emotions. I wrote about taking walks and the beauty of the island. I tried to write about Oswald Chambers, but his century-old reflections felt disconnected from everything happening in my own life.

Eventually, Matthew asked if we could do email instead of handwritten letters because it was faster and easier for him. So whenever I logged on to the family computer during the day and saw an email from him, I didn't open it but waited until my father came home from work so he could screen it first.

For New Year's, my father paid for Matthew to visit us. It was my dad's idea, and I interpreted that to mean he cared about my future and wanted to give me a chance to get to know this potential husband in person.

Chris served as our chaperone when we went on walks. We set off firecrackers in the driveway for the new year, and when I started choking on the smoke blowing in my face, Matthew said, "They say smoke follows beauty." It was a saying I hadn't heard, and it didn't make any sense to me. Yet I knew this was the only way to get a compliment from a boy without getting in trouble: indirectly. The closest we got physically was when my mother had us pose to take our picture. We stood back-to-back on a cliff overlooking Waimea Canyon, layers of volcanic rock eroded by a river cutting into the background.

<p style="text-align:center">* * *</p>

A few months later, my father and I had a conversation about ending my correspondence with Matthew. He said he was "too Baptist" and unlikely to change into a Presbyterian. I knew that infant baptism was a major theological point for my father, so the idea of having unbaptized grandchildren was unthinkable for him.

I didn't feel like our relationship was going anywhere either, and I still didn't have any trouble taming my emotions for him. I trusted my dad that this wasn't the man for me, so I let him go.

<p style="text-align:center">* * *</p>

On Kaua'i there weren't any Reformed Presbyterian churches when we moved there. We visited Baptist churches, Assemblies of God, nondenominational services, and Calvary Chapel. If a woman was preaching, my father would walk us out. If the worship music time was too long, we'd plan to arrive late. None of the churches met my father's standards.

So, when we met a small group of Lutherans who wanted to start a Reformed church plant, we were all in.

We hosted Bible studies at our house every week until a Reformed denomination with Dutch-American roots signed on and started sending us pastors and money to get running. I played piano for every service. My father served as a leader. The visiting pastors were white, middle-class, slick-haired, and male. The services were

dry, and the songs from the Dutch Reformed hymnal sounded more like chants to me than joyful refrains.

As the church plant grew, many of the other attendees were also transplants from the continental US, but a few were from the island. One family, the Johnsons, who had Hawaiian ancestry, had spent time at Vision Forum retreats, so my family connected with them.

We thought we were bringing light, and some would say we did. We brought a Western style of religion to an island of multi-culturalism and Eastern heritage. We told them our way was the only way. Like so many before us, we did not recognize ourselves as colonizers.

* * *

I'd moved too many times to feel like I belonged in any one place. Delaware to Pennsylvania to Colorado to Hawai'i. The land was always shifting under me, and I was forever trying to balance. I was always looking for belonging. Too often I'd failed to recognize the history of the Earth beneath my feet.

But while the land betrayed me and I betrayed it, the sea always felt like the safety of a mother's arms, holding me together, keeping me submerged in one true element.

Whenever I could, I spent time at the edge of the water, looking out to the horizon full of the Pacific. I knew I was sitting on a volcano, old and disappearing. The ocean calmed me, but I was beginning to feel that the quaking of my life, my family, was getting stronger. That it was only a matter of time before an eruption.

HELPER

But for Adam there was not found a helper fit for him. So the LORD God caused a deep sleep to fall upon the man, and while he slept took one of his ribs and closed up its place with flesh. And the rib that the LORD God had taken from the man he made into a woman and brought her to the man. Then the man said,

> "This at last is bone of my bones
>> and flesh of my flesh;
> she shall be called Woman,
>> because she was taken out of Man."

—Genesis 2:20-23 (ESV)

"How do we know all the books of the Bible are actually God's word?" I once asked at family worship. When I was younger, I had asked questions more often, sincerely wanting to comprehend all the things that didn't make sense to me, like Abraham almost sacrificing his son, like how did we know which courtship rules to follow when the patriarchs of the Old Testament had multiple wives, when Solomon had hundreds of concubines.

My father encouraged my questions if they were phrased in a certain way: as a follower asking her guru for enlightenment. He always had an answer, even if I didn't understand it.

He calmly paused from reading the Bible. "That's a good question. Well, after all the parts of the Bible were written, leaders from the church gathered to decide which parts were actually inspired by God. And God gave them discernment to make those decisions. Does that make sense?"

I nodded and wrote his explanation down in the margins of my leather-bound Bible. Dad said the Scriptures were inerrant — perfect. God gave men special knowledge. I was a girl, so my job was to listen to their wisdom in interpreting it.

I had been taught this so often that it became my only way of seeing myself: as a woman I would always be a helper to a man. One day, I would help my husband in his vision for our lives, but for now, I was a helper for my father.

I learned how to make his coffee the way he liked it — two Splendas and a spoon of powdered creamer. I practiced ironing his work shirts and slacks. For a short time, he had me create invoices for his home business.

When I became an adult, I didn't understand that I had the right to leave and create a life for myself. I'd been told that I wouldn't be an adult until I married. In my father's eyes, I was a child. I sometimes thought about other paths in life — like playing the piano professionally or going to college to study writing — but then I felt guilty and tried to suppress those desires, thinking it was sinful to want something that I couldn't have. Leaving was unthinkable.

Once we moved to Hawai'i, my father grew too busy to help me in my training to be a future wife. Chris was too old for me to babysit, and I was already skilled in homemaking: my mother had taught me to cook, clean, and budget for groceries. Now that Chris was finishing up homeschool too, she had less to occupy her time, but her days always seemed busy — washing the laundry, cooking for church functions, hosting Bible study, growing plants in her container garden. There wasn't much left for me to do.

I was frustrated with being alone and not having anything to do but read and take long walks and practice piano, so my father encouraged me to help out in other ways to grow my skills with children, using his charisma to get me opportunities with his coworkers and other families in the church to find ways to occupy my time. He even let me keep the money I made.

So I became a helper to everyone else while I waited for marriage. First, I was a mother's helper for the Johnsons. They homeschooled their ten children and paid me three dollars an hour to help them. My job included feeding, babysitting, and homeschooling the younger kids, as well as deep-cleaning the bathroom and steaming the carpet. Anything that Mrs. Johnson wanted to have done but didn't have time for became my task.

After my fainting spells at family camp, a doctor had told me I had hypoglycemia — low blood sugar — so I needed to make sure I was eating often enough to keep myself stable. At the Johnsons', my migraines got worse because meals were scheduled far apart, and with all the children, there never seemed to be quite enough to go around.

I enjoyed feeling like I was grown-up enough to help, though, and I loved bonding with the little girls, imagining myself as a big sister or even a mom. But I felt inexperienced and stressed that I would make a mistake. I avoided being around Mrs. Johnson, who was stricter than my mother, harder around the edges. I buried my embarrassment when their little boy told me my exercise shorts were too short, maybe something he repeated from his father. And to my relief, a new au pair they'd met at a homeschooling event was moving in, providing an excuse for me to quit.

I was also a frequent babysitter for my father's coworkers. I had proven to him my responsibility, and my conformity, and he trusted me with people who didn't live like us. The families I babysat for didn't go to church or seem that interested in gender roles. I worked for six dollars an hour (or an occasional take-home dessert as a substitute), and the parents needed to pick me up and drop me off because I still didn't have a driver's license, much less

a car. My favorite part was the evenings after the children went to bed. I could be alone for an hour or two without being supervised. I would look at the backs of the DVDs in the TV cabinet and read about movies I wasn't allowed to watch at home — *Almost Famous, Little Miss Sunshine* — but I never watched any. I felt guilty just thinking about it.

My father advocated for other families in our new church to homeschool, and as an extension of his vision, I was available to help them get started. One family with two kids even bought me a bus pass so I could take the small island shuttle to their house. This mother had to work, which my father disapproved of, but at least they weren't putting their kids in public school. When I arrived at their home in the mornings, I would help them get set up for the day, work through lessons with them, try to explain anything they didn't understand in math, science, or spelling.

During science one day, the daughter, who was around eleven, was getting stuck on a concept, so I decided we should do a science experiment. We wrapped apple seeds in wet paper towels and stuck them in jars on the kitchen counter.

"We'll look at it every day and see how quickly the seed grows," I said. It was fun to do something away from the textbook, but I also worried we didn't have enough time to finish the homework before their mother came home.

The next day, the jars were gone, the counter cleaned off.

"Mrs. Williams, do you know where our science experiment went?" I asked as she was hurrying out the door.

"Oh, we don't need any mold growing on the counter. I threw them away." She shut the door behind her.

Later, determined not to get discouraged, I asked the daughter to show me her artwork. I'd seen her scribbling drawings on scrap paper and wanted to encourage her. She showed me a drawing program on their computer and how she liked to play with the colors to draw dragons and cats.

"You're so talented," I said, admiring her work.

"My stepdad says I need to make more Christian drawings," she replied, looking down. Behind her I could see a bookshelf full of Calvin's *Institutes*, systematic theology — books my father had too. I looked at her — tangled hair, glasses — and she reminded me of myself when I was her age. Unsure of who I was, trying to figure out how to belong, how to hold on to creativity in a colorless world.

I knew I was being subversive when I replied, "Not everything has to be Christian."

* * *

People from Reformation Church in Colorado started visiting us once we moved to Kauaʻi. It was cheaper for them to have a Hawaiian vacation since they had a place to stay at night.

One family brought with them the newest film from Vision Forum, a documentary called *The Return of the Daughters*, for us to watch together. The women in the film were old enough to go to college or move out, but they were still living at home. I felt like I was watching a glorified imitation of my own life.

The film didn't portray the women as trapped or coerced. They looked happy as they helped their younger siblings. One of them even took online college classes. Another talked about how her father fell in love with the man she was to marry before she did. And one woman, Lourdes Torres, talked about being countercultural, helping her community, bringing hope to hopeless situations. This was years before she would file a lawsuit stating that Doug Phillips, the founder of Vision Forum, groomed and sexually abused her for years when she was living with his family as their children's caregiver.[29]

The Return of the Daughters said women like me, women who stayed home to serve their fathers, were "the secret weapon of the church."[30] Even in their praise, we became objects in the hands of men.

* * *

When we had visitors, my mother loved playing tour guide and showing off her favorite spots: Spouting Horn, Glass Beach, the Kilauea Lighthouse. She was the perfect hostess, often sacrificing her own comfort to host people in our home, making them hot breakfasts before they left to go sightseeing for the day. I would often go along on her tours, trying to play the helpful daughter, even though I felt awkward as I entered my twenties and still didn't have a plan for my future other than waiting. My friends back at Reformation were getting married in quick succession to homeschooled boys they connected with. I felt isolated and trapped, and the worry that God really didn't love me started to manifest in despair that I would never get married, never move on from my father's dictation of my life.

My father had gotten me started as a piano teacher for some of his coworkers' children, and since there weren't many private music teachers on the island, word of mouth spread throughout the homeschooling community that I could teach piano during the day. I had taken eight years of lessons but didn't know much about how to teach.

I ordered music pedagogy books online — college textbooks on music theory and teaching strategies. Even though I wasn't allowed to go to college, I'd found a way to partly satisfy my desire to learn. I thought back to my childhood when I took music lessons, understanding now the purpose of major and minor scales, the mathematical pleasure of harmonic intervals. I learned to think of music as the integration of reading and rhythm, tone and melody. I could appreciate discord. I tried composing the beginning of a song.

Eventually, I was teaching more than twenty students every week, mostly homeschoolers. I taught three-year-olds how to move their fingers one at a time, focusing on motor movement rather than note recognition. I taught siblings to play duets. I started teaching a student from the community college, who just wanted to be able to play her favorite songs on the keyboard so she could sing along. I wondered what her classes were like, and it felt strange

to be teaching someone my own age. She seemed so much older than me; she was doing things for herself.

I had never wanted to teach piano, but eventually I would realize the power of making money of my own.

COURTSHIP

Pathway to Christian Marriage is a Biblical guide for the journey from singleness to marriage. It describes the dangers associated with "recreational romance," while explaining Scriptural guidelines for establishing a Christ-honoring marriage. The timeless truths contained in this booklet will help one arrive at the altar in purity.

—John W. Thompson[31]

As I neared my twentieth birthday, I wondered if my time to get married would be soon. I had learned homemaking skills, volunteered for church, and built up experience watching children through babysitting. I had maintained my purity. In my father's eyes, I was ready for marriage. I had chaperoned Allison's and Amy's courtships, so I knew what to expect. I had a whole vocabulary given to me in the courtship guide . . .

BETROTHAL

Betrothal in the Bible differs considerably from modern engagements. As an act preliminary to marriage, betrothal implied a commitment almost as binding as marriage itself; its dissolution involved at least a formal divorce (Mat 1:19). . . . Any violation

of the betrothed state was treated as adultery and could result in death for the offender (Dt. 22:23–25). (pp. 45–45)

We didn't use the word *engaged*, only *betrothed*, to show we were following God's ways. To be betrothed meant to be promised. My father had printed out covenants for Allison and Amy to sign with their betrothed — a promise to take lifetime vows. This felt too businesslike to me, contractual. I'd seen enough romantic comedies with my mother to hope that love was more than a signature on a page. I hoped to meet a handsome stranger and fall in love. But I knew better than to speak this out loud.

BRIDE-PRICE
An amount of money equal to several years wages paid by the man at the time of betrothal to his virgin, as a seal of the betrothal covenant, for her protection and security. (p. 11)

I'd been taught that a diamond engagement ring wasn't a symbol of love so much as a portable investment representing a man's commitment to financially provide for his betrothed. Patriarchal leaders told stories of how dating was a modern invention, that courtship ensured women were protected and cared for.

COURTSHIP
The process of getting to know a person in purity with marriage in mind. . . . The word *courtship* derives from the words *court* and *ship*. Court means "a trial of law for evaluating evidence." *Ship* refers to boundaries, e.g., the word *township*, which means "boundaries of a town." So, the term *courtship* speaks of the boundaries, or proper approach, for evaluating evidence of a person's true character, just as in a court of law. (p. 24)

Before I would be able to be betrothed, I would need to go through a courtship process. My father thought some Christians who used the word *courtship* were just practicing a form of "glorified dating"

because their rules weren't as strict as ours. Sometimes they didn't even use chaperones. Courtship in my family was a serious matter.

To use the *Pathway*'s analogy of a court of law, the two prospective spouses would sit on opposite sides of the courtroom, and the girl's father would act as judge as well as lawmaker. My father would make rules to keep the boundaries in place, to make sure I wouldn't develop an emotional bond with a suitor, to keep me from any risk of a broken heart in case the courtship ended.

Risk mitigation. Women were vulnerable, I'd been told, and that's why courtship was used for centuries before dating. But I wondered if a heart could be overprotected — if, instead of breaking, it could dry up from the lack of love.

DATING

A temporary romantic relationship focused on current enjoyment. . . . In his penetrating book *Christian Courtship vs. The Dating Game*, Pastor Jim West concurs, "The phenomenon of dating is a relatively new institution in the United States. Prior to 1920, courtship laws included rigid supervision of the female. Courtship was not entered upon unless parents were first consulted and their approval secured." (pp. 15–17)

My father said secular dating often resulted in harm and bitterness, but when I asked my parents about their experiences dating, they said it didn't matter, that they had emotional baggage and didn't want that for me. I'd heard from church leaders that dating had become normal because of wickedness in the culture: feminism, World War I, urban living, the ease of traveling by car, movies, co-ed universities, dancing, the abdication of fathers. The list seemed endless. My father reminded me that I should be grateful he was so invested in my future that he was prohibiting me from dating.

DEFRAUDING

Defrauding means cheating someone by offering something you cannot righteously fulfill. Girls, selfishly, pridefully attracting

boys with your eyes, walk, or dress is defrauding! Boys, treat every young lady with respect and purity, the way you want other men presently to be treating the woman you will one day marry. (p. 22)

When my father wasn't monitoring my clothing, I was self-policing, watching how I walked and how much makeup I wore. I was careful not to flutter my eyelashes. If I were to try to attract the opposite sex, I would be causing them to sin, to stumble, to cheat on their future spouses with their thoughts. My father told me not to be the thief of another woman's love.

I remembered, *My body is a risk. My body is a dangerous thing. My body is the vessel for someone else's sin, a sanctified temple for a husband's worship.*

LOVE
The most essential ingredient is mutual love between father and child. Why is this so? Because a child who sincerely loves his father will be motivated to obey and follow him. (p. 25)

Love is action. Love is obedience. Love is a father spanking his child for trying to touch a hot oven. Or so I'd been told.

If I were to rebel against my father's courtship rules, he would interpret my disobedience as saying I no longer loved him. He said often that he wanted only the best for me. He made the rules because he loved me. And when I followed the rules, I was worthy of love.

PATRIARCHY
The word *patriarchy* is a perfectly good word that means "a form of social organization in which the father or eldest male is the head of the family and descent is reckoned through the male line." . . . Patriarchy is presently subject to much abuse and misunderstanding.

Men, I'd been taught, were created to be in charge. End of story.

PATRICENTRISM

OT scholar Daniel Block suggests . . . "Like the spokes of a wheel family life radiated outward from [the father]. . . . Biblical genealogies trace descent through the male line; a married couple resided within the household of the groom; in references to a man and his wife or a man and his children, the man is generally named first (Gen 7:7); children were born to the father (Gen 21:1–7); fathers negotiated family disputes (Gen 13:1–13; 31:1–55); God generally addressed heads of the household; when families worshipped, the head of the household took the initiative; and when men died without descendants their 'name' died. In short, the community was built around the father; in every respect it bore his stamp." (pp. 11–12)

Christian patriarchy taught that fathers were supposed to be the center of society. Even in secular America, society is based on patriarchal principles. At birth I was given the last name of my father, and at marriage it would change to my husband's.

My father became the center of my life — everything I did had to meet his approval. I moved freely only within the boundaries he'd created.

But I'd also been taught that his authority over me had nothing to do with inequality. I was equal in worth, just not designed for anything but submission.

I saw this patriarchy represented in the Bible I read every morning. Genealogies were listed through the male line, and the few stories of women seemed to show them mostly as abused, assaulted, sacrificed, or murdered.

PREPARATION FOR DIVORCE

Dating literally trains young people to break off difficult relationships rather than to work through their problems, conditioning them more for divorce than for marriage. They learn that when the going gets tough they can bail out of relationships. (p. 21)

Divorce was evil, I was told. Brokenness and dysfunction. Giving up. Dating would lead to divorce, but courtship protected from it. No emotion equals no heartbreak. No dating equals never divorcing.

Adultery or abandonment were the only excuses for a woman to divorce her husband — not if her husband hated her, not if her husband was abusive.

PREPAREDNESS

Readiness for marriage both spiritually and vocationally. . . . Before marriage, a young woman should be spiritually prepared according to the pattern of Sarah, Mary, and the Proverbs 31 woman. . . . Some parents downplay developing their daughters' talents for fear of encouraging an attitude of "careerism." Yet with proper heart instruction, developing their gifts will not cultivate careerism, but a Biblical "dominion helper," i.e., a wife who will truly strengthen her husband in his chosen life work. (p. 13)

Young men preparing for marriage were to develop leadership skills, skills that would ensure them good jobs and positions in the church. College was allowed if necessary for their chosen profession, but it was recommended not to go to a liberal university. The young men I knew of from back at Reformation often became apprentices with other men in the church or entrepreneurs running their own businesses.

Young women, on the other hand, didn't need to learn leadership skills or how to be independent. That would have been counterproductive. Dependence was required for women in Christian patriarchy to be godly and submissive. Anything I learned at home was something that could help me as a future wife. Learning accounting skills meant I could help manage my husband's finances. Learning to play piano meant I could accompany hymns for family worship. Some girls I knew from Reformation were allowed to become EMTs because that meant they would have medical skills to treat their future children.

While it may seem innocent, romantic touching can put one on the "slippery slope" of temptation. . . . A man and woman together alone is an opportunity for the flesh, even being alone in a public place away from one's family. . . . But *physical* morality isn't all that is included under the purity principle. Unrestrained and undisciplined sensual, romantic feelings can lead to mental impurity. . . . Romantic looks, language, and touching can easily cause emotional fraud. (p. 13)

I was familiar with mainstream purity culture and the phenomenon of purity rings and *I Kissed Dating Goodbye*, but in my family, those precautions didn't go far enough. I believed that my body belonged to my future husband, so anything like holding hands or kissing was out of bounds. And my father emphasized emotional purity; I remember him warning that emotions out of control was something women were especially prone to. I had to keep myself clean of any romantic feelings until the betrothal covenant was signed.

But it was difficult for me to repress my emotions — I'd been doing this for so long it was as if I'd built a stone fortress around my heart. It started to feel too tight to exist, like I was stuffing down the very parts of me that made me human.

ROMANCE

The affections and physical intimacy expressed by a couple in love with each other. Expressions of affection should be reserved for engagement or betrothal after making a commitment to marry, preventing broken hearts. Similarly, physical affection should be withheld until or after the wedding, when the chaste couple experience their first embrace and kiss. (pp. 37–38)

I knew that once I had an engagement ring on my finger, I would be allowed to let my heart out of its fortress. I would be allowed to feel all the emotions and excitement of someone getting married.

I was told that real love would follow all the preparation that happened in the courtship and that on my wedding day I would be excited for my first kiss.

The thought of having my first kiss in front of hundreds of people sounded awful to me. I already hated being the center of attention, and I had no experience with kissing, so what if I did it wrong? Worse, what if I hated it?

But I was told that if I just followed the process, I would fall in love with the right man, at the right time. All I needed to do was take the four necessary steps to happily ever after . . .

Friendship

Friendship was the stage where I would get to know someone of the opposite sex in order to observe their behavior. This kind of friendship had to be pure, emotionless, educational. It was supposed to be about getting to know someone's real character. It was when fathers could observe the young people to help them decide whom they should marry. This was as far as my relationship with Matthew had gone.

Courtship

Courtship was the next stage on the path to marriage. It would start when a man asked my father for permission to court. My father would ask him about his intentions, and if the interview went well, the courtship would be allowed to proceed. But I was reassured that it would not be an arranged relationship — at this point, if I didn't like the man, I could decline the courtship.

During this stage, I would sit in weekly meetings with my father and the young man to discuss the courtship questions from the *Pathway*. Questions like *Do you want pets?* and *Do you floss?* and *Are you planning on homeschooling your children?* and *What is your life*

purpose? How does the young man view women? Is he possessive? These would help check off the boxes to see if the suitor would be a compatible match for me. This process would take a few months.

At that point, my father would have to decide whether we made a good match. If he didn't think so, the relationship would end.

Betrothal

When the courtship questions were done, the young man could ask my father for my hand, and then he would approve (or disapprove), after which the suitor could propose to me. If I said yes, then we would sign the betrothal covenant promising to marry each other.

Marriage

The final step: marriage, the end of the pathway. It would start the moment I said, "I do." The name of my father would dissolve as I would take on the surname of my new husband and, with it, a new identity. Being a wife would be the fulfillment of everything I'd prepared for as a stay-at-home daughter. As a helpmeet to my husband, I would be the keeper of my own home, a cook in the kitchen, the sidekick in the passenger seat of the family minivan — or if God blessed our quiver, perhaps a fifteen-passenger van. We wouldn't use birth control because that would be like playing God. If my path resembled Allison's or Amy's, I would be busy with children in only a few years. I wondered if I would laugh at my impatience to be married then, if maybe marriage wasn't everything I'd been told it would be.

PARADISE

Not far from the airport in Līhuʻe was a white building, wings wide-spread like a gull landing — the veterans center. In the parking lot was a fighter jet, the windshield painted over to look like a reflection of cloudy sky. It was always windy when I stood outside the entranceway, wondering if anything would ever happen, hoping someone new would show up.

For two hours every Sunday morning, we would crowd into a little room in the building for worship. As a church plant, we stored everything in a trailer and had to set up the room to look like a chapel every week. We dragged the flags of America and Hawaiʻi to the back, making way for a wooden pulpit in front. I was in charge of setting up the keyboard while everyone else lined up chairs, distributed hymnals, and laid wire for the speakers.

Usually we had the whole building to ourselves, but sometimes there were parties out in the main hall: first-year birthdays or graduations or gong dances. Once a year, Buddhists filled the space with flowers to celebrate the Buddha's birthday. A small figure of the Buddha waited on a stand to be washed with water as each follower entered the hall. In our little room, I accompanied the traditional Dutch Reformed hymns on the keyboard, suspended between the small congregation and the visiting pastors wearing black robes who

flew in every week to preach us sermons until we could afford a permanent pastor.

We often had visitors, and many of them were single men — a construction worker from the mainland working on a short-term contract, or a relative of one of our members, or the occasional unmarried seminary student who had come to practice preaching. Every man I met struck me as a potential suitor, but I was determined not to be desperate to get married, even though it was what was expected of me. I wanted to marry someone I could fall in love with, not just anyone who checked off all the right qualities on my father's list. I'd witnessed the tension in my sister's marriage, struggled to find signs of true unconditional love there. And I knew I wanted something different. But I couldn't do anything about it — I had to be passive, wait for a man to pursue me. My parents weren't pressuring me to get married, but it felt like my life wouldn't move forward until I became a wife. I imagined myself at thirty, still vacuuming my parents' floors, still sitting next to them at church, an extension of them and not a person of my own.

I was twenty years old the first day Will visited church, and he caught my eye right away. Linen pants, ironed shirt, skin tanned gold. Curly brown hair. Green-blue eyes set above quickly vanishing dimples. He was from the West Coast of the continental US, but he had just moved to the island because he liked the idea of living in Hawai'i. He was a few years older than me and came from a Christian family — they even practiced courtship instead of dating. But that's not what got my attention.

Will was magnetic, a teller of stories. Even if they weren't all true, I was enthralled by his voice, his words that fell like the foamy surf, eventually sinking back to the sea. I hoped he would notice me, the quiet girl who didn't know how to catch the husband she'd been told she should have.

* * *

Roads of red dust led to the dry side of the island. Rain rarely fell west of the canyon. The land looked desolate after driving past the small

town of Waimea, past the naval base, past the long stretch of sand at Kekaha. It was desolate until we found our way to the water.

Will and Chris, who was seventeen now, were in the front seats of Will's sporty red Mazda, windows down. In the back seat, I closed my eyes to the wind and listened to them sing along to Rihanna, music we wouldn't be allowed to listen to if my dad had been around. I didn't know that Rihanna was only a few weeks older than me; our lives couldn't be more different.

We drove miles on a narrow road between thick weeds and flattened fields before the ocean at Polihale emerged, blue against the reddish-brown end of the Nā Pali Coast.

Polihale felt to me like a place of beginning, of the joining of worlds. The land meeting the water. The water meeting the sky. In the distance, I could see Ni'ihau, the Forbidden Island. We had traveled as far west as possible.

The water at Polihale was opaque with sand upturned from the current of the channel, pulling the water south. Catamarans sailed past on their way up the coast. Whale watching in the winter, snorkeling in the summer. The beach was wide, barren. Locals from the West Side drove their lifted trucks out on the sand, sent their fishing lines out for pāpio or moi. Tourists came for the burnt-orange sunsets, dead center on the horizon. The three of us looked like tourists.

At the beach, I took off my swimsuit cover, revealing my swim skirt and halter-neck tank top. Still covered. We all swam in the turbulent waves, the kind of surf I felt too weak to swim in. I'd never been athletic. Will and Chris had become fast friends, and they talked while I listened. I was tense with the feeling that I was in danger of being led by my emotions. I was enjoying being around Will too much. After we swam for a while, I sat on the hot sand, looking for whale spouts on the horizon, wondering if this was a beginning or an ending.

* * *

My family lived in a house surrounded by banana trees and palmettos. Not the dome anymore, but a white house on the side of a hill in Kalaheo. Down below, the Lāwaʻi Valley tumbled into seaside coffee fields. Chickens roosted in the trees, the roosters crowing out each hour of the night like grandfather clocks.

Will came over for dinner often, my parents always being hospitable and feeling bad that he had no family on the island, and he brought his extravagant stories with him. How he'd coasted all the way from Kapaʻa to Līhuʻe on an empty gas tank. How he had gone to music camp with a famous pianist. He seemed to have an exciting life. He knew how to make me laugh.

One hot afternoon, Will came over and watched Christmas specials on TV with me and Chris. Our walkout basement had a tiled floor that felt cool to the touch on my bare feet. Outside, the humidity was clouding up the atmosphere. Will seemed restless, and so was I, wishing we could have snow for the holidays, wondering if I was wrong to think Will might be interested in me as more than a friend.

But then he disappeared upstairs. I could hear him talking with my parents, and I had the feeling. The feeling of *this is it. Maybe it's my time.*

Later, after Will left, my parents told me he had asked permission to court me. They seemed surprised by his interest, even though they had been the ones to invite him to dinner every week. As long as I gave my consent to the relationship, we could begin an official courtship. I quickly said yes.

After our relationship changed from "sort-of friends" to what my parents called "courtship buddies," Will and I did the same things we always did. We drove to the beach with my brother and swam in the ocean and hiked in the rainforest and drank iced coffee. Chris became our official chaperone. Now that he and I had swapped places as the third wheel, he must have felt dragged around by us, an unwilling witness to awkward conversations, frustrated with our mild attempts at flirtation. We drove around the island a lot, but now I got to sit in the front seat. And Will opened my door for me every time.

But in addition to these chaperoned outings, we had to go through my father's courtship process to see if we were compatible for marriage.

* * *

Shortly after our courtship began, my family moved to Princeville on the North Shore, mainly to live closer to Will, to make the courtship process easier without the complication of long drives for courtship meetings. Will started coming over more, and my father printed off the hundred-plus questions from John Thompson's *Pathway to Christian Marriage* for us to go through together, about ten a week. The questions went something like this:

"Do you have any food oddities?"
"What is your level of personal hygiene?"
"Do you have financial debt?"
"What are your political leanings?"
"Who are your heroes?"
"What are your personal goals in life?"
"What are your views of the Sabbath?"
"What are your views on birth control and abortion?"
"What do you believe about the sacraments of baptism and the Lord's Supper?"
"What are your views on homeschooling?"

As my father sat between me and Will as moderator, I felt as if my answers were stifled, forced. It didn't feel like a natural conversation, but more like I was answering in a way that would make my father happy.

Talking about birth control in front of my father and the man who might become the reason I might need to take birth control made me feel adrift. I didn't know how contraceptives really worked, much less sex, but I had been taught birth control was an arrogant way to manipulate God's design. I had heard that to think you could stop God from giving you a baby was ridiculous. Even if you took the pill, you'd get pregnant if God wanted you to.

One Sunday afternoon, the three of us were sitting in the living room. Out the window was the Pacific, an arc of sapphire in the distance. I wanted nothing more than to get out of this sunny room, get away from the walls and rules to the freedom of the water.

"Will, have you ever looked at pornography?" my father asked, reading from his list of questions. This wasn't a surprise gotcha; both Will and I were given the questions a week in advance to prepare our answers.

Will looked uncomfortable, shifted in his seat. "When I was younger, yes, but not anymore."

My father moved on to the next question. I don't remember being asked if I had ever watched porn, something I knew little about. My mother used to cover up the magazines in the grocery store checkout lanes — I didn't really know what an adult woman looked like naked, much less a man. I avoided looking at my reflection in the mirror, never exploring my own body. Once when I was a teenager, a pop-up ad of a naked body had interrupted a web search I was doing when I was helping my father with his invoices. I had felt a flush of shame, worried I had somehow asked for the ad, so I immediately told my father. He had confirmed that it was bad, but he seemed to understand that it hadn't been my fault since I'd confessed right away.

Next, we talked about Will's former relationship, a woman he had almost married. He said he had kissed her one time, but he was sorry for it. This seemed like something I could forgive. I'd been taught that physical intimacy should be saved for marriage, but I imagined wanting to be kissed by my fiancé. I realized the reason Will was sorry was because according to the courtship rules, it was as if he had cheated on me.

There was never a time when I was alone with Will. I never knew what to say without thinking through all the boundaries I had to follow. I never really got to know him. I didn't know how to ask him, *What are your craziest hopes? Where do you want to travel? Do you really want to get married? Because it feels like maybe you don't.*

The top of the trail down the cliff to Anini Beach was halfway between our house and Will's apartment. Sometimes Will and I would meet here, only if Chris agreed to chaperone, and we walked down to the sea.

Shallow water spread out between the shoreline and the reef. A line of surf broke on coral just below the horizon. Sitting on the beach, I could barely hear the water crashing. I felt the calm of long-legged sea birds, of false kamani trees, of brown-sugar sand on the soles of my feet as I searched for rare kahelelani shells, smaller than teeth. I used empty Tic Tac dispensers and 35-millimeter film canisters to store the shells I found.

In the months to come, I'd walk here alone, then wait until dusk before climbing back up the cliff. But for now, we enjoyed sitting in the sun, waiting for the afternoon rain. We talked about nothing more than the temperature of the water, or where to get the best smoothies, or where to hike to see secret waterfalls. Will did most of the talking, telling us about his family or the interesting people he met at his job working for a company that sold Bali-style homes to millionaires on the island. My days were simple, full of books and music. His were full of adventure.

* * *

At Lumahaʻi Beach, a crescent of sand dipped down to meet a well of ocean held in by lava rocks.

I was worried that Will might just decide to break everything off and leave even though I had nothing concrete to base my fear on. It wouldn't have been hard for him to move home to the mainland. He had a family to go back to, a support system. But if he left, what would happen to me? I'd be alone on this island, stuck with my parents, back to waiting.

A pile of rocks stood sentinel between the cove and open ocean. Will and Chris climbed up and jumped off, over and over, like children on a slide. They convinced me to jump just once. Terrified,

I stood above the water rushing across undersea rocks, waiting until a surge deep enough spread out beneath me. Then I jumped into a rush of air, falling into the silence of the sea. I felt the thrill of gravity released, the calm of containment, the arms of the current pulling me in.

Another day, we came here after our weekly courtship meeting. It was a relief to get out of the house and go to the only place I could feel peace: the ocean. Lumahaʻi was my mother's favorite beach, so she didn't mind chaperoning us here, where she liked to walk and hunt for shells or sit in the shade of the breadfruit trees. She encouraged us to swim, even though she knew my father wouldn't want us to be alone out of earshot. "I can see you," she said with a smile.

Will and I wandered into the shallow side of the cove, pulled deeper by the waves. Underwater, our hands almost touched.

I was starting to feel *something* for Will. I looked forward to our time together, and when we were apart, I could think of nothing but him. My excitement must have been apparent because that week my father had started to tell me I needed to be more careful about my feelings for Will, and I felt heavy with anxiety I didn't understand.

"Your emotions are out of control," he'd said. "You have to take a step back. You have to keep this in perspective."

His presence was powerful, his voice inescapably loud. It echoed through my mind long after our conversation.

"I don't know how to do that. I don't know how to stop what I feel," I said, a little desperately. I had tried telling myself to stop feeling close to Will, to stop feeling anything at all.

"The reason we do courtship is because it is supposed to prevent emotional intimacy until a marriage commitment, and you don't know yet if he's the one you're going to marry! What would you say to his future wife if he's not the one for you?"

* * *

When Will's family visited, I was petrified I would do the wrong thing, say the wrong thing. I didn't know how I was supposed to

fit in. They had such different lives — the West Coast seemed like a more exciting place to grow up than the mountains of Colorado.

But I quickly found a new kind of discomfort on a car ride with Will's mom as we drove home together after church.

"So, do twins run in your family?" she asked, out of nowhere.

"Mom!" said Will's sister, who was sitting in the back seat with me. She was already happily married through the courtship process and had a couple of children already. Will drove in silence, but he looked uncomfortable too.

"I — I don't think so," I stuttered.

"You *do* want kids?" she pressed.

It wasn't like I hadn't imagined a future with Will. But instead of children, I had imagined fun vacations and living the stories he'd told me about visiting friends in other states or going to restaurants without a chaperone. He had mentioned the possibility of moving to Canada, and I wondered what it would be like to move to a new country. Maybe I would find I really was in love with him. Maybe he would stop scooting away from me on the couch as if he were afraid to touch me.

"Of course," I said. I assumed having children would be part of my future — that was one of the reasons God wanted his people to be married: to be fruitful and fill the Earth.

To celebrate our relationship (with a nearing betrothal on all of our minds), Will's parents took us all out to dinner at a tiny restaurant nestled into the green back of a mountain in Hanalei. The servers brought bottles of wine to pass around, and a waiter poured me a glass, even though I was still only twenty. My father kept beer and whiskey in the house, joking that it was part of being a Reformed Christian, and sometimes he'd give me small glasses of wine on special occasions, but I'd never had a drink in a public place before. I'd also never had dinner with potential future in-laws before, and I didn't feel ready. The twinkle lights in the room felt too much like a fairy tale, like it was only a matter of time before the twilight turned to harsh morning and the prince was gone on another adventure without me. I felt like a spectator to my own

story. If I were to walk out of the restaurant, I wondered if anyone would even notice.

<center>* * *</center>

For my twenty-first birthday, my parents woke me up with surprise plane tickets to O'ahu, a twenty-minute flight. We were all going: me, my parents, Chris, even Will. I couldn't believe I would get my own day to share with him.

When we boarded the plane, I sat next to Will. I noticed how good he smelled, like bergamot and Listerine, but of course we weren't allowed to give compliments.

We spent the entire day in Honolulu, drinking beer at the Aloha Tower Marketplace and wandering the Ala Moana Mall. My father let me, Will, and Chris go shopping by ourselves, and Will bought me a birthday milkshake from Godiva, even though he wasn't allowed to buy me gifts. Like compliments, gifts would encourage inappropriate emotions. I thought maybe he was starting to get to know me — he'd remembered that I liked chocolate — maybe he was just restraining himself from being too obvious about his feelings. He always felt so far away from me. I hardly knew who I was, the core part of me outside of the family rules and religious restrictions. I didn't understand how to make a decision on whether to get married.

We had so many talks with my father, but none of the conversations felt relevant to me. How could I think about my expectations for how to raise children when I didn't even know if I liked kissing him? We weren't supposed to talk about things that might "bond" us, so I wasn't allowed to ask him about anything deeper than our religious beliefs or general habits of life. It was confusing that I could know his stance on birth control and his past experience with pornography and still know nothing about how he really felt about me, about who he really was. I felt like I was courting a shadow.

Will didn't know that I was getting in more trouble as the weeks went by, that I was being told constantly by my father that I was letting my emotions get out of control, that I was giving my heart away before it was time.

<center></center>

He would scold me every week after Will went home, berating me until I retreated to the bathroom to cry in the shower. My tears were just one more sign that I was emotionally compromised. My father was asking the impossible of me: to think about if I wanted to marry Will, without having any affection for him.

I don't know why my father thought I was losing self-control. Was I enjoying myself too much? Was I too happy? Was I too disappointed when Will canceled plans or when he wasn't at church? Was I too invested in our relationship, not having anything else, no job or education or social life, to provide a different outlet for my love?

I felt like he wanted me to be like stone, emotionless. And I started to think he was wrong to ask this of me. I began to wonder what else he was wrong about.

* * *

High in the mountains east of Hanalei, Will was house-sitting for his boss. The house was sprawled out, with covered walkways, rain catchers under the eaves, and wood stained so dark it was almost black. Doors opened up entire walls. I imagined that living here would be like living in a tree house.

Will had invited Chris and me to hang out, but as we walked up the dark walkway to the starry light of the house, Will didn't come to greet us. He was already in the hot tub, and there was another man sitting next to him. I awkwardly took off my swimsuit cover and slipped into the steam. The other man, whom Will introduced as his friend Kai, didn't talk to me, didn't smile, just sulked in the corner, the water bubbling around him. It felt as if he didn't like me, but I tried to ignore that feeling.

I started to regret coming; this wasn't what I had expected, and my father hadn't wanted us to come anyway, having given in only after being persuaded by my mother. I wasn't sure this was worth his displeasure. It was getting so dark we could barely see each other's faces, and it started to drizzle. Above the glowing water, our heads floated in shadow. Chris and Will took over the conversation, tell-

ing far-fetched stories, making jokes. Kai and I avoided eye contact across our shared bath.

<center>* * *</center>

My father called Will's boss for a character reference — another box to check off the list — telling him about our courtship.

When his boss said, "I thought Will was gay," my father said that was strange, telling me later how that just went to show how Will was immature and not as masculine as he should be. We never talked about it again.

I didn't put together the pieces until years later. Kai showing up the time Will was moving, avoiding talking to me. Will giving Kai his ice cream maker we had used so often after courtship meetings on Sunday nights. How Kai seemed to hate me, how I wanted to hate him without understanding why. I would be angry about how Will treated both of us, but also sorry that he felt he had to lie. I would want to go back to that moment in the mountains under the stars, say something, ask something. Maybe I would start to understand how I got into a hot tub with three gay men, none of whom had been able to tell me the truth.

<center>* * *</center>

The neighborhood we lived in was all white stucco, shaved grass, and red-roofed condos lined up like Monopoly buildings. Days buzzed with lawn mowers and weed whackers; nights with the sound of the community pool splashing. Hot tub jets. It was like no one lived there — the condos were mostly empty, waiting for owners to come for a winter vacation. Or they were lived in by retirees, recluses, or workaholics. A neighborhood for wealthy mainlanders, condos built for white people who could afford the half-million-dollar mortgages.

My family could only afford to lease in this neighborhood for a couple of years, but still, the closed-garage-door policy and roving security guard in a golf cart meant we lived in privilege. I wasn't sure if I fit anywhere in the world, much less in Hawai'i, and this neigh-

borhood heightened my feeling of being out of place. I hated how everything echoed in the vaulted ceiling of our condo or outside between the buildings. The reverberation constantly reminded me of how empty it all was.

Will and I had finished our courtship questions, but the next stage of our relationship, betrothal, hovered just out of reach. Will kept moving from job to job, and my father worried about his finances, in addition to his concerns that Will was immature and seemed to exaggerate the truth. I would tell myself I loved Will — what else could that twisting of anxiety in my gut be? I would tell my father that I didn't want to give up on Will, and he would be angry that my emotions tied me to a man who might not work out. I kept telling myself that God wanted me to submit to my father, no matter what. That it was right for him to make these decisions for me.

Finally, when Will still wasn't getting enough work to meet my father's requirements, my father told me he had decided to put the courtship on hold. He said if things got better, maybe we could start back up.

"But I love him," I said, both relief and worry hitting me as I said the truth for the first time.

My father frowned. "I knew I've been too lenient with you. I want you to be happy, but this is not right. You aren't supposed to love him."

That Sunday, we had one last afternoon together. Will came over after church as usual. We were both quiet, not having much to talk about anymore since we had run out of courtship questions. We went to the neighborhood pool with Chris for an hour after lunch and dipped our feet in the tepid water, feeling the cleanness of it, the chlorine. I thought he must know what was coming, but I didn't know how to talk to him about it. After months of imagining getting married to him, I didn't have the slightest idea of how to tell him I hoped he would keep fighting for me. At the time, I didn't know anything of his own suffering, how he was forced to hide himself in order to gain acceptance. We were both trapped in a patriarchal system with no escape hatch.

When we got back to the condo, I watched from the window as Will walked across the street to his car. My dad was walking him out, casual in the hot afternoon, his shirt off like he'd just gotten up from a Sunday nap. I watched them pause in the middle of the street, my father talking. I knew he was telling him his decision. I felt hopeless, unable to say anything, unable to make Will turn around and look at me one last time. In only a few minutes, Will was in his car, driving away.

Soon after our courtship ended, Will moved to O'ahu and became a car salesman. He was trying to prove he could work hard, but his new job made him work on Sundays, and this became the new issue for my dad. Whenever one problem was resolved, another took its place.

Will came back to visit once for Thanksgiving, and we awkwardly played board games and avoided talking about the future. At the end of a long day, Chris and I drove him to the airport to fly back to O'ahu. He gave Chris a hug and then turned to me. I held back my tears as I said goodbye, wishing he could hug me. I didn't know that was the last time I would ever see him.

* * *

One night, my father called me into the living room. My mother, always sympathetic to my feelings but unable to stand up to my father, was sitting, quietly staring at the floor.

"Caitlin, I've called you in here because I need to talk to you about something serious. I warned you that you shouldn't let your emotions get away from you."

I noticed the echo of his voice expanding across the vaulted ceiling. My mother's compression.

"And you let your emotions go anyway. And now, you've put me in a difficult position. I can't let you marry Will, but I want you to be happy."

Happy. I couldn't seem to remember what that felt like.

"You need to repent! You have sinned against God for giving away part of your heart, and you need to repent. You need to make a 180-degree turn now. I'll be here to help you. You just have to trust God."

I felt his words like claws down my abdomen. I imagined blood spilling out. I felt numb. Then I felt like I was floating near the ceiling, looking down at my parents, at myself, unsure what to do anymore.

Then suddenly I knew I needed to get back to the safety of my room, and I said, "I can't do that. I can't repent of feelings I can't control."

My father left me alone for the most part after that; he avoided bringing up Will. I was still submitting to him. I was still a stay-at-home daughter. Maybe my father knew he couldn't force me to change my feelings. Slowly, I recognized that Will wasn't putting up much of a fight for me, and I let him go.

I started running in the heat of the day. I'd run miles through Princeville to the end of the road, where the sea stretched out like unbroken stained glass, bottle green bleeding into cobalt, the half-moon of Hanalei Bay peeking into view. I'd think about jumping off the lookout, gliding toward the horizon, and falling into oblivion. I'd think about what I could do if only I had a choice. Run away? But to where? I couldn't yet comprehend the logistics of leaving. I felt like I was at the end of the road, unsure where to go next.

One Saturday, on one of the rare days my parents didn't need our only car, I was allowed to drive myself to the beach. I didn't have any close friends on the island, and Chris had just moved back to Colorado to join Kevin Swanson's "shepherd center" for young men to learn to be godly leaders. Will had disappeared from my life. I was twenty-two, but I felt like my life was over.

I knew much of the island by this point, but I found a new beach on the map, a quiet cove out of the way of tourists, where I might be able to vanish, at least for an afternoon. On the way, I bought myself an iced coffee with my piano-teaching money. I put in a Zee Avi CD, listened to "Bitter Heart," and for the first time in months, I felt a little alive.

I parked on the side of the road beneath a curtain of elephant grass and walked up the dusty path to the beach. I passed a man needling a fishing net, his nimble hands hardened from the sun. I walked along the beach as far as possible to the end of the cove.

When I closed my eyes, I heard the breeze knocking around the glass bottles tied in the branches of a dried-up tree, the waves gently breaking against the beach. When I opened my eyes, I saw cerulean and aqua, the glimmer of broken shells underwater, the skim of sunlight on the line of sea meeting sky. Sitting there with the water before me, I could imagine that being alone wasn't all that bad. This island felt at times like a prison, but no one would have believed me if I had confessed it. Hawai'i is many people's idea of paradise. But after the past year and a half, after my courtship ending, my feelings of depression, my growing doubts about whether my father really did know what was best for me — or really did *want* the best for me — I wanted out. I wanted to be able to make my own decisions. I didn't know how to get there, but I knew I couldn't do this forever.

I had waited a long time for Will to come back for me, to speak up for us, but he never did. I watched the horizon and imagined him selling cars on a blacktop miles from the beach in the heart of Honolulu, trying not to sweat on his polo. I couldn't be sure if he imagined me at all.

I wondered for a moment — what if I hadn't been the passive recipient of the rules that had destroyed any chance at real communication that we had? But I let those thoughts pass.

Feeling abandoned by Will did little to distract me from knowing that I was not enough for my father. I had followed all the rules, and still he accused me of sinning with my feelings. There was no winning in this.

All that I had now was this solitude. I realized my life was driven by fear: fear of disappointing my father, of disobeying God, of doing the wrong thing, of being hurt. I had been so afraid that I had never stood up against the rules that kept me in submission. More than all, I'd been afraid to find out who I really was, what I was capable of. Maybe I was more than a wife in waiting.

* * *

In an alternate timeline, maybe Will would have asked me out on a date instead of a courtship. Maybe he would have taken me out to a romantic dinner at Duke's on Kalapaki Beach. Maybe we would have fallen in love quickly, sharing our interest in music, in going to the beach, in travel and adventure. Maybe we would still be living on Kaua'i. Maybe we would have been happy.

In a truer timeline, a kinder one, maybe he would have been able to bring his boyfriend to church instead of hiding his sexuality. Maybe we would have become good friends. Maybe we'd still get together for brunch or hikes in Kōke'e.

And then yet another timeline occurs to me: we get married. Maybe we elope. We move to Canada to be close to his extended family. We buy the good wine we can't afford and plane tickets on our credit card. We have disappointing sex, both of us grappling with a shame we can't name. We have children, little curly-headed babies. We visit our families on the holidays, but in the end, none of it is enough to keep us together. Maybe with love and truth telling, or maybe with bitter anger, we separate, we rift apart.

OPHELIA

Hamlet

By William Shakespeare

> *Ophelia:*
>
> *And I, of ladies most deject and wretched,*
> *That suck'd the honey of his music vows,*
> *Now see that noble and most sovereign reason,*
> *Like sweet bells jangled, out of tune and harsh;*
> *That unmatch'd form and feature of blown youth*
> *Blasted with ecstasy. O woe is me*
> *T' have seen what I have seen, see what I see!*[32]

Synopsis: Some might say *Hamlet* is about Hamlet, the prince, about madness or justice or the shifting of power. But really it is about Ophelia: her loss, her appearance of madness, the lack of justice for her, her lack of power. She is a woman torn between loves, for her father, brother, lover. She inhabits a world in-between: not quite the child of her father and not yet the wife of her lover. She waits to no end except loss. She listens to Polonius, Laertes, and Hamlet, men whose words conflict, and each in turn abandons her. And she can do nothing.

* * *

I carried my complete and unabridged fourteen-hundred-page volume of Shakespeare to the beach so many times that the binding cracked and I had to tape the pages together. I didn't quite know what to do with Ophelia. At first, her death seemed tragic, romantic, beautiful. But then I wondered why she had to die at all. Why did her loss of love and sanity mean she must be taken out of the narrative completely? I imagined a different ending, one with Ophelia surviving the ending blood bath, with her the one to say, "Good night, sweet prince." She would tell her own story at last.

I wished I was like Ophelia, a little. If I died of a broken heart, people would believe that I had really been in love, that my emotions were real. Falling in love with Will, or the idea of him, was my biggest mistake if I was to continue being a faithful stay-at-home daughter. When Will left, I wanted to put flowers in my hair and find a river. I wanted to lose my mind and mourn even though no one had died. Instead, I survived the violence of my imagination, and I carried my story safe in my heart until I could speak it out loud.

PLANS

I did not have the language for depression — I knew only the long days of numbness, of not eating, of wanting only to sleep.

I did not have the language for emotional or spiritual abuse — I knew only how I felt burdened by my father's fear for me, by my fear of him.

I felt like I was disintegrating.

I started drinking my parents' alcohol after they went to sleep. I would sit by my window, listening to distant traffic, and envision walking in front of a speeding car.

I'd had my own laptop for a couple of years by then, and I could access the internet. Before, I wouldn't have dared to look up my questions online. I only used the computer to write stories for myself, to post articles about homeschooling and teaching piano on a freelance writers' website, and to write a blog under a pseudonym about my life in Hawai'i.

But one night, I opened up Google and started searching.

Slowly words surfaced, coalescing into a description of my reality: *control, authoritarianism, manipulation, coercion, abuse.*

At first, I didn't want to believe that the tethers keeping me at home were not made of truth, that my whole life had been con-

structed to keep me from leaving. I shuddered when I read the definition of emotional abuse: "Emotional abuse involves attempts to frighten, control, or isolate you. This type of abuse doesn't involve physical violence. . . . It's characterized by a person's words, actions, and the consistency of these behaviors. Abuse may start gradually, but it happens again and again."[33]

I didn't know what to do when I found out that spiritual abuse was using God and the Bible to control someone, that my father had shamed me into submission by telling me I was sinful if I made decisions for myself. The words from the commandment "Children, obey your parents" that once anchored me in static passivity, now meant nothing. I was no longer a child.

Night after night, I researched. On Facebook and blogs, I found stories of homeschoolers who had survived abuse. Reading their stories was like reading my own. I grew in courage, layers of hope covering layers of grief. One survivor talked about sorting her education into two piles: the truth divided from the manipulation. Another spoke about struggling to adjust to college, always feeling like an outsider. They all questioned their home education. They all eventually left home.

* * *

On my blog, I started to grapple with my doubts, my cognitive dissonance, though I obscured my fears behind metaphoric language, hiding even from myself. I wrote about the Psalms because their melancholy appealed to me the most out of all the Scriptures. I wrote about the books I was reading, looking for ways to understand what was happening to me.

After reading *To the Lighthouse* by Virginia Woolf, I contemplated the character Mrs. Ramsay, the Victorian wife. She was an ideal beauty, defining herself in relation to her husband. A scene where she looks out to sea without her glasses fascinated me, and I wrote, "It is the not seeing and then the seeing and the being silent. Looking out without my glasses, all I see is blurred shapes, splotches

of color colliding together in chaos. I then look through the clear glass and suddenly I see the lines and the boundaries, the glorious details I had missed."

What had once seemed unclear was starting to come into focus.

* * *

I was told so many times that God had a plan for my life. I was promised that suffering would lead to blessing, that my patience would be rewarded with joy beyond measure. Time after time I was told I just needed to obey my father. My father, telling me to do the dishes, vacuum the carpet, plan the meals, be more patient, read my Bible more, pray more, trust more, stop feeling love. I had scolded myself often for being so full of doubt, so full of pain, telling myself my suffering would make me godlier. I just needed to trust in God's will for my life, even if that meant heartache.

I believed them all — my father, my pastor, women in the church — when they said I just couldn't see what God had in store, that I just needed to trust and obey.

* * *

I had been told so many times that I needed to submit to my father no matter what, that I mistook his abuse and control over my life for love.

When I had told my father I loved Will, he said he thought there must be something wrong with me, that I must not have been ready for courtship because I was having such strong emotions. That he had made a mistake in allowing the relationship. Even after all the years of following the rules and telling on my siblings and self-reporting my own sins and joining the church and serving my father's every wish and getting permission for every little thing — *I wasn't ready.*

Something snapped inside me then, and anger seeped out, and I knew I would never apologize for my feelings again. The part of me that had hidden away all my life started to rise up, and I realized my father wasn't always right.

Slowly, I started to wake up. And as I awakened, I dreamed up a plan.

THE PLAN

1. Don't tell anyone the plan.
2. Save up money from teaching piano lessons and babysitting.
3. Buy a plane ticket to Philadelphia, where my brother Kyle lives.
4. Move in with Kyle.

After that, the plan got hazier:

5. Go to college?
6. Get a job?
7. Pick a career?
8. Go on dates?

I realized my plan had more questions than answers. I didn't have basic skills like budgeting. I didn't know how to apply for college or a job. I'd finally gotten my driver's license, but I couldn't just drive off since we lived on an island, and I didn't have a car anyway. All I knew was that I wanted to get out. I knew that if I didn't get out soon, I might be stuck under my father's rule forever.

I didn't tell anyone but Kyle, who had left the army and reconnected with us, what I was planning to do. Everyone else would just try to stop me or try to convince me that God wanted me to stay with my parents. But I already knew that if there was a God who cared about me, he wouldn't want me to live with this much fear.

I didn't know how to break up with my parents or how to actually follow through on the steps I never wrote down. The plan was a dream I was storing away, hoping I would be able to make it come true.

But then, just when I started imagining a new future off the island, I found a reason to stay.

REBEL

When I first met David, I was lost in the aftermath of my courtship with Will. David was the son of the pastor who took the permanent call to lead our church plant. He seemed quiet and avoided being the center of attention, but he was also kind, a good listener, and a middle child like me. One of my first memories of him was when his family came over for dinner and he sat in a corner reading a book. I knew we would get along.

David was a few years younger than me, but in many ways he seemed older. He could do so many things I wasn't allowed to do — he had a car, a job, a cell phone. He was independent. He was planning to go to college in Michigan, where his family was from.

His father — our new pastor — was conservative, but not part of the Christian patriarchy movement. He taught that wives should submit to husbands, that men were the leaders of the home. But he had no problem with dating, with women having jobs before they became mothers. When he preached about the grace of God, it felt like I was hearing the gospel for the first time, like maybe God wasn't a controlling father.

David asked me once why I didn't have a job, and I tried to explain. He seemed confused, but I could tell he didn't judge me.

More than a year had passed after Will had left, and David's family and mine had become close friends. Chris moved back from the shepherd center and started working at an ice cream shop with one of David's brothers.

No one seemed to notice as David and I became closer friends. Our families had bonfires at the beach, and we would sit next to each other and silently watch the stars appear over the water. He played guitar to accompany my piano at church, and I sneaked glances at his sharp jawline and imagined kissing his dimples. Once I caught him looking at me from across the room after church, his deep-brown eyes a little sad. When he left to spend the summer in Michigan, he hugged me in the church parking lot to say goodbye. Something about the way he held me in that moment felt like home.

My love for him grew slowly, silently — my own private rebellion.

* * *

The first time we were alone together, we had driven to the mall with Chris and his friends from work, and while they were at the gym, David walked with me through the mall to the Borders bookstore. I bought a hot mocha at the Starbucks on the way even though it was warm out. David made me laugh about something, and I spilled coffee on my white shirt. I apologized, feeling embarrassed that my clumsiness was on display, but he just smiled, and we kept walking.

When we got to the bookstore, we wandered through the aisles, talking about books we liked. The store was closing, and they were selling everything at a discount. I wondered what would take its place, what would come next.

* * *

For a couple of weeks, my father got me a gig house-sitting for one of his colleagues, and I was able to borrow her car. I played her grand piano by the window and read books out on the lanai. I felt like I could breathe when I was alone, playing house.

An idea came to me then — I would ask David out. In secret. I was tired of waiting for someone else to choose me, and I knew we had a special connection.

So I called David as I ironed a summer dress, to see if he would want to grab lunch. Without hesitation, he said he would be there. We met up at the café in Kōloa, but when he started to pay for my sandwich, I stopped him. Even though I was breaking the rules, I thought I could avoid calling it a date if I bought my own food. I thought I might be able to get away with it. He looked disappointed, a little confused, but didn't say anything.

* * *

Without telling me, David went to my father, knowing the only way he would approve our relationship was to have a courtship. My father said yes, at first, and I thought maybe this time it would work out. I'd changed — I knew myself better. I wouldn't let myself be shamed for my emotions. But I believed that David and I could find a way to be together that would satisfy my father.

Right after my father approved a courtship, he left on a business trip for a week, and my mother let David and me watch movies in the living room unchaperoned. She cooked us dinner, and we talked out on the lanai looking down to the sea. It was strange to think we were actually going to have a relationship with my father's approval, and I wondered if this was God finally rewarding me for my patience and submission. But I also felt uncertain. I recognized now how unpredictable my father could be, how he changed the parameters of his rules to keep control over me. I'd seen it before in my relationships with Matthew and with Will, and I was worried he would interfere with David.

By the time my father returned, he had already changed his mind. He said we couldn't have a courtship after all. He said David didn't have enough money or a college degree or a house. I remember him saying that forty thousand dollars in savings or a four-year degree with a career would be the standard in order for us to

even start a relationship. Until then, we could remain friends, but nothing more.

I felt anger boil up inside me — my father always found a reason that a man interested in me wasn't worthy. I didn't know why, but it seemed like he would always find a reason to keep me single and at home. I was tired of being told what to do, of his directing my life. It was my future at stake, and I resolved not to let him ruin it.

David and I continued our friendship with the understanding that maybe someday, a few years in the future, my father would approve of our relationship. We found ways to be together, not quite dating, but not just friends. Without the courtship process keeping us in line, we fell in love.

Sometimes David and I would sit on the lanai of my house and play board games or talk about our lives. My father allowed this because the lanai was within earshot of his desk in the living room. The days would cool off as the sun set, and the clouds' blushing pastels made it feel magical. David started bringing over his guitar so we could practice for Sundays, and he taught me how to play a few chords.

We tried to spend as much time together as we could, but my father would say no much of the time, and we never knew when we could be together. Some nights we'd meet up at the ice cream store where Chris worked, sipping espresso and playing chess until closing. I'd started feeling like my father would never let me be happy, and one night in the parking lot, I told David he should just move away and get on with his life, not delay college for me any longer. I wasn't sure how we'd make it together, knowing my father's shifting rules. But he stayed anyway.

* * *

Once on a Saturday, we kayaked up the Wailua River with two of David's younger brothers to a deep swimming hole. It was peaceful on the river, quiet. The swimming hole was never busy because most tourists took the other side of the fork to the waterfall. On the

way back, we took a break at a slow spot on the river. David's brothers explored the bank while we sat on damp rocks in the shade.

"I love you, Cait," he said, his eyes locked on mine. The shock of his words hit me, breaking something inside. These were words I wasn't allowed to hear from him. I cried for an hour while David held me. His brothers looked impatient to go but kept their distance.

I'd tried to keep my emotions in for so much of my life, tamping down anything that was not permitted. The feeling of being loved by him felt terrifying but also like what I'd always been looking for. My father's love felt suffocating, making me want to shut down. But this love was different. David never told me what to do or manipulated me. He asked my opinion about things. He listened when I told him about how difficult it was at home. It felt safe to be loved by him.

Eventually, I got enough breath to tell him how happy he made me, how I loved him too. I didn't have words to describe how I'd been so afraid of love, so resistant to it for much of my life. Now I was faced with an uncontrollable, unconditional love, and even though I didn't know what would happen next, I trusted that we would find a way.

* * *

David lived up the street, and I had to pass by his house almost every day when I walked to the bus stop to go to my homeschooling gig. On my way back around noon, David was often outside, digging the foundation for an extension on his parents' house. I liked to watch him work, the sawdust clinging to his clothes, to the back of his neck.

When he was outside, he would take a break to sit with me for a few minutes before I continued on my walk home. I could only stay for a short time so that my parents wouldn't notice I was late, and I worried that my father might drive by at any moment.

He always seemed to be watching, waiting for me to do something wrong. But the fire that had kindled in the days after Will left was getting hotter, and I wasn't going to let him keep me from happiness again.

One afternoon, David and I were in his parents' sunroom, looking down the hill toward the ocean. His parents were supportive of us, but also wanted to be diplomatic with my father since he was an elder in the church. Their house felt safe to me. As we sat side by side, David told me about something that he had been through that was difficult, and all I wanted to do was comfort him, to make him feel loved. I reached over and took his hand in mine, our fingers interlacing for the first time.

* * *

"May I kiss you?" he asked, brushing my bare shoulder with a finger. We were sitting on his front porch. I was wearing a pink-and-lace sleeveless dress, and I shivered as the sun dipped out of sight, leaving us in a shadow. David must have just gotten out of the shower; he was wearing a fresh white T-shirt and he smelled clean, like he'd just put on cologne.

I nodded yes. I'd been waiting for him to kiss me ever since he'd told me he loved me. But I could sense that he didn't want to make me uncomfortable, not after I'd started telling him more about what my life was really like.

Neither of us had ever kissed anyone before, but our lips touched gently as David moved his hand to the side of my face. I sank into the moment, forgetting my worries about going home.

* * *

At Lumaha'i, David found a vine on the beach and twisted it into a bracelet as we sat facing the water. He slipped it over my wrist, and I smiled, remembering how just the other day he had quietly voiced what we were both thinking. *We should get married.* It seemed like the only way forward, the only way to be together. I hid the bracelet away in my bedroom, a reminder that he was never going to leave me.

CHAVA

My father was yelling at me again, telling me I was too emotional about David. He'd seen me drive up in David's car the previous night and give him a kiss good night.

According to Dad, I was a rebellious, sinful, disobedient feminist — the worst insult he could imagine. I'd grown up hearing things like *feminists want to be free from the family, feminists destroy families.*

I worried that it might be true, that I was killing my family.

When I was younger, we used to watch *Fiddler on the Roof* together. Even though we were Christian, not Jewish, the ideas of tradition and family resonated with my father.

But the daughters of Tevye were telling me secrets that I didn't dare speak out loud. Tzeitel, Hodel, and Chava were like me. They were expected to work at home and help around the house. They were expected to marry, to have children, to belong to a man their entire life, whether their father or their husband. But like me, they were unsettled by having their story written for them.

Tzeitel, the oldest, wanted to marry for love instead of following the tradition of leaving the choice up to the matchmaker.

Tevye pushed back against this breach of tradition, but he eventually gave in.

Hodel, the second oldest, didn't ask her father's permission to marry, just his blessing.

Again, Tevye pushed back but gave in.

And Chava was the most heartbreaking of all. She eloped with an outsider.

This was too much for Tevye. Too much for his beliefs and sense of tradition to encompass. He felt as if Chava had died to him. And he rejected her.

I carried that scene from the film in my heart for a decade before it became truth for me as well: the scene when Chava finds her father with the milk cart on a dirt road between fields. Chava is distraught, bundled against the cold, asking for acceptance. Tevye emerges from a daze, and he pauses for a moment to internally debate his options: accept or reject his daughter. He finally stops himself with solid resolution. Waves his hands in the air as if he is dancing or pushing the presence of Chava away, out of sight. He turns his back and leaves her on the hard dirt-packed road between the barren winter fields.

That is the image I had of my father as he followed me into my room, arms like knotted ropes, arms like steel. I felt as if he filled the room with his presence.

He cast his judgment: I was ruining everything our lives depended on. I had so much potential for a good marriage: a quiet spirit, perfect obedience, the ability to please. And now? Now, in his eyes I was wicked, hurting my family out of selfishness.

Perhaps he had the same image of Tevye and Chava in his head. Maybe he battled the same conflict: on the one hand, his conviction; on the other hand, his daughter. Maybe he heard Tevye's final choice: "If I try and bend that far, I'll break. . . . On the other hand — no! There is no other hand!"

My father folded his arms, red in the face. He wanted me to apologize, cower, cry.

I felt cornered. The room felt hot. I started to argue back, but then my body snapped into flight mode. I managed to run past him and down the hall toward the front door. Outside, the afternoon air

rushed through my hair as I bolted up the street. I had only made it halfway up the hill when he chased me down and herded me home. I knew he would keep following me if I didn't listen. I wondered if the neighbors had seen us: a twenty-four-year-old woman running for her life out of the house and her father calling after her, not wrestling her physically, but shouting enough to make her turn and let him guide her back to the house.

The arguing continued inside, and I could feel myself dissociating, disconnecting from my body. The next thing I knew I was running up the hill again. This time, I made it to the golf course across the street. It was after hours, so no one was there to see me crying.

I ran as far as I could and hid on the other side of a grassy hill, overlooking the ocean. The water arced across the horizon, seemingly endless. This was where David and I met to take walks sometimes, and we'd wander the empty green in peace, alone at last. I wished he was there, but I didn't have a way to tell him what had happened.

As twilight fell, I turned and saw David in his white T-shirt walking across the grass, headed in my direction. I knew he could see my red face, and I wondered if he could see how broken I was. He sat down next to me and without a word wrapped his arm around me, letting me cry into his shoulder until it got so dark that we had to head back.

Later, my mother would tell me that my father had gone looking for me, all the way to the golf course, but that he had turned around when he saw me with David. I wondered why he hadn't approached us and pulled me away with him. But as it usually happened when Dad was upset, after the night passed, we never talked about this argument again.

* * *

I still thought my father could be reasoned with, that I could hold on to him as well as David. No matter how many times he got angry with me, he was still my only dad. I'd witnessed what happened when Kyle had left home, when Allison had almost eloped — he had seemed willing to cut them off.

But maybe if he could understand why I was hurting, that how he was treating me was wrong, he might change. Maybe he would see that I loved him. So I printed out an article I'd found on psychological and emotional abuse and wrote a letter to my dad. In it, I tried to point out what my father had done that I felt was abusive — restricting me as an adult, keeping me isolated, controlling my love life, not letting me make decisions. I highlighted passages in the printed article that felt important. Then I walked up to my father's desk, handed the papers to him, and asked him to read it. When he called me back later, I knew it had been a mistake.

"I'm not abusive," he shouted. "How can you say that?"

"I feel like I shouldn't have to repent for my emotions. And I think I should be able to make decisions about my relationships."

"Children, honor your father and your mother," he said, quoting the Old Testament as he often did.

"I don't think that verse means I need to submit to you when you're being unfair. And even if it did, I'm not a child."

"You are a child until you are out of my house."

I tried a different approach: "I feel like things changed when we moved to Colorado and you went to that Vision Forum retreat. When you came back, we changed. Everything about courtship and not dating started around then. Maybe it wasn't the right thing after all."

"That's not true. I had convictions about courtship *years* before then."

I felt confused. Had I remembered wrong? My mind raced through memories — my father's hands on the Bible, my sister twirling her hair, Mr. Mitchell and the issues of *Patriarch*. It had all happened, I knew. But he was questioning my timeline, and this made me feel unsure of myself and of reality.

What was even real anymore? My father said he loved me, but this article said that his behavior was abusive. My father said he wanted the best for me, but I felt like he just wanted to control me. Everyone at church seemed to think he was a wise, godly leader, but I'd seen the way my mom shut down in response to his shouting and

his criticism. I'd been watching Chris pull away for months, trying to assert himself, while our father went through his room when he was out of the house, looking for contraband.

I had only just learned what abuse really meant; I had not yet grasped the words *gaslighting, love-bombing, walking on eggshells*.

* * *

The more time I spent with David, the more I trusted him. I started telling him the things my father said and did in the protection of our home, how he treated me, how I wasn't allowed to move out, what I knew about domestic abuse. David wanted to talk to him and try to make him see reason, but I knew this was a bad idea.

I listened from my bedroom as David confronted my dad in the other room. David's voice was steady, calm, yet assertive. My father's voice was stern, loud enough that I could him clearly: "I don't chain her to the bed! She's not a prisoner! You have no idea how much I love her. You don't have a right . . ."

I could feel my heartbeat soar, my hands shake. There would be no convincing my father. But I wasn't going to give up on myself this time. I wasn't going to give up on a future with David.

* * *

I knew we needed help. David had talked to his own father about our relationship, but I felt I needed to speak for myself. I hoped he would understand and believe me. I was worried, though, because he was also the pastor of the church, and my father was the only elder, and no one knew how overbearing he was at home.

First, I sent him an email secretly, saying I needed to talk with him. Then I had to walk to his house because I knew I couldn't use the car. I waited until my father was gone on an errand. As I climbed the hill to David's house, the hot tropical sun overhead felt too cheerful. I felt like a black hole. Like a canyon hungry for a river.

When I got there, David and his dad sat at the table with me. I pled my case like a defendant with no attorney. I talked about the

years of control and keeping me from making my own decisions. I remember crying, but I don't remember if I used the word *abuse*. I told him only bits and pieces, about my friend Rebecca that I'd felt forced to cut off, about my father regulating my relationships, but not the whole terrible truth: the yelling, the cornering of me in my room, the controlling of my clothes and hair and education and work and finances, the decades of indoctrination. I wasn't sure yet if I could trust him.

David's dad listened with compassionate eyes. He believed me. I felt heard, like my voice mattered, my feelings mattered.

He said he'd have to think about how to help and that he would talk to my father. I knew he would have to because of my accusations, and I also knew it would be hard for him. We were a small church plant. Confronting the only elder would mean disrupting the status quo.

I asked him not to talk to my father right away; I didn't want him to find out I had left the house that afternoon. I didn't want to get into trouble. Maybe I didn't convey clearly enough how scared I was of my father. Maybe my pastor didn't quite hear me. Maybe he did.

I ran home through the woods along the road, trying to get home without being seen. I cut myself in the brambles, my heart beating fast and hot. Finally I slipped through the front door and into my room, unseen. My father hadn't come home yet. I sat down and tried to recover from my revelation. I had been so scared to speak the secrets of my family, and I was terrified of what could happen next. I had committed the ultimate betrayal: I had told someone on the outside. Not everything, but enough.

Deep down, I knew that if I was strong enough to tell, then I was strong enough to leave for good.

I heard the sounds of my father coming home, sitting down at his desk, typing on his computer.

I tried to breathe regularly.

Then the phone rang, and the air stopped.

A few moments later, my father burst into my bedroom. His bright red face, his dark-like-cold-lava eyes, his arms crossed over

his chest, veins bulging. My thinking stopped in its tracks, and my body noticed the signs of danger: how tall he was, how much stronger he was than me. I could feel the last time his arms had wrapped me in a hug, his restrained power. There was no escaping.

I stood on the other side of my bed, five feet of mattress and pillows between us. I froze.

"How dare you! How dare you! What have you done? What did you say? After all I've done for you. I am your father and you don't respect me. I can't believe you would do this. I only tried to protect you!"

I knew I needed protection *from* him, but even the church couldn't do that. I was confused why the pastor — David's father — had called so quickly after I'd asked him not to.

I imagined my father hitting me, fists in my face. I could taste the relief. *People will believe me now.*

But he stayed on the opposite side of the bed. When he finally stopped yelling, his breath running out, he left and slammed my door behind him. I couldn't breathe. I felt nothing but ice.

I sank into the green butterfly chair my parents had given me when I was a teenager, the chair I used to hit my wrists against to feel something. And then the air rushed in and I started to hyperventilate.

I wondered, distantly, if I were having a heart attack. Maybe I was dying. Maybe I had wrecked my whole family because of my betrayal.

I don't remember how long I was there, panicking, struggling to breathe, to feel anything but the sensation of looming death — an hour, two hours. I was waiting to die. I could think of nothing but the pain.

My mother finally came home from running errands and found me still frozen in the chair. I couldn't speak. I didn't know what my father had told her. She knelt down and wrapped her arms around me. She held me until I calmed down enough to go to bed.

* * *

One day while I waited for the bus after a morning of homeschooling, I called my friend Jane with the family cell phone I was allowed to take with me. We still regularly wrote each other letters, but I needed to hear her voice, to tell her what was going on.

She listened and sympathized as I told her how I felt trapped, that I didn't know what to do. It was so hard to be submissive to my father when my heart and mind were pulling me in another direction.

When I got to the part about how I got in trouble for kissing David, she paused.

"I think that was probably too far for you to do," she said.

I looked up at the sky, the noon sun beating down. The neighborhood where I was waiting for the bus felt empty, most people still at work.

I felt alone — again. I was already past the fear of kissing, of making my own choices about romance.

But she couldn't understand. She was also a stay-at-home daughter, still waiting for her God-ordained husband. Even with everything I'd told her about how my relationship with Will had ended, she still thought I needed to submit to my father. That's what God would want.

* * *

On Facebook, I saw pictures of Megan's wedding. She had worn a beautiful pure white gown with a red ribbon at her waist representing the saving blood of Jesus. But her parents weren't in the pictures. We had maintained our friendship after that first family camp, but we'd lost touch the past few years, and now something seemed off.

I gave her a call. I ended up telling her what was going on in my life, that I had someone that I was seeing but I didn't know what to call him since my father wouldn't allow us to have a courtship.

"He's your boyfriend," Megan said matter-of-factly.

I smiled. "Yeah, he is."

I told her I didn't know what to do, that my father was being irrational, abusive even.

Then she told me that something similar had happened to her. She had wanted to have a courtship with the man she liked, but for seemingly arbitrary reasons, her parents hadn't approved. She believed he was a good person, that God was leading her to get married to him, so she had chosen to leave her parents and get married without their blessing.

I found courage in hearing a story so like my own. Maybe there was a way out of this.

ENGAGEMENT

After months of trying to figure out what to do, David's father was still trying to mediate for us, smoothing things over with my dad. He opened his home to me so that I could spend time with David in a safe place.

But my father wasn't budging on his rules for a relationship. *Forty thousand dollars. College degree. House.*

That seemed nearly impossible.

David's dad advised him to move back to Michigan, where he wanted to go to college, and get a job there. The first step in moving forward, with or without my father's approval, would be for us to have some kind of financial stability. He bought him a ticket, and by November, David was gone.

Before he left, David took me to the mall to get me a cell phone. He helped me pick one that I could afford with my piano-teaching money. That way we could stay in touch until he could come back for me. It felt powerful to have my own phone, to be able to call for help if I needed it. It was my first time having a regular bill to pay. And instead of making me feel helpless, David's going with me made me feel less alone, like he was there to be with me as I made this step toward independence.

Now when my father was upset with me or when my parents were arguing, I could take a walk and call David. He knew, more than most people, what it was like for me to be in my parents' home, where I felt I had to keep the peace as much as I could or risk setting off my father's anger.

The more I had talked to my father about why I was unhappy and how I wanted to make decisions about my relationships, the angrier he had become. One day in frustration, I raised my voice: "I don't think you know what's best for me. It doesn't make sense anymore!"

"You can think whatever you want," my father said. "You just can't act on it."

He swiveled on his office chair back to his desktop, and I realized that arguing wouldn't change anything.

Instead of giving up, I resolved even more to withstand whatever was to come because I knew I would get out. Each night before bed, I'd call David to say good night. He was in a different time zone, so he would be getting up for his early shift at a factory. I fell asleep knowing he was as resolute as I was.

* * *

A few days before Valentine's Day, David was able to take some time off at his new job and fly back to Kaua'i. I knew why he was coming. It wasn't a surprise. I was excited that we would make our relationship official.

My parents were out of town the day I walked up to David's house. We were planning a day just to ourselves, no little brothers as chaperones. David's parents let him borrow the minivan, and we took off in the morning, the bright sun in our eyes.

"Take me to your favorite beach," David said.

I directed him to my secret cove, the one I had only ever been to alone. The one with no other memories than of me finding my way to myself.

When we got there, the morning sunshine lit up the gentle waves as they crested and fell back toward the open sea. We went swimming, and I felt lighter than I had in a long time. It was just

the two of us, and I could forget for a moment all the struggles of the past few years. It was beautiful.

Then next thing I knew, David had jumped out of the water and rushed back to his bag on the beach. I followed him, and he pulled out a diamond ring and knelt down in front of me. I'm not sure he even asked the full question, "Will you marry me?" before I shouted yes and kissed him quiet.

* * *

I don't remember the moment I bought my plane ticket to Grand Rapids. But I do remember telling my father I was leaving and moving to Michigan to be with David. We were going to get married there and start our lives together.

I didn't ask his permission. I was no longer obedient. I was almost twenty-five.

My father was working at his desk as usual, and I had practiced the words in my room until I knew I needed to get it over with before I lost my nerve. To my surprise, he did not yell when I told him I was leaving. Unlike the moment when I had said I thought he was abusive, he did not fight back. Silence. A nod of his head. I do not know if he felt angry, or defeated, or sad. Or maybe he just had too much work to do to deal with me. I'm not even sure how I felt, except for the sensation of ripping apart. The knowledge that there was no other way.

* * *

I called my sister to tell her the news. Once she had taken a moment to process what I'd said — that I was getting married — she started yelling into the phone. David was sitting beside me, and he looked concerned as I held the phone away from my ear. My hands shook as I struggled to understand what she was saying.

"How could you do this to Dad? Why are you being so disrespectful?"

She knew we hadn't had a courtship, that our relationship was not approved. I wasn't sure all that my father had told her or her husband. This would not have been the first time my father had

pitted my siblings and me against each other. We were always trying to get in his favor.

Eventually, through her eruption of words, I said I had to go — I didn't know how to argue with her. David held me as I cried. The clouds shimmered purple as the day ended, and we went inside to have dinner with his parents.

* * *

The day my wedding dress arrived, delivered by DHL air mail, I was alone — Chris was working at the ice cream shop, my parents were shopping. The package was much smaller than I had expected. I had pictured yards of lace and tulle, puffy like a down comforter. Instead, I held a small plastic bag, a little heavy but easy to carry.

When I tore open the plastic wrapping, the dress was exactly as I had designed it. I had drawn in pencil an elegant outline: a small train, netted flowers, a not-too-revealing V in both the back and the front. I had been inspired by looking through bridal magazines, wishing I could afford the six-thousand-dollar gown of my dreams. The seamstress I had found on Etsy had imitated the drawing exactly, for only a few hundred dollars. The lace felt a little stiff and cheap, and the flowers I had requested were cut out of organza and hot-glued to the skirt — but it was still my own dress.

It took some time and elbow bending to zip myself in, but suddenly I was a bride. We didn't have any mirrors in the house large enough, so I climbed on a chair and used a hand mirror to see how the skirt draped gracefully to the floor. I spun a few times, imagined putting on the dress again in a few months at my wedding, and I took it off to stow it safely and discreetly in my closet.

I would show my mother later, but my father had no interest in discussing my wedding plans. I was marrying without his permission. I was just thankful he hadn't kicked me out of the house.

I had wondered for a short time if I could convince my parents to take me dress shopping on Oʻahu, where there were bridal shops. I had wanted to include them in the planning somehow. I looked up store websites, calculated the flight costs. But it would have been expensive to go, and I couldn't even imagine convincing my father.

I thought of all the weddings I had been a bridesmaid in. Many of my friends from Reformation Church had married quickly after high school to men they hadn't known for very long. At the time, they had all seemed happy, and their parents had been involved in their courtships. Their marriages were approved and seen as blessings in the church. In comparison, my upcoming wedding felt like a show of tradition, a ceremony legitimizing our relationship — a formality I could only hope that my parents would attend.

Even though David's family had welcomed me in, the wedding still felt like it would mean a loss. A loss of my family, my former identity, and my way of life.

* * *

I opened my hope chest. It contained so many things I'd saved in the hopes I would bring them into my new home as a wife: cake pans, kitchen gadgets, mugs, cookie cutters. I listed them all on Craigslist. Everything had to go — it was too expensive to ship them overseas. They all felt like empty objects now anyway, symbols of a life I was supposed to have but that I was leaving behind forever.

I used the money I had to box up my only valuables, my books, and ship them by boat to meet me in Michigan when I got there.

* * *

It was Thursday — the one day a week I could borrow the car to teach piano to children who lived on the other side of the island. I had parked near the beach and was sitting on a bench for a short break between lessons. I looked down at the ring on my left hand. Only a few more months.

My cell phone rang.

I saw on caller ID that it was my father calling, and I picked it up anyway.

"I only have one thing to tell you and then I'll let you go," he said. "If you do this — if you marry him — I don't think I can in good conscience walk you down the aisle. I'm not saying I won't come, but I can't give you my blessing. I can't give you away because you're not asking me to. You're not willing to submit to my wishes."

I looked out at the sea and said nothing. Imagined sinking under the water.

"That's all," he said.

I hung up.

Cutting off the call felt like a gash in my side. Then nothing. I felt nothing as the sun created a hot seam down my backbone. I cried only because this had been a long time coming, like sand from an oceanic trench, regurgitated. Old sand. Broken shells. Crab carcasses. I felt nothing because I had already felt everything.

* * *

The next day he said he didn't mean it. I felt myself dissociate from my body as he hugged me and kissed me on my neck. I felt pulled into a dangerous current: my body wanted to run. I didn't want him to touch me like that. I noticed how my father flipped between rage and affection so quickly. I wondered if this was his plan all along, to drop me so that I would want to be held. But I didn't want to be held by him.

* * *

My parents took me to the airport at the beginning of April. I saw my father's face in the rearview mirror, a single tear falling down his face.

I didn't know how to minimize the damage, but I had to get away. I didn't know how to leave without a trace, and I felt like I was leaving brokenness in my wake.

My parents watched me as I walked through the security line; my mother was crying. I knew she wanted me to be happy. I wasn't sure what my dad wanted. I turned and waved one last time, then collapsed onto a bench just out of their sight.

I felt the cracking of my foundation. I felt eroded. I didn't know how to build from here, just that I had to try.

SELENA

So Big
By Edna Ferber

> *"You don't know what you are doing, Mrs. DeJong. The Haymar-*
> *ket is no place for a decent woman. As for the boy! There is*
> *card-playing, drinking—all manner of wickedness—daughters of*
> *Jezebel on the street, going among the wagons."*
>
> *"Really!" said Selena. It sounded thrilling, after twelve*
> *years on the farm.*[34]

Synopsis: It is the Midwest in the 1920s, and Selena is a woman who
knows her own mind. When Selena's father dies, she decides to avoid
the miserable fate of her spinster aunts and becomes a teacher at
a country school in farming land. She learns to navigate the Dutch
immigrant community as a teacher and then as a wife to a farmer. But
when her husband also dies, Selena knows she has only one option: to
survive and support her son. By breaking social codes for women and
doing forbidden activities like going to the market, Selena becomes a
successful, independent farmer, gaining respect within her community.

* * *

I was drawn to characters like Selena because they're quirky and don't conform to society's rules. Selena is strong, wise, and smart. She adapts to her changing situations with a grace I wished I had. She knows her own mind. I wished I knew mine. My thoughts felt like scattered wildflower seeds, some of which had landed on pavement, some pushing into rain-softened ground, waiting to break through.

I'd been told the world was dangerous for women, that being out of the protection of my father would be asking for harm. A woman alone was an easy target. I was an easy target. But I ventured into that danger anyway when I left my parents' home, and with it the Christian patriarchy movement. Only later did I realize how much danger I'd left behind.

MICHIGAN

Gichigami — the Ojibwe name means something like "Big Sea," what we call Lake Superior — is a hollow in the ancient Midcontinent Rift. It is the largest, coldest, deepest of the Great Lakes. The sea is so large that it follows its own tide. Sapphire and emerald fresh water covers the skeletal remains of erupted earth, volcanic activity long since burned out. A billion years from fire to ash to ice, and the warming of the sun, the melting of the glacier. And now this: a rugged coast of painted rocks, the opposite shore too far away to see, scattered lighthouses we've raised on precarious cliffs to see our way across the water in the dark.[35]

PURE

To my surprise, my father eventually went along with our wedding plans. Maybe it was my mother who pressured him, or David's father who warned him he was about to lose me completely.

No one else at church knew what had been happening or how much my father disapproved. When my parents invited the church over to celebrate our engagement, my father played along publicly but kept his distance from me and David. Only a couple of days before, he had told David he wouldn't give us his blessing when David asked for it. At the party, he mingled with the guests; he always seemed nicer when other people were around.

At the time, I was grateful he had backed off, that he didn't ruin all our plans or sabotage our wedding, like I'd been afraid he might. My parents offered to pay for most of the reception costs, a few thousand dollars. I was grateful for that too, although I wondered if my father felt in control when he was the one spending money.

When I got to Michigan in April, I stayed with David's grandparents while he lived at his older brother's house. We hadn't found our own apartment yet, and even though we had broken my father's emotional purity rules, we still felt bound to wait until our wedding to sleep together.

Those months before the wedding were like the lightheadedness after being trapped underwater in a rip current. Euphoria at not having died. Unaware of the injuries I couldn't feel yet.

I sat in Opa and Oma's basement most days, embroidering my wedding dress with tiny pearl beads and silver thread. David worked during the day, and after his shifts, he would come pick me up and we would take walks in the park or fill out apartment applications or shop for inexpensive wedding decorations.

We were dating out in the open for the first time, without a chaperone, without my father lurking around the corner. We were happy and in love, but we were also trying to figure out finances and housing, planning for our future.

* * *

One Saturday evening, David and I had an argument — about something insignificant I don't remember now. He went home, and I cried myself to sleep. I hated conflict. All I knew was my parents' fighting, being afraid to go near them when they weren't getting along, trying to make each of them happy in the hopes that they would make up. I didn't want that kind of tension for us.

I woke at dawn to a text from David: *I'm outside. Can you let me in?*

Still in my pajamas, I stepped to the walkout basement door and unlocked it.

"I just couldn't stand making you upset. I'm so sorry," he said.

"Shhh. You'll wake up your grandparents."

I led him to the guest bedroom where I was staying, and we sat on the bed, the door cracked.

We talked through the argument, what had gone wrong the previous night, and what we could do to communicate better next time. I felt relief. Conflicts could be resolved. I was so happy that he had cared enough to come in person to apologize.

"David?" A voice from the hall. It was his grandfather. My relief dissolved into anxiety. I knew how this would look. My father had always said to never be in a bedroom alone with a man.

David left the room to talk to Opa.

"It is disrespectful to stay overnight here," he said in his Dutch brogue. He had granted us a lot of freedom by giving me the basement for a few months, but this was too far. He, too, wanted us to stay pure.

"Caitlin let me in this morning," David said. "I just got here."

As I listened to them talking, I felt flush with embarrassment. He'd thought we'd slept together. And even though I wasn't under my father's rule anymore, I still felt an intense need to *be good* while also wanting to follow my impulses.

David often stayed late in the evenings to watch a movie with me, and we made out instead of paying attention, but he always left just when I wanted him to stay over. I didn't know my own sexual ethics now that I was no longer under a man's headship. I was ready to throw all the rules out the window. I felt desire and didn't feel ashamed for it. But I'd been warned by David's mother that we would regret it if we didn't wait until the wedding. I didn't know where the line of right or wrong was, the tension pulling me back and forth between parts of me I didn't have words to explain: my rule-following self and my newly freed self.

* * *

I'd been taught that I was supposed to be pure on my wedding day. As a bride, I would wear white as a symbol of my virginity. I was supposed to walk down the aisle in a white wedding dress decorating me as the untouched, the clean, the unkissed.

I remembered my sister's wedding. My father had instructed the congregation on how every aspect of the ceremony was symbolic, and the bride was the ultimate symbol. The white veil to show her submission. The white dress to show her purity, both sexual and emotional. The aisle was lined with a white runner just before she walked down. Her first kiss was the seal on a forever covenant. My father giving away his daughter, her husband taking her from him. The words *transfer of property* went unspoken.

But brides have not always worn white. Queen Victoria popularized the color as the elegant choice for wealthy brides when she wore a white ball gown to her wedding because it would show off some lace from a factory she wanted to support. It wasn't until later that white was married with innocence and virgins, as Victorianism was associated with modesty, femininity, and chastity.

White has been used as a uniform, as a statement of resistance, and as a statement of hate. White has been worn to show cleanness. White has been worn to show prejudice. The suffragettes. The Ku Klux Klan. Nurses and doctors. 1950s milk delivery men and 1980s Madonna. Naval officers and painters and the Dallas Cowboys and Catholic priests.

* * *

In church they told me that Jesus died to save me from my sins, which were like filthy rags, and that his sacrifice would make me "white as snow." But the image that stuck with me the most was Jesus calling the hypocrites "whitewashed tombs."

Snow is beautiful in its pure, perfect veiling of the earth. In its first moments, snow is heavenly. But given time, the snow mixes with the dirt underneath. Pristine doesn't last.

* * *

When Chris came out to me a few months before I left home, I didn't know what to say. Everything I'd been taught about homosexuality flashed through my brain, all the lies about the "gay agenda" and how gay people were evil.

And at the same time, I could see the suffering in Chris's eyes. His need for support. His courage in telling me.

"It's like being told you can never be with someone you love, that you have to be alone forever," he said. I tried to imagine what that felt like. I had been told all my life to lock up my heart, and it had only caused me pain. Now I was making choices to be with the man I loved, even if that meant leaving my family. I had a glimpse

of what he was trying to convey, what it must feel like to be told you can *never* have a relationship with the person you love.

I don't know what I said, if I offered to pray or if I said I loved him. All I know is that it wasn't enough, wasn't the right thing to say. Nothing I'd been taught had prepared me for this moment. It had been so easy to condemn gay people if they were on TV or far away, but it was difficult to judge when someone I loved was asking me for acceptance.

He eventually told our parents, which led to his being excommunicated from our church.

The teachings of Christian patriarchy that had oppressed me as a woman had also hurt my brother, and I couldn't begin to comprehend what it had been like for him. All the sermons, all the things my dad had said in contempt of gay people. There was no room for my brother to be himself in the black-and-white world we'd grown up in. We were so focused on purity, on an idea of holiness, that we missed the relationships right in front of us.

* * *

David and I were married on a warm June day in a little white church in rural Michigan, the same place David had been baptized as a baby.

I would have happily eloped — the stress of planning a wedding while leaving my family was almost too much. I had pulled away enough to know I needed to find safety, but I wasn't sure yet of my opinions about gender roles. I knew I loved David; he loved me. We agreed that the patriarchy I'd been taught was harmful. All we wanted was to be together.

It had been enough to dismantle my fear of my father, to move forward with making my own choices about my future. I did not know how to go further, to think through the traditions and norms we still kept.

I took David's last name. I wore a white wedding dress. I deferred to my family's and David's family's wishes for the wedding and reception — my father giving a prayer at the ceremony; my mother want-

ing us to have a cake instead of the pies I'd rather have; his father marrying us in the church he used to pastor. I didn't want to trouble the waters any more than I had simply by falling in love with David.

I was surprised we had pulled off a wedding at all. But after all we'd been through, I was grateful I still had people willing to celebrate with me. Allison, Jane, and Megan all agreed to be my bridesmaids, and even though we had different views on courtship and the role my father played in mine, they were all willing to be there for me.

At the altar, David and I promised to love each other, without mention of obedience or submission. We promised to take care of each other for the rest of our lives.

* * *

Years later, we watch the video recording of our wedding on our anniversary. I can still feel the thrill of excitement, the expectation I had of finally making my dreams come true. The camera didn't capture the moment when I stood alone at the bottom of the stairs leading up to the sanctuary. My father hadn't come to walk with me yet. I had taken a deep breath, knowing that despite all the decorations and ceremony and traditions, it was just me, by myself, making a decision for my own life.

I hadn't wanted a white runner, my one dissent. It seemed archaic and ostentatious to me. We watch the video as my father walked me down the aisle, and I wonder how I managed to hold on to his arm as I walked toward the man I loved. I had called my father abusive, had rebelled against his wishes, and still I let him lead me to the altar. None of us wanted a scene.

I ask David to fast-forward the parts of the video where my father speaks in the ceremony. For too long, he lived in my head, telling me what to do, and it's taken me years to stop the echoes of his voice. I don't want to go back. But I can't erase the fact that he was there. I watch his face in double-time as we skip over his toast at the reception, over the father-daughter dance to "My Girl" — the song I had chosen knowing it was one of his favorites.

Was it all pretend? He had told me he did not think of me as an honoring daughter, as emotionally or even physically pure because David and I kissed before our wedding. And yet he was there. There for the show.

Maybe I was also playing a game — a game I had learned the rules of so young. I knew not to shame my family in public, not to speak out loud what happened behind closed doors. Now that I was out of his house, the yelling had stopped, and I just wanted to move on. I was grateful I hadn't lost my father completely.

When I think about our wedding, I remember the reception tent, on a golf course near Lake Michigan, the sun setting behind us as we toasted to our future. David leading me to the dance floor. The relief as we said goodbye and left for our honeymoon. The warmth of safety, of mutual love, of hope.

HOME

Three days before our wedding, David and I signed the lease on our first apartment off Main Street in a small town in West Michigan. It was the upper half of a hundred-year-old white house. Paint peeled off the doors; the steps outside see-sawed back and forth as if in a life-and-death battle with the slow rot of many thawed winters. Balancing groceries in both hands and climbing up the steps was like doing a high-ropes course, and about once every winter, I'd slip from the top, sliding on my back to the pillowy snowbank at the bottom.

Back on Kaua'i, I had joked with David that I could survive on beans alone if it meant we could be together. He'd laughed and said it wouldn't come to that. But there we were, newlyweds, eating mac-n-cheese on a cardboard box we used as a table. Until we bought a loveseat at a garage sale for ten bucks, the only furniture we owned was an electric piano that was a wedding gift. We slept on a borrowed air mattress, and I would ask David to turn off the glaring ceiling light when we made love.

We kept each other warm those first winters. I had never experienced Midwest cold before: I felt like I was freezing from the inside out. The steam-heat radiator groaned and clicked on the rare occasion that it started up. It sounded like creatures were living in

the pipes, hammering away with tiny mallets. We boiled water on the stove to make a hot bath, like prairie pioneers, because the tap never reached above lukewarm. Outside, lake-effect snow piled up, and we shoveled it into mountains on either side of the driveway. The apartment became a sauna on high summer nights. The one window air conditioner we had sounded like a freight train, its magic cooling never reaching beyond the living room. We'd sleep naked, sheetless, praying for a breeze through the opened window. I got up every few hours in the night to wash off the sweat in a cold shower. In the daylight, the silent streets suffocated under the full green maples, and yet I felt it was a peaceful heat. The kind of heat associated with driving nowhere in particular on a Saturday or stopping for soft-serve from the ice cream shop next to the dollar store down the street.

In our first few months living together, I didn't have a job. I'd wake up at five to make David breakfast and then go back to bed to read the prohibited Harry Potter. I breathed in the lilac bushes and visited the purple-pink hydrangeas in the yard. I rested.

As summer turned to autumn, I listened to the middle school marching band that practiced in the street. Day after day I walked to the library to fill out job applications and look up how to get into college. I wanted to be sure there was a way to afford it before I told David that going to school and becoming a writer were dreams of mine.

We had so many things to figure out, and every day brought new challenges. One night a frightened bat got into the apartment, and we chased it from room to room before catching it where it hid on top of the kitchen cabinet. We waited until every last leaf fell to the ground in November before raking the leaves to the curb. We managed to stuff a Christmas tree into the Honda Civic and put it up in the living room, taking up the entire space. Out in the yard, David tripped over a root after playfully chasing me and snapped his collarbone in half. He passed out, and when he came to, he said he didn't need to go to the hospital. But I took him anyway.

This was our first time on our own, and we learned about the hidden parts of life, the cracks in the wall you don't notice until af-

ter you move in. We listened to muffled sounds of the single father who lived downstairs as he watched TV and yelled at his kids; they moved out in the middle of the night, no notice. Later we heard the new neighbor, who was allergic to electricity, snoring as loud as our air conditioner as she slept under a lead blanket. She was a Jehovah's Witness, and she left brochures about the end times on our doorknob. I tried to talk with her granddaughter whom she homeschooled, but she didn't seem to want to talk when her grandmother and father were around. I sensed something familiar in their self-imposed isolation, but I didn't know how to help.

The neighbors must have heard us too: vacuuming, strumming guitars, laughing about a movie, arguing about hurt feelings, crying, frying eggs before dawn. We all shared this space, stacked on top of each other. The plaster was slowly decaying, the foundation sinking, but David and I put our roots down anyway.

* * *

I thought when I left my parents that I would be able to move on, to finally be happy and live on my own terms. I was free, and I wanted to forget what had happened.

But after only a few months of being married, I started to have panic attacks. They felt like the one I'd had after my father had found out I'd told on him to David's father — like I couldn't breathe, like my heart might stop. But now the anxiety seemed to come out of nowhere. I could be having a good day, and then I'd crumple on the floor hyperventilating.

Sometimes it happened when we had sex, and this scared me. I felt safe with David, so I didn't know why my body was reacting this way, as if it were in danger. David didn't understand what was happening when I shut down, when I collapsed into a fetal position, when I hyper-focused on a crack in the ceiling and left my body. He tried his best to talk me through it, but it was as if I couldn't hear the words he was saying. He learned that the only thing that brought me back was to lie down next to me, gently hold me until I could breathe again.

We couldn't afford health insurance, much less therapy, so I did my best to push through, to ignore the pain I still felt. I started dissociating during sex, going through the motions without feeling anything. It was easier than dealing with the aftermath of another anxiety attack. With the practice I'd had for years, I shut down my emotions, not knowing how to deal with them.

WORK

"Dykema," I heard him grumble through the receiver. I recognized his voice: a disgruntled old man I'd seen in the bakery before, now placing a call-in order for two loaves of raisin bread, no cinnamon.

"Can you spell that, please?" I asked politely, pen in hand.

"It's a common name!" Dykema. A common name — in one county in one state in America. D-y-k-e-m-a. Even though David had the longest Dutch surname I'd ever seen, I still had to practice my spelling.

I hung up the phone and set aside two sliced raisin loaves, the sugar sticking to the plastic bags. I knew it wouldn't be long before Mr. Dykema marched in, demanding his bread after shrieking, "Konnichiwa" at me. Every day, it was the same. He had fought in World War II, which meant he knew one Japanese word and wanted everyone else to know it. I'd learned to avoid eye contact, count his change quickly, and not respond to his prodding. But I had also learned that I could give him day-old bread and he wouldn't know the difference.

The Dutch community in West Michigan has managed to squeeze a nation-sized ego into a few small towns huddled next to the lakeshore. Being blunt is a virtue here. David's grandfather would often say, "If you ain't Dutch, you ain't much."

Once I replied, "But I'm not Dutch, Opa," only to be rebuked with: "Well, you are now!"

For months I had applied to every entry-level job within twenty miles that I thought I could handle. Finally, I'd managed to get hired at this little hole-in-the-wall bakery down the street from our apartment. I suspected the "church pianist" entry on my meager resume had given me an edge. Like many of the Dutch descendants in West Michigan, the bakery owner was old-fashioned Christian Reformed. The shop was closed on Sundays and employee tasks were strictly gender-designated.

As one of the Ladies — all married women — my job began at five or six in the morning: as I stepped from the still-dark parking lot through the back door, a wave of heat from the walk-in oven hit my face. It smelled like burned sugar and hot grease. The Bakers — all men, but never called the Men — had been there since the early morning hours making the traditional assortment of breads and pastries.

I would get to work boxing donuts, slicing bread, and placating irritable customers who wanted print and not cursive writing on their cakes. Soon, smeared chocolate from the donuts would stain my crisp white apron and it would already feel like a long day. While the line of customers grew and the sun lit up the street, the Bakers would pull the last donuts from the hot fryer and wipe down the giant wooden table in the back. They stacked person-sized bags of flour and tubs of cherry filling, each weighing about fifty pounds. The Bakers' night shift was almost over, and they would go home for a few hours' sleep before coming back to proof dough and grease cake pans. Later, when school would let out in the afternoon, the Girls — mostly blond teenagers — would come in to take over the counter and wash the iron trays sticky with frosting.

I loved being able to work and what it meant for me: a paycheck written to my name and the freedom to spend it on anything from piercings to tattoos to rock concerts. But I felt too old to do anything my parents would have deemed rebellious, and yet perpetually behind other people my age. I paid rent and budgeted for

groceries. I would drive the shopping cart through the aisles at the Aldi as if I owned them. The desire for ownership drove me, a desire to own myself and my life.

I enjoyed filling out my timesheet, putting on my baseball cap to cover my hair, and feeling my independence. I got to know my co-workers, mostly retirement-age women who wanted to make some "egg money." We gossiped about people who lived in town, and it seemed like everyone knew each other. The other women could always figure out who someone was by making connections based on their last name. They called this Dutch Bingo.

But the bakery's strict gender roles were too familiar to me: the women wore aprons and provided a pretty face to the public, while the men did the heavy lifting. I knew how the system worked. I had been taught that limitations on women were a good thing, that they were a protection. But I realized that I hadn't felt protected so much as trapped.

* * *

Allison's first job had been at a Dutch bakery too, back in Colorado. I had visited her once during the brief time she'd been allowed to work there. It was a quiet storefront with greenish murky light leaking through the windows. Clean aluminum counters gleamed in the back. She showed me how she frosted cakes on a spinning plate. She had a *job*, and she was good at it.

Later, after she had almost eloped with her coworker, my father had said it was a mistake to let her work there, to let her have a job. When Allison had come home instead of getting married, she was forbidden from working again. She was quiet after that, sewing quilts most of the day in a one-window closet she called the Sewing Room. Forgiven and compliant. Maybe the threat of losing her family had been too much for her. Now I knew the feeling.

* * *

I grew tired of the nine-hour shifts with no breaks, the minimum wage that barely paid my bills, the customers with their sugar anx-

ieties. I wanted more than eleven-cent tips in a jar we were not allowed to label "Tips." I was insulted by the sign on the ancient freezer in the back that said, "No Ladies Allowed," implying we were not strong enough to close the broken door correctly (when the men weren't around, we used it anyway). I noted how it seemed like management disregarded applications if they were from the wrong gender. I learned to decorate cakes to try to get a promotion, but I heard that my boss was afraid I might get pregnant.

I had imagined that I was leaving patriarchy behind me, that this new world would accept me and let me heal, but it didn't take me long to realize that this world wasn't new at all, that the confines I'd grown up with hadn't disappeared, only expanded.

RACHEL

Devoted
By Jennifer Mathieu

> *Now I know I haven't just left because I was afraid. I've cho-*
> *sen—with my whole heart—not to follow the rules anymore.*
> *That's why I'm not coming back. That's the truth of all of this.*[36]

Synopsis: Rachel Walker is like me. She's good at hiding things. She's
homeschooled and she goes to church with her family, cooks dinner,
cleans house, wears modest clothing: all in preparation to be a wife
and mother one day. She submits. But she also reads. She reads things
she's not supposed to, like *A Wrinkle in Time* and a blog written by a
girl who left the church. When she starts emailing the girl, she dreams
of a world kept from her. She imagines a narrative in which women wear
bikinis to the beach and don't have to get married at eighteen and don't
have to devote their lives to childbirth and children, where women can
choose their own paths. A world that isn't black and white but colorful.
A world of opportunities with no need to ask permission. But when her
father reads her emails, troubled by her rebelliousness, he gives her two
options: go to Journey of Faith, which is a camp for troubled youth (read:
brainwashing), or move out and never come back. Given her father's
ultimatum, Rachel must make the most difficult choice of her life.

I wasn't the only one to leave the Christian patriarchy movement. I was joining a scattered group of outcasts who felt like we belonged nowhere. We read each other's stories on the internet, in virtual forums like Homeschoolers Anonymous (a kind of therapy), but I still felt lost in the world I'd never really known. I laughed at jokes I didn't understand and nodded at pop-culture references I didn't get. Even though I was out, I still worried I was living the wrong story. I felt guilty for breaking away from the path set before me. I felt shame for feeling shame. I worried God with my questions. When people asked about my past, I only let slip a few key details: not allowed to date, not allowed to get a job, not allowed to go to college, not allowed, not allowed, not allowed. They responded with attempts at categorization. One asked, "Amish?"; another exclaimed, "Kimmy Schmidt!"

When I first heard of *Devoted*, I was afraid the author had written it out of a fascination with the fringe. But once I read it, I realized she'd written it out of compassion and empathy, not out of a need to other the victims of fundamentalist religion. So much of this book is true to my experience, and I felt unable to express how grateful I was to have this story told.

When I met the author at a writer's conference, three years after leaving, I heard her speak about how she'd written the book, interviewing women like me who'd left home, whose parents didn't talk to them anymore. I stood in line waiting to meet her at the book signing. I stammered a few words about how I'd never read any book where I had felt so seen. I told her how much it meant to me. And she stepped around the table, and she put her arms around me as I cried, and she told me that I did belong in the world, and I knew, finally, that it was okay to talk about the story I wished I hadn't lived.

* * *

We were stay-at-home daughters, but we didn't stay at home forever. Some of us escaped.

We became voices on the internet, peeling back the skins of our sheltered lives and scooping out the beating hearts of our stories. We support each other with the telling of our lives, exposing the dark, making known what had always been kept hidden, hushed in the night. We are beginning again. Some of us are married, some divorced. We share memories of a time when life seemed simpler. We share the knowledge that nothing was as it seemed.

It was like living in a dream, being sedated by the weaving of words, half-truths, total lies. Some of us have woken up from the dreams, the hallucinations, only to suffer paralysis or night terrors. We do not always know the names of our emotions. We don't know how to wake the others up.

ESSAY

I walked into a room submerged in the blue light of a January morning. The desks felt small, cramped.

I'd had to write my own high school transcripts from memory to apply to community college since my parents hadn't thought to keep records of my education. College hadn't been an option since I was supposed to be only a wife and mother.

My first class was a writing class. Composition. I wanted to learn how to compose my thoughts into words, to make meaning of my life. The teacher passed out something she called a syllabus. It had the schedule for the semester and all the writing assignments and how our grades would be calculated. We were to write four essays across fifteen weeks. I'd never written an essay before, but I was determined to figure it out.

The first assignment was to write a personal essay. I wrote the only thing I could think to write: the story of my family, how I left, and how I was starting my life over.

In class, I brought my draft, proud of writing these three pages of truth. But then the professor asked us to read our essays out loud, and I cringed. I wanted to run again, but I forced myself to stay seated. My workshop group was made of all men. And this shouldn't have mattered, but it did to me. I doubted they would care or understand my story. But eyes down, voice shaky, I read my essay, and they listened.

DAUGHTER

I remember peanut butter and jelly on whole wheat bread pulled out of brown-paper bags. A golden autumn day. Rush Limbaugh on the radio.

My father liked to take lunch breaks in his car. He'd drive to a peaceful spot by the river, close his eyes, and rest before heading back to the office in downtown Wilmington for the rest of the afternoon.

This time I was with him. I was ten years old, and even though we had just moved to Colorado a few months before, my father had kept his job and was commuting back and forth to Delaware for work every ten days until our house was built and he could start his own business full time. He stayed in his sister's spare bedroom to save money.

I had felt upset, disoriented, unstable. We were living in a small apartment in Colorado Springs, and I missed my friends from our old church; I missed the feeling of familiarity. My parents noticed when I started shutting down, crying when my father would leave to go back to his job. So this time, he took me with him on his work trip. Just me and him. I spent the daytime in the office with him, stuffing advertising envelopes or coloring in the black-and-white architectural drawings my dad printed out for me. In the evenings, I played Monopoly with my aunt.

But mostly I remember our lunch breaks down by the river. How I felt special sitting next to him, sharing a view, eating sandwiches together. This is how I want to remember my father, in that moment of peace. A time when we got along.

At the same time, I can't forget the abrasive tones of Limbaugh shouting out of the speakers. I don't remember what the topic was or whether my father explained any of it to me. But the radio voice almost felt like an extension of my father's. The ranting about "them," the rage, the belittling, the name calling. It felt connected and familiar. Enough that I almost didn't pay attention.

* * *

I've always been told I take after my father. As a child I always felt a special connection with him. We had the same sense of humor, or maybe I was just imitating him. I hated when my siblings said I was his favorite, and at the same time, I loved it.

All daughters are supposed to stay at home while they grow up, go to school, go through puberty, figure out what they love and what they want to do with their lives. All daughters are supposed to feel protected at home, safe until they're ready to brave the world on their own. All daughters are dreamers, and all daughters are supposed to follow their dreams.

All daughters should be loved.

My father has always said he loves me. But I think we have different definitions of love.

* * *

I was taught that patriarchy is the most loving way to live because it protects women from the evil of the world.

In patriarchy, I would never have to work a job because I would be provided for by the men. I would never have to go to war because men were called to be the aggressors. I would be encouraged in my gentleness and femininity, given the opportunity to spend all my time making a home, raising children, creating beauty with music, bringing the softness that the male world needs. Staying

home would be hard because kingdom work requires sacrifice. It would require great patience, long-suffering, the pains of birth, the exhaustion of childrearing. But these were the pursuits God gave women. We should not complain. We are in loving hands.

* * *

The truth is patriarchy forces conformity. It relies on hierarchy and oppression to survive. The men at the top benefit, and everyone else is left trying to get close to power. The enablers are often girls and women who unknowingly believe their safety relies on obeying the rules that a society made by men has created for them, rules of behavior and clothing, of outward appearances. We teach each other how to behave.

At church: One Easter when I was a child, I dressed up in my finest (wide-brimmed hat, white gloves, Mary Janes). I felt pretty and special, like I fit in with the lilies in the sanctuary. Then after the service, my friend asked me in a sarcastic British accent, "Are you off to visit the Queen?" My mother said that just meant she was jealous, and I learned that as girls we compete for attention, for good looks, for beauty and compliments. But looking like you're competing is unacceptable.

At swim lessons: I struggled to pull myself out of the swimming pool, my weak arms leveraging my adolescent body high enough to stick an awkward leg onto the concrete so I could roll out. The water felt heavy, my body wanting to sink. One of the girls in the class said I looked like a beached whale. I pictured a giant blob dying on the hot sand, too fat to save itself. I believed my body deserved policing, that I was too clumsy, too chubby, to make a show of myself.

At home: The granddaughter of a neighbor came over to our house, and even though she was my age, thirteen, I didn't know how to entertain her. She wore makeup and nail polish, things I wasn't allowed to have. She asked me where I got my shorts, and it didn't feel like a compliment. I was wearing knee-length purple denim shorts my mother had bought for me at Goodwill, and I suddenly realized how terrible they were. I had never picked out clothes in

the store for myself, and now that I had outgrown the frilly pink dresses of my childhood, I didn't know the first thing about fashion. I realized I needed to dress in style, to be feminine to fit in.

On the homeschool girls' basketball team: We never played any real games because we were just in a co-op, not in a real league. My father was the coach. Once during scrimmage, another girl said I was playing too aggressively. I remember playing defense, my arms wide as I bounced around the player with the ball, just as I had watched the 76ers do on TV. But we weren't in the NBA, and I learned that even in sports, I couldn't be too strong or too hard on the other girls if I wanted to be liked.

The system of patriarchy thrives when we hold each other back.

* * *

The women in the church said I was a good daughter. They said I would make a good wife one day. Maybe I would even marry a pastor, or a missionary.

I stopped being a good daughter when I decided to push back against the rules my father made. I was only accepted when I obeyed.

But obedience was never enough. Obedience didn't stop the depression. Obedience didn't stop me from imagining ways to kill myself. Obedience didn't heal heartbreak.

* * *

I am a child, wobbling on my pink-and-white bicycle with the tassels hanging off the handlebars. My first time without training wheels. My father clings to the bike as I ride down the hill, holding on to me for as long as he can. Until the momentum pulls me away.

* * *

We are gravediggers, my family. We bury our truth and pretend it doesn't haunt us. At my paternal grandfather's funeral when I was little, my father told a story about how his family would go boating on the Chesapeake Bay every weekend in the summer. They weren't

very religious, but the water was their church. They'd commune silently over bologna sandwiches and offer fishing lines to the sea gods, while his mom would suffer the purgatory of the cabin below, seasick and wailing. My grandfather would call my father his first mate, letting him steer the boat through the estuary.

We don't talk about our deepest wounds at funerals. We hope they will disappear with the coffin.

My father didn't mention my grandfather's anger or how he would tie his kids to trees if they were misbehaving or how he never talked about his time in the navy during World War II. My father wanted to remember those sunlit mornings out on the water. Whatever resentment he might have felt, he buried it.

My father's inheritance was a Japanese rifle from the war. My grandfather never said how he got it.

* * *

I have been tempted to bury my anger, but it rises up anyway. I have felt resentment for not being loved the way I needed to be loved. The disconnect from father to child has become an inherited loss, a cycle passed down the generations.

* * *

When I visited my parents a few years after my wedding, I still had hope that my father and I could have a relationship. I pushed through my anxiety, detached, dissociated, promised myself the trip would be short.

They had moved back to Colorado, back to the old house in Divide that they had rented out while they were in Hawai'i, and my father went back to being self-employed. They were empty nesters now that Chris had moved to Massachusetts to go to college.

David went with me, and when we arrived, my mother greeted us with food, my father with a smile. Maybe we could get through this.

But my father didn't look me in the eyes. He asked David questions about his job and talked about his own work. The minutes moved slowly, and he never asked me about my job, about what

I did with my days now that I was not a stay-at-home daughter, now that I wasn't a stay-at-home wife. During dinner, I mentioned that I was enjoying my college classes. I had graduated community college and was planning on going to a writing program at Michigan State. My father said, "We weren't perfect parents, but at least we gave you a good foundation." As if it were his accomplishment instead of mine.

My parents pulled out photographs from when I was a child, pictures David had never seen. My father spread them out on the hardwood floor by the wood stove. Me roller-skating, armored in knee pads and elbow guards and helmet. Me with bangs and ballet shoes. Me wearing a straw hat I'd decorated with ribbons and an American flag for the Fourth of July.

My father had a soft look in his eyes as he gazed at these snapshots of my younger self, almost as if twenty years hadn't passed. He still avoided eye contact with me. And I realized he couldn't see me, not really. Instead of a woman in her late twenties, hiding her posttraumatic stress disorder (PTSD) symptoms and pretending everything would be okay, he could only remember the eight-year-old girl who always seemed to have scabbed knees. He could only see something innocent. He could only see the promise of his child trained in the way he wanted her to go, the child who had departed.

I watched him looking at the photos and realized I was not what he had wanted. I could never live up to his expectations. And I didn't want to try anymore.

* * *

My parents took us to visit the Florissant Fossil Beds near their home. On the way, we stopped to have coffee with Heather's mother, our old neighbor. Heather was married and had a child already. Her mother welcomed us with hugs as we sat down to catch up in the room where Heather and I used to watch PBS at lunchtime. She told us a story about her church, talking about women in leadership in a way I knew my father disagreed with. She talked about God like she had direct access to him outside of a man's me-

diation. My father's face wrinkled into a frown; he sat back and grew silent. I watched as my mother kept the conversation going so that Heather's mom didn't notice — something I'd watched her do countless times over the years, softening any sign of inflexibility.

"We better get going," my father said, and he herded us back outside to drive us to Florissant. I left my half-finished coffee in the kitchen.

I could feel the tension in the car; it triggered so many memories. How my father stonewalled whenever someone spoke against his own beliefs. How my mother tried to make small talk to cover up his silence. I felt like I would break down if I didn't get out of the car soon. It was all too much, too soon, and I didn't know how to navigate this now that I had moved on with my life.

At the fossil beds, I went on a walk with David, leaving my parents to look at the exhibits in the museum. My heart was racing, but David held my hand as we walked along the snowy path while I tried to calm down.

We photographed the fossilized redwood stumps, read the plaques out by the frozen fields, learned about the geology of this place so near the area I'd grown up. I was reminded of what I'd learned at college — how the planet is alive, always shifting and changing. How life has evolved out of the Earth.

I could imagine the ancient past: The volcanoes coming alive, sparking, bleeding melted rock. Mudslides flowing with the force of an avalanche, decimating everything in their paths, everything except the giant redwoods. Mud wrapped around the trunks, cementing the roots to the earth. Over millions of years, the trees decayed and vanished, only the stumps remaining. What was once alive, veins pumping sap, had become fossilized stone. Mineral replaced organic, and the trees had become statues. An image of the past, but not the past itself. The mud had moved on, stopping up the freshwater streams, creating a lake in the valley. Fish swam and died and became stones in the mud. One day, the lake dried up, and the mud became fields. People walked here and called it Florissant, meaning "flowering." Blue flax and fireweed bloomed out of ash.

I look back and trace the debris of our past, solidified like layers of rock. I contemplate interactions with my father and wonder, *Is there a line between loving and manipulating?* I talk with my siblings, and we try to piece it together. We find laughter because we're tired of crying.

He was a reader of our diaries, a listener to our phone calls. He controlled every aspect of our lives. He'd found a home in the Christian patriarchy movement because it justified this control. Perhaps authoritarianism was the outcome of his own anxiety or insecurity. Maybe he would have joined any group if it meant he could be in charge.

* * *

I only have one framed picture of my family all together, only one with my father. It is a frame I made in Vacation Bible School: tiny seashells glued to popsicle sticks. The photo is of all of us, circa 1995, standing on the porch of that summer cabin in Upstate New York.

I hide the photo from myself. Sometimes I find it in a corner of the bookshelf, or in a pile of other bits of nostalgia.

When the picture surfaces every few years, I spend a few moments with it, like it's a religious icon pointing me to God. Maybe I can find the beginning of us. If I look long enough, maybe I can trace where the breaking started, where we began to rift apart.

In the center of the picture is my mother holding my little brother, who seems unsure of what we are all looking at. My mother is wearing her signature flats and smiling, pressing her cheek against my brother's. My sister stands just to her left. Her mouth is cracked open in a half smile, and her eyes look a little away from the camera lens. A foot away from her, my older brother stands straight, as if he is trying to look taller. He is standing so far from my sister that there is a crevice of air between them, between him and the rest of the family. He's already pulling away.

I am standing on my mother's right side, wearing a Minnie Mouse T-shirt and pink jelly shoes with white socks. I am also trying to stand tall, but the weight of my father's hand on my shoulder is visible in how my head tilts over. Six feet tall, he is standing behind me, one hand on me, one on my mother. His face is slightly obscured inside the shadow of the porch, but I can see the glare of his glasses, the flash of his teeth.

A picture is a lie, I tell myself. It is a moment picked out of time, and we make it into a memory.

Yet I can't help but think of us, clustered on the porch, the forces pulling us together, and those that would eventually tear us apart. My mother is centered in the sunlight, but my father is the one who draws my attention as I search his face for malice, for any ill will in his eyes. Had I just missed it before?

I can find none. I see a father happy to be on vacation, ready to take his kids canoeing or to the ice cream stand. I see a family with teenagers who aren't sure of themselves yet, with children who haven't yet discovered life's darkness.

But again, a picture is a lie, I say. And this moment on the deck of a small cabin on a lake in the forest is a moment I don't remember. So I focus on the shadow that starts in the background covering my father, slowly inching over each of us. The shadow I remember.

Sometimes I think maybe my father also has photos he hides from himself only to find later, photos to study in hopes of finding the moment when it all fell apart.

* * *

I can't choose to remember only the shadow or the light. Both colored my childhood. And so I rehearse as many good times with my father as I can.

The time we flew a kite together in Brandywine Park.

All the weekend afternoons he'd take me to see half-constructed houses he had helped work on. The smell of sawdust and drywall. His hand helping me up the stairs when there weren't any railings.

How we started to build a dollhouse together but never finished the roof or the walls or the paint.

How he taught me how to color in the lines in my coloring book.

And I can never forget how I felt like his first mate when we spent summers at the lake. A forest surrounded the dark water, and the air was thick with mosquitos. My dad would lift me into the canoe with him, then push us off from the dock. I remember being afraid of tipping over into the murky lake, but somehow he'd right the canoe with the paddle, and for a moment, we'd hover in perfect balance before the swaying uncertainty returned.

VOICES

"Since the woman was created as a helper to her husband, as the bearer of children, and as a 'keeper at home,' the God-ordained and proper sphere of dominion for a wife is the household."

— "The Tenets of Biblical Patriarchy"[37]

"Women inescapably need godly masculine protection against ungodly masculine harassment; women who refuse protection from their fathers and husbands must seek it from the police. But women who genuinely insist on 'no masculine protection' are really women who tacitly agree on the propriety of rape."

— Doug Wilson, *Her Hand in Marriage*[38]

"Motherhood is the only career that lasts for eternity. Don't waste your life on things that you will leave behind."

— Nancy Campbell, Above Rubies, Facebook post[39]

"In Proverbs 31, we can see from the way this woman's family responds to her that all of her work, all of her buying, selling, and trading, was a direct blessing to them. . . . They aren't all at home fending for themselves while mom is off on another business trip or living her dreams in the corporate world. They didn't rise up in the city gates to say, 'Well we are all really glad that she was able to fulfill herself and follow her dreams.' The Proverbs 31 woman is an impressive, hard-working, high-achieving, high-earning woman — but it is all aimed at *her people.*"

— Rebekah Merkle, *Eve in Exile*[40]

"If you want to teach the world how the church submits to the Lord, become a wife who submits to her husband."

— Voddie Baucham,
*What He Must Be . . . If He Wants
to Marry My Daughter*[41]

"An excellent wife who can find? She is far more precious than jewels."

— Proverbs 31:10 (ESV)

VIRTUE

A virtuous woman, who can find one?
Look at her there, she is valuable as money,
she has a husband but really her husband has her,
she never talks back, bites back, fights back,
she gives him all her days,
her hands never stop with the sewing and the cooking and
 the cleaning,
she doesn't need sleep, she can sleep when she's dead,
she has knotted arms from kneading bread,
she works for little to no pay,
her change she gives on the streets, and anyway
she wouldn't know what to buy for herself,
she wears thrift-store dresses and baggy jeans and
small-business-branded T-shirts and knee-length cargo
 shorts and
button-down blouses and soft loose cardigans and
never lets her bra strap show,
see she can stay awake on another pot of coffee,
worry worry as winter comes, making sure all the kids have
 coats that fit,
she can recite the Scriptures like the ingredients for
 Ezekiel bread,

morning, noon, and night she is with the children,
saying the catechism, repeating the questions and answers
 prepared by the ancestors,
running it deep in their neural pathways, singing the words if
 it helps,
but time is always getting away and she doesn't have time
 to eat,
what with the children hungry and the husband hungry
and the animals hungry and the garden hungry and God
hungry, always hungry for her every thought and prayer,
and her husband sits over there in the gate with the guys,
calling to the other women passing by,
laughing it up with the boys,
getting home late,
telling her she's the prettiest, though, in case she was worried,
she doesn't have to worry, he says,
and her children call her blessed for a short while but then
they run away or move out or marry young,
and she ages like berries growing green, ripening, and falling
 to the ground,
and her beauty turns gray,
and her fruit disappears
as she has fewer coats to mend
and fewer mouths to fill
and barely any dirt on the floors,
and she is left with all the thoughts and dreams and desires and
fantasies and false hopes that she started with and never
 could say.

I told you to look at her, but really, you're not supposed to.
She is made to quietly serve,
sacrifice, submit, stay home.

UNEARTHING

I thought the panic attacks would stop over time on their own, but they always seemed to lurk at the edges of my life — demanding I pay attention. The anxiety would strike when I wasn't expecting it — at church, after a mild argument with David. I thought I would heal if I pretended everything would be fine.

One Thanksgiving, as I was nearing my college graduation for my bachelor's degree, we decided to visit my parents again. I had been writing my creative thesis about my childhood, and I was understanding more how I had been impacted by my experiences. After the stress of feeling trapped with my parents at our last visit, I decided I didn't want to stay overnight in their house. Being away at night helped, but I felt pressure build over the two days we were there. I was a tunnel of lava trying to find a vent. I kept calm and lied to myself that everything was fine. But being around my father was becoming more difficult. I noticed the ways he talked to my mother, his sense of superiority, of being the wisest one in the room. I noticed little manipulations, the small ways he took control over every situation or conversation.

When we finally left, he hugged me and kissed my neck, and I was instantly transported to when he had threatened that he wouldn't walk me down the aisle at my wedding, how he'd later

said he didn't mean it, how I felt him try to control my emotions, how he'd wanted to control who could touch me, as if he owned me. It was as if the past and the present were happening at the same time, and my fight-or-flight was kicking in. I needed to get away.

When I got in the car, my whole body was on fire. My vision narrowed, my lungs emptied, my stomach cramped. I couldn't breathe. Something was killing me.

I curled up in my seat, the seat belt choking me. David drove us to a parking lot, and he held me until I remembered who I was. I wasn't that trapped girl anymore. I was free. My father could no longer control me.

* * *

The last time my father contacted me directly was in 2019, my first summer out of college. I was interning at a local publishing house, trying to start a career as an editor.

Writing had become a way for me to express myself and take control over my own story. I had written blog posts under a pseudonym about abuse. I was interviewed by the *Christian Post* about my experience with purity culture and patriarchy. I was tired of silence, ready to speak out about what had happened to me, what it was like for girls like me to grow up in a world where we didn't have personal agency.

I was careful about what I said: I never used my father's name, never tried to direct hate toward him, but only tell my perspective of the past. I felt I had the right to tell my story.

But then he texted me in the middle of the night. Text after text after text rolled in. He had found my pseudonym on the internet, which meant he had been searching for me, watching my every move online. He didn't have his own social media profiles, so it was strange that he had found me out. On Father's Day, I had posted on Twitter about why I didn't send my father a card, how I didn't know how to make small talk anymore when he wouldn't admit to anything he'd done wrong.

This was what he was upset about. He texted me that he didn't know I felt that way. He told me he was disappointed in me, that

it was bothering him. He flipped back and forth between saying he had always loved me and that I shouldn't have said what I said, that he'd done the best he could, that he wanted to follow God's word, that I'd hurt him. His last text said he wanted to move on with his life.

I didn't respond for a few weeks. I had worked so hard to find my way out of an abusive situation, and now I felt alone and sad and furious and anxious. I felt guilt too — should I not have said that? Was he really that hurt? But then I reread the texts again and realized he never apologized or admitted wrongdoing. He only said he was sorry that I saw him as abusive.

I had been talking with a therapist through a virtual app, and she helped me think through what I wanted to do. I wanted to respond in the best way I could. So I wrote him a letter and emailed it.

Dad,

I got your texts. I had been thinking about telling you about what I'm writing about, but I honestly didn't think it would make a difference. I didn't think you would respond with an open heart or with listening or be able to step outside yourself to see my point of view. I didn't want to upset you needlessly by bringing it up, and I didn't expect you to dig through my Twitter account.

I have a hard time understanding why you would say you didn't know I felt this way. I vividly remember the last few months to last few years I lived in your house and all the fights we had. I remember you coming into my room unasked, yelling at me that I was a rebellious feminist. I remember you chasing me up the street when I was trying to get away from you. I remember sharing an article with you about emotional abuse and I remember how you dismissed it. I was trying to tell you how I felt for years, but you never truly listened.

So no, I didn't think I needed to tell you how I felt before writing about my own life and my own experience. I don't know what you think happened back then, but the way I remember it, you tried to keep me from having a relationship with David

beyond "friendship." You shamed me for having "feelings." You tried to control every move I made, even though I was beyond ready to make my own decisions. You kept me from getting a job (I never wanted to teach piano, but it was the only thing I was allowed to do) or from getting an education (the time you mentioned a couple of classes at junior college doesn't count because it wouldn't have been my choice). I was twenty-four years old, but you treated me like I was thirteen.

I don't need to share with you how these traumatic experiences have affected me over the years, but I have made progress, and to your comment, I have found what I'm looking for. What I was looking for was freedom to be my own person. In the past few years, I have worked my own way through college to get a degree in writing. I have worked lots of jobs that I never thought I could do. I have met so many people from so many backgrounds who have shown me how beautiful and complex this world really is. I have grown from seeing the world as black and white, to understanding that I don't have all the answers. And I have found God's grace and unconditional love, even when I make mistakes.

I realize you're not sorry for how you treated me because you believe you did nothing wrong. That somehow chasing your adult daughter down the street and triggering her first panic attacks and keeping her from pursuing her own life was righteous in God's eyes.

But I forgive you anyway. I'm not chained down by what happened anymore. I have a lot of anxiety when I see you, and I struggle to know how to talk to you anymore, but that doesn't mean I can't forgive you.

But the relationship we had was broken. I have always loved you, and I believe you when you say you love me. But that doesn't mean you were always right, and it doesn't excuse how you treated me. It would mean so much to me if you could even just acknowledge what happened. Since I moved out, it has felt like you want to pretend like we are all good, that we could just go back to having a relationship. But you can't do that without rec-

onciliation. And you can't have reconciliation unless both people are willing to listen, to acknowledge wrong, to change. Would you be willing to do that?

I know that everyone goes through difficult times in their lives, and that you and I are not necessarily unique in our experience. I also believe that wounds can be healed and relationships can be restored — but it takes a lot of work. But I believe it's the only work that matters. That Jesus came for reconciliation, for grace, for forgiveness. He didn't dismiss sin, but he helped people find redemption.

As for moving forward, I have certain boundaries I need so I can heal. I'd appreciate it if you didn't text me in the middle of the night, which is disruptive to my life. I'm not writing this letter as an invitation to debate about what happened when our relationship broke apart. I don't want to discuss these things with you further unless you are willing to acknowledge what happened, take responsibility, and work to change, which means respecting me as an adult. I found the wording in your texts to be emotionally manipulative, making you out to be a victim. This is not what an open conversation looks like. I know I don't have control over this, but it feels like an invasion of privacy (even though I'm aware my Twitter page is public) for you to read my Twitter page in order to quote my words back to guilt-trip me. What I say in public is about me, not about you.

As for my writing, I have learned through years of study to keep my writing in my own perspective. I have no right to judge you or write your story for you. But I do have a right to tell about my own experience, and I don't need your permission to do that. But I do promise to always write with compassion, with openness, and with honesty.

My father never replied.

* * *

187

For years, the nightmare returned countless times in different shapes after I left home. Always, I was running through a dark house, different every time. The halls morphed and shifted as I struggled to find the exit. Always, my parents were a few steps behind me, keeping me inside. I told my therapist it was so obvious, so simple; I understood now that I had been trapped, that I had to survive, but I was out now, so why did I still have the dream?

She is a practitioner of eye movement desensitization and reprocessing (EMDR) therapy, and we spent sessions diving into the memories that felt more like present experiences. I held a buzzer in each hand, closed my eyes, and followed her prompts as my mind walked through the memories, jumped to seemingly unrelated memories, and returned to the one that was stabbing me. I was making meaning from the fragments. I was letting go. After a few months, I realized I hadn't had the nightmare in a while. Maybe something was healing over.

* * *

I wanted to create an image that felt like the liberation I was striving for. Using Photoshop, I designed a picture of a bird flying out of a cage. I put a quote from *Jane Eyre* at the bottom: "I am no bird; and no net ensnares me; I am a free human being with an independent will."[42]

I printed out a copy for me and one for my sister. Allison had apologized for getting upset with me when I'd gotten engaged to David. She had survived an abusive marriage, had found freedom through divorce, and had fought for and won the custody of her children. She was working to make a new life for her family, and I wanted us both to celebrate. I didn't know if either of us felt free yet. But I knew we both wanted it, more than ever before.

* * *

When we had been married for eight years, after both of our families moved back to the continental US, David and I traveled back to Hawai'i. We said we would make new memories. We visited

the golf course where we used to take secret walks, the trails we'd hiked with our siblings, the ice cream shop, the hidden path to Shipwreck Beach. We remembered all the beautiful moments we had created amid the chaos of the early days of our relationship, when we were struggling to find our own way. And now we were free to be together.

On one of our last days, we spent a few quiet hours on Anini Beach. The sun was shining, but I had remembered the beach most in the rain of winter, the times I'd spent here with Will and then alone, thinking I would be broken forever. The waves were crashing in the distance at the edge of the reef, and I wondered how much of it was left, how much of the coral was dying now with the ocean temperature rising. The water lapped gently on the beach, but I could hear the roar of the waves far away, and I knew I would never be closer to it.

* * *

I hold these new memories close when David and I travel to North Carolina for my grandfather's funeral, my mother's father. I know my dad will be there, and it has been nearly four years since I've seen him, since that awful Thanksgiving. He hasn't spoken to me in three. But I decide that I have a right to be part of this family gathering, that I need to grieve with my family.

I knew I would have to see him at some point. I've prepared mentally and emotionally, but I'm still not sure how my body will react to being in his presence again. Would I run, scream, spit, pass out, laugh, cry, fall over?

David drives us up the dusty road to Grandpa's farmhouse, past the pond. I look for alligators, but all I see is a turtle perched on a rock. When we get to the end of the drive, I see one of my aunts and a cousin sitting out on the porch. I give them hugs, and then my mother walks out the front door, followed by my father. I see her red eyes; I feel her tiredness from sleepless nights watching over Grandpa in his last few days. Light fractures through the leaves of the cypresses.

I can barely look at my father: gray hair, beard, slumped shoulders. He is in his sixties now. I avoid his eyes. I hug my mother, notice her nervous smile. In my peripheral vision I see David stretch out a hand for a shake, only for my father to pull him into a hug. Then I sense my father triangulate toward me, my back toward the porch. No escape. I can feel everyone watching. Whether he's conscious of it or not, I feel manipulated to interact with him. To pretend like he hasn't cut me off for years.

"How are you?" he says.

"Good," I say.

He moves toward me, arms out, and the words I practiced saying disappear, my voice frozen. *I don't want a hug. I don't want to be touched.*

His arms reach toward me, and I hold out my hands with my palms facing him, and I turn my face away slightly.

My meaning is clear: *Don't get any closer.* I worry that if he gets any nearer, my resolution will cave and I will give in.

But his arms go down. He backs away like a receding wave. I am the rock on the shore. I am on the other side of the rift.

"How are you?" he repeats, quieter.

"I'm good."

And at last, I am.

WILDERNESS

One of my earliest memories is peeling the paper wrappers off my crayons because I didn't like the way they felt. The roughness of the paper, how it tore apart. I wanted the shiny smooth color underneath.

Sometimes I feel like a muddle of diagnoses. Chronic migraine. Hypoglycemia. The first time I visited the doctor after moving to Michigan, she added "generalized anxiety disorder" on my chart without notifying me.

Years later when I could afford a therapist, I started a new list of diagnoses. My therapist added PTSD to my record. Months later, OCD. A year in, we started talking about my sensory processing issues.

* * *

When I was very small, my friend's mother died in her car in the garage of her own home from carbon monoxide poisoning. My own mother told me this very quietly, although I was too little to understand what death was. Before this, I didn't know anyone who had died. All I knew was that flowers wilted after you picked them. All I knew was "Your dad's going to kill me" — the words of my mother who worried she would get in trouble for going over budget at the store.

When my friend's mother died, my own mother said, "She fell asleep. She was so tired that she forgot to turn the car off." I pictured gray smoke and heard the loud rumble of an engine. I could feel the concrete barrenness of a garage when you're there all alone. The flicker of a naked bulb, the threat of spiders in the dark cobwebbed corners. I couldn't understand why she wasn't able to stay awake enough to go inside. I couldn't understand why she didn't fall asleep in bed.

My mother did not use the word *suicide*.

* * *

I have always thought about death and existence in a distanced, abstract way. I used to lie awake as a child and wonder if we were all toys in a giant dollhouse. Was God the grand puppet master, moving us room to room, day to day?

* * *

The more I learn about my present self, the more I unbury my former selves: the child who loved to follow the rules, the friend who hid in her room when the other kids were playing too loudly, the teenager who made prayer lists to read through every morning.

But this unburying feels like a death more than a resurrection. As if I had buried myself alive, and I am digging it all up just to have one last breath.

I do not know if a diagnosis of any kind will save me from myself. I sometimes wish that diagnoses came as certificates I could hang proudly on the wall, no explanation needed.

You could see them and know, this is why I am like this. This is why my hands are chapped and bleeding from overwashing them. This is why the sound of chewing feels like it's cutting me. This is why I used to hit my wrists against the corners of chairs when I was alone as a child.

There are so many ways to alter ourselves. And while I consider taking medication to ease my anxiety, I also wonder, at which point do I become more myself? At which point am I disconnecting with whatever is here, in my chest?

I practice breathing in yoga, I ask for the prescription, I wait for the change.

* * *

When I went to university, I had to commute over an hour each way. I would drive my car from West Michigan to East Lansing, park in a neighborhood without meters off campus, then walk to class. I almost always walked alone.

I would bundle up in a scarf and hooded coat, put on my head-phones, and walk to class listening to true-crime podcasts. Nothing like walking through suburbs in the early mornings and twilight evenings while constantly looking over my shoulder for the one crazy man with the machete who might live on Maple or Pine. At least it got my heart racing, got my blood pumping, got me to class on time.

* * *

I remember quiet nights with my mom watching *Dateline* or *20/20* or *48 Hours* or *Cold Case Files*. I knew I'd get nightmares, but I couldn't look away. My mom would sit on the couch sipping from her giant plastic cup of iced Diet Coke until she fell asleep in front of the blue-black light from the screen.

When I grew old enough to really know what they were about, I avoided the living room whenever my mom turned on the TV. I called them "death shows" — thinking they were just there to make us afraid of death, to make us dwell on the gruesomeness of other people's ends.

Now that I'm in my thirties, I'm drawn to the same shows. The same unsolved mysteries, crimes unimaginable, sociopaths and psychopaths who could be any of your neighbors. It's like staring at an accident to see all the broken pieces, imagining the moment it all fell apart.

* * *

I was raised on a fundamentalism that kept me thinking in binaries. We were "us," and the world was "them." You were either evil or good; there was no fence-sitting. So when I left, I thought I was jumping to the other side of the canyon, as if there are only two worlds. The world of abuse and the world of freedom.

But I'm realizing there are no easy answers. There is no switch to turn off the PTSD or the OCD. And the more I wander here, the more I realize how I will forever be searching myself for answers.

* * *

When I'm alone, I check all the corners and closets, under the beds, behind the shower curtain, in the pantry — just to be safe. I double-check the front door is locked. I keep my cell phone with me if I move to a different room. I run through scenarios of dangerous strangers in my head. What if he comes at me when I'm in the shower? What if he sneaks in the apartment when I'm in the shared laundry room down the hall? What if he's been living in the guest bathroom all this time?

I tell myself my hypervigilance isn't paranoia. This is preparation. This is practice so my mind can handle the shock and know how to react. Grab the phone. Then a kitchen knife. Or first the knife, then the phone. Go for the eyes. Or the crotch. Hide in the bathtub. Jump from the balcony. Run.

* * *

Decades after my friend's mother died in her garage, I realized what must have really happened. That she must have left the car running on purpose. That my friend must have woken up the next morning without a mother. None of this had occurred to me at the time.

I realized that my mother knew she couldn't protect me from the fact of death, but she could protect me from the fact that sometimes people cause it.

* * *

When I was a child, my mother taught me to scream "Fire!" if any-one ever came after me, if anyone touched me, if anyone tried to lure me into a van filled with candy. I should yell as loudly as I could and run away like a wildfire was racing behind me.

My mother taught me to be afraid of many things: cars, strang-ers, the ice, the heat, the stove catching fire. She would stand at the electric stovetop, touching all the knobs to make sure they were pointing at "off," then as soon as we left home, she'd ask, "Did we turn off the stove?"

Now as an adult, I stand at the stove in my apartment, fiddling with the knobs. There is a small space that "off" occupies. The knob can move back and forth in this safety zone between two hard stops. If the knob goes past either of the stops, the burner comes on, and if the burner comes on without anyone noticing, it will catch fire; it will burn us all down. I stand at the stove and make sure each knob is equidistant from the stops in the safety zone, as closely aligned to the "off" label as possible.

* * *

I used to silently repeat prayers in my head, just in case I died by a sudden accident or an unexpected illness or a meteor. I thought I was combating my own sin. I thought depression and anxiety would send me to hell.

Now when I feel the sparks in my chest or the aching in my stomach or the tension in the back of my head, I can name it. I aim to be neutral: *I am feeling anxious right now. Maybe the phone call I had or the book I read yesterday triggered it. Maybe it was the neighbor or the work meeting or the person who brought up the past. Maybe today is the anniversary of something traumatic.*

Sometimes I can pinpoint it, sometimes I can't.

Sometimes I try to shake it with a walk in the park or a cup of hot tea. Sometimes I'm jittery. Sometimes I pick at my face. Some-times I try to start an argument. Sometimes I hyperventilate. Some-times I curl up on the carpet.

<center>* * *</center>

I try to believe it when others tell me it will get better. But then I think back to the forest fire and how it almost destroyed our home. I remember the abuse that nearly made me suicidal, the harm and discrimination that so many of my family members and friends have suffered and survived. I think of the fragility of trees, of islands, of seasons. I think of the Earth, how it began as heat and how it surely will return. I know my father's silence, my mother's apologies. I cannot escape our holidays spent apart.

People have told me I was brave to leave. But I think I simply acted on the most basic human need: to survive.

<center>* * *</center>

When I was very small, I went to the viewing after my great-grandmother's passing. They said she had reverted to childhood in her old age, always clinging to a baby doll in the nursing home.

Across the room I could see the coffin, open. She was inside, pale face upward as if to heaven. I did not want to get closer.

<center>* * *</center>

I'm in the kitchen making dinner for friends. They are all sitting in the living room where I've carefully lit a candle, placing it a good distance from the wall, from the picture frame, from the potted plant.

I hear David and the guests laughing. I hear him say, "She has a thing about fire. But it makes sense because her house burned down when she was a kid. She's just always worried about it."

I think at first, he must have confused our burning car with our house, so I set the story straight. "My house never burned down!" I shout from the kitchen.

Our friends laugh. David, instantly apologetic, says, "But the fire — you know the forest fire. I thought you said you were evacuated?"

I can see how he was confused. The car fire, the forest fire, the evacuation — he must have mixed them up in his head, created a narrative in which I was traumatized by fire destroying my home.

<center>196</center>

I can picture myself, a child digging through the ashes, finding photographs with holes in them, the ribs of my piano sticking out of the rubble. But my husband's wrong. My house didn't burn down. And I haven't always been afraid of fire.

I think back to when I was young, watching the flickering light in the driveway, or the time my grandfather gave me his cigarette lighter to entertain me. The way he showed me how to wrap my fingers around it, how to roll the pad of my thumb on the wheel until it sparked. Playing with fire. I think about the forest fire burning all around us. I think about the fire I feel inside me, the flame that compels me to check the knobs on the stove over and over again, to place the flat of my hand on the burner every day before I leave home, just to make sure it isn't hot. In a way, I'm not afraid of fire at all. I just want to know where it is. I want to see the boundaries of the ash trail. I want to feel the force of heat, understand its raging. All I want is to feel that it is my hand that turns the knob, it is my thumb that spins the wheel.

* * *

For a long time after leaving the Christian patriarchy movement, I still went to church, wanting to hold on to a divinity that loves me, while throwing away all that has harmed me. But the very experience of being inside a church building, interacting with people who seem to have no problems with church and no questions about God, became too much for me. I felt on edge, tired of hiding in the bathroom during the prayers, of dodging conversations about my extended family.

I try not to make church people a new "them," a new "other." But what they don't know about religious trauma is that the words that uplift them, inspire them, sing them to sleep, are words that pull on the strings of my memory, unraveling the scraps of experience I have so carefully tried to weave into a new reality. While they find wholeness, I am falling apart. Where they find healing, I am reminded of the wounds inflicted by men of religious authority.

When they sing to God with their faces lifted, "Goodness and mercy all my life / shall surely follow me,"[43] I am reminded of the dark-

est days, times when those same words were told to me by my abuser. I have been left wondering, *Where was the goodness of God then?*

When the pastor yells at the culmination of his sermon, and the people shout amen, all I can feel is the yelling of Kevin Swanson on Sundays, his face red, spit flying out of his mouth, screaming about how God would condemn gay people. And the room becomes airless.

And when they say, "I'll pray for you," they don't know how many prayers I whispered in the night, sleepless, no way to escape, no answers from heaven.

* * *

I thought I had left patriarchy on the other side of the canyon when I moved away. I believed my experience to be extreme. No one in the outside world seemed to have heard of the Christian patriarchy movement or Vision Forum or stay-at-home daughters.

I believed the church David and I joined would be a home for us, a place of belonging and acceptance. A place where I could still hold on to God.

In the beginning, we found something like this. Before the associate pastor retired, he and his wife mentored us, listened to my story, believed me, prayed for me. I felt accepted and loved by them. When David broke his collarbone and we didn't have any money to pay for the surgery, the church discreetly paid our bills. I knew if I were to get pregnant, the church ladies would throw me a shower.

But this peace lasted only while I conformed. The more I started to speak up about my ever-present questions, the more I felt the door closing on me.

One woman said my experience with abuse made me biased in my opinion about women's equality. Another asked me out for the symbolic "cup of coffee" when I attempted to speak up in defense of trans people. Another said she had never witnessed women being abused in church. The speaker that the church hired for the women's retreat said Christian feminists weren't really Christians.

The church ladies seemed to all believe in complementarianism, the belief that men and women are equal before God but hold separate roles in life — and I realized this was patriarchy under a different name.

My gut lurched when I wanted to write some resources on spiritual abuse for the church and the pastor made sure to ask David if he approved. When a book by Voddie Baucham showed up in the recommended reading section of the church newsletter. When the new associate pastor started sharing Doug Wilson's materials and teaching his books in Sunday school. I should have walked out when he preached that you shouldn't recognize the children of gay relatives. Even after we left, knowing it wasn't the place for us, the senior pastor texted David about my online criticism of the church (which I had not named) because he said I was accountable to my husband.

For a long time, I tried to be the change. And then it was time to move on.

* * *

I had found old voices in that new church. Voices that pressured: *Are you praying and reading your Bible every day? Are you going to church on Sunday mornings and evenings and Sunday school? Are you participating in the women's Bible study where you are supposed to learn how to be a biblical woman?*

By *praying*, did they mean asking for favors from the God who (they'd also told me) had planned everything out already, down to the hairs that fall from our heads? By *Bible*, did they mean the stories of genocide and rape and sexual slavery that I've been reading by myself since I was a little girl? By *church*, did they mean the place where my clothes, my language, my thoughts and opinions are policed? By *biblical woman*, did they mean the concubines or the secondary wives or the unnamed women who were abused and told to be submissive anyway?

Too often, I felt as though the people of God thought that life on Earth was just a waiting period until we will be in heaven, as if

thinking about God is more important than honoring and caring for the rest of creation.

When I tell my story, some Christians will say, "That wasn't really Christian. Your church wasn't really Christian." It's easier to call my story an anomaly than to face the reality that Christians have caused both great good and great harm. But that only perpetuates the problem, and the harm. Instead I wish they would say, "That was wrong." I wish they could acknowledge how they are tied to a broader group of people, that they would seek accountability and justice instead of washing their hands clean of the so-called bad apples.

* * *

When I think back to Reformation Church, I can still see the overhead lights beaming down on the pulpit. Me and my friends in our long dresses and long hair. The boys rushing to stack the chairs at the end of the day. I can feel my legs cramping after the two hours of morning service. I can hear the babies and toddlers crying in the pews. I can hear the shouting from the pastor, the way he held on to the pulpit and leaned over to glare at us, the way he ran back and forth on the platform, demanding our attention, teaching us that the world is corrupt and we are called to be light.

I'm sure some of the parents there wanted to follow God first and foremost. Some parents really believed that this is how God shows love: with rules and regulations, with cutting off the unbelievers.

But I can't forget the children whose parents felt justified bruising them. The queer kids who were told they were an abomination. The girls who were told they would never be more than helpers. How we were all promised beautiful, blessed lives and then handed over to abusive marriages and broken families and religious trauma and PTSD and anxiety disorders and excommunication.

I'm reminded how painful it was to be squeezed into such a small world of existence, to have every part of my being managed and altered and controlled, and one day it finally hits me:

I was in a fucking cult.[44]

* * *

In 2015 I read a headline: "Republican Candidates Attend Rally Where Pastor Advocates 'Death Penalty' for Gay People."

The National Religious Liberties Conference. Ted Cruz, Bobby Jindal, and Mike Huckabee in attendance. The host of the event: Kevin Swanson.

In videos of the rally, I watch my old pastor, hands in the air, holding a Bible high, calling America to repent from *Harry Potter* and *How to Train Your Dragon* because they have gay characters. He says that it would be better for parents to be drowned before they let their children watch these movies.

I watch, sick to my stomach, as he runs around the stage, screaming about God's pending judgment on America. And then with the fervor and hatred I am all too familiar with, he shouts, "The apostle Paul does say that homosexuals are worthy of death — his words, not mine! And I am not ashamed of the gospel of Jesus Christ! And I am not ashamed of the truth, of the word of God. And I am willing to go to jail for standing on the truth of the word of God."[45]

* * *

I imagine the Israelites in the desert, eyes glazed with dust, feet blistered from wandering for forty years waiting for God to let them into the promised land. They are hungry for food, for rest, for somewhere to lie down and call home. An entire generation must die before they are allowed to enter Canaan, with Joshua in the lead. Hundreds of thousands of the Hebrew people die in the wilderness, but they leave their children with a hope, a future in a new land.

But when the next generation arrives in the land of milk and honey, they realize the cost of paradise. God tells them they must uproot the Canaanites, killing the men and the women and the children, even the animals, before they can settle down in their new home. They must spill blood to live in the promise.

I like to imagine a small group of the generation of Joshua, standing on the edge of what was promised to them. They see the future, and they wonder if a new home is worth the cost of blood-

shed. Maybe they look back at the wilderness and think it wasn't that bad after all.

What if they turned around and kept walking through the desert until they found a different land, a place uninhabited, a place already free. What if they made their own future and promised themselves they wouldn't harm anyone else to please God.

What if I could have seen it earlier: the suffering, the abuse, the authoritarian control. What if I had left earlier. What if I could have left before the damage.

* * *

If *better* means making progress, then I wish I had a data sheet to show you the exponentially decreased number of panic attacks I've experienced. I could show you the points for the downward trend: when I stopped seeing my father and when I stopped going to church.

If *better* means finding purpose, then I can point to how I show up in my life, how I share my story because I know there are other women and young girls who are being told to be quieter and smaller and more compliant. How I can finally use my voice, which was trained for so long to be silent.

If *better* means healing, then I'm afraid all I have to show is a tangled line that follows how I've revisited the past, bandaged wounds, struggled to cope, worried if it will ever end.

I do not know if *better* will ever be a sufficient word to encompass what it is like to leave my parents and my beliefs, to struggle to find the core of who I am when my individuality has been suppressed since I can remember, to get up every morning and live into a new future every goddamn day.

* * *

I am not the prodigal, and I am never returning to my father. I am not the lost dog he told stories about — running hungry through the streets with God at its heels, wanting to find home, punished until I repent.

I don't know if I will ever step foot in a church again, but I believe that divine love is everywhere, all around us, and can never be circumscribed to pews and altar and baptismal.

I no longer think about my existence out of fear of eternal punishment, but as a way to sink into the only moment we will ever have: right now.

Better is breathing through the pain, one moment giving way to the next.

Better is acknowledging the trauma, noticing when it wants to intrude in my thoughts.

Better is receiving and showing compassion, holding close all that is broken and all that is beautiful.

I was taught not to trust myself: my heart, my emotions, my thoughts. I hadn't been given the tools to discern things for myself. I'd been trained to be dependent, unthinking. I did not know what to do with my anxiety, my suicidal thoughts. Repenting of them hadn't been enough to make me healthy. But as I got out, I learned that I didn't have to struggle alone to find my way forward. I found people who loved me, supported me — my spouse, my therapist, my friends from school, and my professors who mentored me. I learned to listen to my intuition, hear my own voice. I learned from my mistakes, knowing that the new community I was finding would keep me steady.

* * *

Without patriarchy, who would I have been? Would I have gone to public school? Maybe I would have had a group of friends I hung out with every day, instead of only on Sundays. Or maybe I would have been lonely, an outsider by nature. Maybe I would have listened to the Spice Girls, fangirled over 'N Sync. I might have planned to go to college or spent a year backpacking in Europe and sleeping in hostels. I might have had a terrible boyfriend who broke my heart. Or a nice one who took me to the movies and shared his soda. Perhaps I'd have worn a bikini to the beach. Or not, feeling ashamed of my body, not because I was told I would be a tempta-

tion to men but because of secular society's expectations for female bodies. Maybe I would have studied music at Juilliard. Maybe my parents would have driven me to my first dorm, bought me a mini fridge, hugged me, and wiped away a few tears before leaving me to discover the unsettled feeling of being an inexperienced adult, to learn how to take care of myself.

Maybe I wouldn't have felt like a fake, a facade of joyful submission, a prop, an object to be named after a man and moved from place to place.

I have to tell myself who I am over and over, so I don't forget.

I am a survivor who persisted through the wilderness, and I must continually keep the wilderness at bay.

I am a person who breaks the stories told to bind me. I must tell new stories to keep the ropes from knotting over again.

I am a woman, not defined solely by my daughterhood or my marital status.

And I am a feminist, not because I hate men or want to destroy the family, but because I am a human being with a mind of her own, a body of her own. I have a heart loosed, cracked open in the dark, ready to pour out and take in the disarray of a new song starting on the offbeat.

ORIGINS

If you have come to help me, you are wasting your time. If you have
come because your liberation is bound up with mine, then let us work
together.

—Aboriginal activists group, Queensland, 1970s[46]

2022. I'm driving from my older brother's house in Pottstown to
East Falls, and the landscape is hauntingly familiar: rolling hills
embroidered with the heavy trees of August, winding roads and
then the interstate into the city. But once I reach Philadelphia, I am
an outsider. The waitress who served lunch to me and my mother
yesterday said I didn't look like I was from Pennsylvania. I haven't
lived here in nearly twenty-five years, and I wonder where I do look
like I'm from. Not here, I guess.

I was born not too far away, down the river in Delaware. It's
called the First State because it was the first to ratify the Constitu-
tion of the United States. My homeschooling curriculum taught me
to see America through the eyes of the first Europeans to land here.
This was the "New World," a place where pilgrims could start over
fresh, safe from tyranny.

Now I know Wilmington is a city built by colonizers and the people they enslaved, named after a British prime minister who lived more than three thousand miles away. Delaware is a state named after one of the first colonizing governors. But even before there was a city or a state or a colony, there are the Lenape. This land has a long memory.

From time immemorial, the Lenape people lived in matrilineal clans and took care of the land we now call the Delaware River Valley. Their name roughly translates to "original people," but they are often forgotten when we teach the history of the United States.[47]

The Lenape name for the Delaware River is the Lenape Sipu, and some today call it the "River of Human Beings."[48] But colonizers spent no time learning names in a language they didn't understand. So, they gave the Lenape a new name: the Delaware Indians, after the Englishman who was the governor of the Virginia colony, the Baron De La Warr.

We took away their land, and we took away their name, and then we named them after ourselves.

William Penn, a Quaker and pacifist who founded the colony of Pennsylvania, said of the Lenape: "Light of Heart, strong Affections, but soon spent; the most merry Creatures that live, Feast and dance perpetually."[49] Penn wanted fair treatment of the Indigenous people and fair payment for the land. And yet, the land that he settled was named after himself, and eventually the colonists forced most of the Lenape to migrate.

* * *

My Christian history books whitewashed the past, saying that the Native Americans weren't civilized and that enslaved people were blessed by having Christian slave masters. White people were the center of the story, the drivers of exploration, science, missions, and politics. It was easy to see myself in this narrative, as part of this grand plot, even if only as a helper to the men. It was easy to think I was on the right side of history — the image I'd received over and over again was of us as white saviors. I was not told of the genocide, of the forced

migration, of the residential schools that stole children from their homes. My Abeka textbook painted colonialism as a global good:

> After Livingstone's explorations, many other European countries — especially France, Germany, Belgium, Portugal, and The Netherlands — colonized regions in both Africa and Asia. There is no doubt that the resulting economic development benefited the lives of many Africans and Asians who had known only poverty, disease, warfare, and slavery.[50]

* * *

I think back to the time my mother whispered, even though we were on the phone and I could barely hear her: "You have ancestors who were on the *Mayflower*." She paused, a moment of acknowledgment. "I don't want to tell anyone."

Maybe when I was a first-grade homeschooler we would have excitedly talked about this fact and watched *The Mouse on the Mayflower* for the twentieth time. Maybe I would have written a profile on my colonizing ancestor, drawn an imaginative picture with pencil on lined paper. My mother would have given me extra credit.

But we didn't sound excited at this moment, talking long-distance on the phone. We sounded a little embarrassed. Ashamed of our ancestors. I was now an adult who had taken enough classes in college to know our past is fraught with oppression and oppressors. I'd told her what I was learning, and we'd both grown in our understanding of history, of our own place in it, of what we'd inherited.

The truth is we can't ignore history or where we came from. We also can't erase the crimes and horrors our ancestors committed in the name of freedom or exploration or states' rights. We have to face it and do our best to make amends.

* * *

The first treaty after the formation of the United States was made with the Lenape. The colonizers promised that if the tribes helped

the colonists win the Revolutionary War, then they would be given statehood. In pursuit of freedom for the white colonists, they were assured their own liberation. This, too, was a broken promise, and both British and American soldiers killed many Lenape in the war.[51]

* * *

My ancestors dreamed of new lands and new lives.

My ancestors sailed ships across oceans, bringing hopes, bringing disease.

My ancestors starved, thirsted, struggled.

My ancestors worked the land.

My ancestors survived.

My ancestors wore blue uniforms.

My ancestors wore gray uniforms.

My ancestors were enslavers.

My ancestors were too poor to enslave.

My ancestors were refugees.

My ancestors created refugees.

My ancestors used god to get power.

My ancestors used god to get freedom.

My ancestors were godless.

My ancestors abused and were abused.

My ancestors gave life.

My ancestors served themselves.

My ancestors fought in wars and killed in battles.

My ancestors killed each other and killed themselves.

My ancestors.

How can we make amends for this? How can I?

I hold it all. I say, *I see the generational damage we have done to Native peoples, to people from whom we stole land, to people whom we stole.* I ask, *How can I change?*

I hear an answer: *Acknowledge. Tell the truth. Repair.*

But calling attention to my own reaction feels like one more sin. Even when I try to decenter myself, I cannot help but be the subject of my story. I can never escape the eyes I see from, though I can learn to recognize and question the lenses I see through.

My entire life has been lived on land once occupied by Indigenous people, people who were driven out by my people. This land has changed me, even as I change it, as we change it. And I no longer want to perpetuate separation between us, between people and land.

Activist Dr. Randy Woodley, who is of Cherokee descent, reminds me that the original Western colonizers of America failed to "tread lightly, with humility and respect, on the land. The settlers wanted to live *on* the land, but the host people lived *with* the land. Living on the land means objectifying the land and natural resources and being shortsighted concerning the future. Living with the land means respecting the natural balance. To Indigenous peoples, the problems of a Western worldview are obvious. The way of life demonstrated by Western peoples leads to alienation from the Earth, from others, and from all of creation."[52]

* * *

The Lenape people are still in the Delaware River Valley, although for years their existence has been denied. For too long, white people like my ancestors have forced them to leave or to hide, to assimilate to a colonizing culture if they stayed. Chief Adam Waterbear De-Paul, the tribal storykeeper for the Lenape Nation of Pennsylvania, explained, "Today, the Lenape people have nations that represent those that were forced to leave their homelands, and those that never left. Four nations of Lenape people are active in maintaining and revitalizing their culture in the Delaware River Valley."[53] Every four years, starting in 2002, the Lenape Nation of Pennsylvania paddle down the Lenape Sipu, the Delaware River, inviting other Lenape and the public to join them, and recommit to a new treaty: a treaty of peace, of restoration, of renewed brotherhood.[54]

I've decided to join them for a treaty ceremony toward the end of their three-week journey, down at the river in Philadelphia. As I pull into the parking lot, I feel like an intruder, and I wonder if I should even be here after all. But I've come this far, traveling from Michigan, and I'm willing to make mistakes, as long as I'm pushing forward.

Uncomfortable, I'd rather be an invisible witness, detached, hover on the fringes of the crowd — but that would contradict the whole point of being here. Renewal requires presence.

I contemplate what makes us who we are — is it DNA or the land? Are we what we imagine ourselves to be? An identity of the mind. Or are we the air, the earth? The space we occupy.

Or are we our ancestors? Their blood is our blood. We are alone in our bodies yet contain multitudes.

Is this yet another push to find belonging — the way my mother spends her days mapping dead ancestors on a genealogy website? If only we could trace a family out of the past, carve out where we belong — to whom we belong — perhaps we could heal . . .

But what if your ancestors caused the rift?

* * *

The Lenape who are federally recognized by the government are the ones who were displaced by colonizers and now live in Oklahoma, as well as Wisconsin and Ontario, Canada. Some of the Lenape nations of the diaspora, like those in Wisconsin and Ontario, work with the homeland nations on language and other revitalization projects;[55] yet some other tribal members in Oklahoma reportedly do not recognize the Lenape who remained behind, who assimilated into settler communities to survive, because they have been separated from their cultural traditions and their people.[56] The rift has happened in more ways than one.

* * *

I am smudged with cedar and white sage to clear the negative energy, to bring me into community. Cedar is the age-old tradition of

the Lenape; sage, while not native to their homelands, represents the peoples of the diaspora who were forced westward out of their cedar forests and is included in remembrance and to bring them to the ceremony in spirit. My body is shrouded in the smoke of blessing, like a sacrament. Chief Chuck Gentlemoon DeMund and Chief Adam Waterbear DePaul, the tribal storykeeper, guide us in the ceremony and treaty signing, and I draw closer in the crowd, listening to the stories and the prayers and the music. I sense a welcome, even if I don't deserve to be here.

During Chief Gentlemoon's prayer, an ant climbs onto his forehead. He pauses for a moment, takes the feather he is holding, and gently pushes it under the ant's tiny legs. He bends down and nudges it into the grass. The chief reminds us that we are no better or more valuable than the eagle or the ant. We are all creatures loved by Creator. At the signing, I hear the Prophecy of the Fourth Crow, a story that gives meaning to the past and hope for the future.

Chief Robert Red Hawk Ruth has given this explanation: "We now know that the First Crow was the Lenape before the coming of the Europeans. The Second Crow symbolized the death and destruction of our culture. The Third Crow was our people going underground and hiding. The Fourth Crow was the Lenape becoming caretakers again and working with everybody to restore this land."[57]

I wonder what that would look like — working together, all of us, with the land, with respect and awe, honoring our shared history, turning away from the colonizer ways, turning away from the violence. And I know this wondering is only the first step.

* * *

After the ceremony, I find lunch alone at a café in the city. At the table next to mine is a family who seems familiar although I've never seen them before. Two men in button-downs, dress shoes with white socks. A woman who must be the wife of one of them — perfect white-blond curls, almost like a wig. Three young women with long blond hair down their backs. Pink makeup, prairie dresses, walking shoes, perpetual smiles. One of the girls prays before their meal.

Once, perhaps, I would have met them at a homeschool conference or church. Our families might have shared curriculum; our fathers might have debated the nuances of baptism; our mothers might have exchanged bread recipes. We kids would have been forced together out of our parents' shared interests. We would have practiced our public smiles, have tried to fit the roles made for us.

But now, I feel so different, so separate from all of it. I probably don't look too worldly to them; I wear shorts and a T-shirt, nothing too bold or revealing. But inside I feel as if there is a chasm between us. Here I am alone, trying to figure out how to move forward with my life; there they are, merged into a single unit, following an unspoken set of rules, conscious of how they stand out, yet smiling like they believe their very shining presence is a witness.

But I don't feel alone in this café. I think of how I was welcomed by strangers at the treaty signing, how I was accepted as who I am, how all that was asked of me was to come in peace — and I think about how this is everything I ever wanted from church. A sense that my presence is welcome — me in the shape I am, all my sediments and salt.

* * *

Now that I've gained distance from my former life, it's painful to consider the damage that my family, my father, and my church caused. And to know we perpetuated a patriarchal system that is centuries old. To know my family's patriarchal values can be traced back through chattel slavery, Manifest Destiny, white supremacy, and violence of all kinds. Patriarchy thrives anywhere men are praised for their will to dominate — and Christian patriarchy blesses this pursuit of earthly power by imagining it's a heavenly duty. Like abuse, Christian patriarchy, at its core, is about power and control — at any cost.

CHOICE

For most of my life, I've found my reproductive organs mysterious, as though they are a universe of potentiality, locked away in a part of me I know nothing about. I grew up disconnected from my body, having few words to describe the parts of me I felt ashamed of, having no knowledge of *clitoris*, *orgasm*, or *sexual pleasure* until I was in my midtwenties. The only thing I truly understood was that my female body was supposed to bear children, that this was why I had been created.

And when I am in my early thirties, I learn my reproductive system will likely never reproduce.

On my worst days, I punish myself with the thought that my experience with infertility is part of my curse for leaving the world of patriarchy. I defied God's plan for my body, which was to have as many children as possible, and because of that, I don't deserve to be a mother. Real mothers wouldn't use contraceptives. I imagine my belly as a dark empty nothing. I hear the words of Kevin Swanson saying that the birth control pill makes your womb into a graveyard for dead babies.[58]

I now know that statement is both preposterous and false, not to mention deeply misogynistic. But still, it has stuck with me. In my act of preventing life, have I become an empty hole, a symbol of a grave?

Am I just a dark place for dying eggs and shrinking ovaries? I know that even if I had married straight out of high school and had never taken the pill in my life, I might still struggle with infertility.

But even the word *struggle* implies I'm fighting against it. Really it is the most passive thing in the world to stop using pills and condoms and pray a sperm is strong enough to make it through to your short-lived egg waiting in the dark.

* * *

My friends from Reformation talked often about future marriage and children as if they were exciting prospects.

I always felt like something must be off with me. I didn't feel any immediate desire to have children, and although I wanted romance, I had a difficult time imagining being married. I secretly wanted something different.

When I left my parents' home, I chose to get married but not to get pregnant. Before I left, I remember walking to the doctor's office to get a prescription for birth control. I didn't know how it worked, but I knew I didn't want to have a baby right away. I didn't even know what my life would look like in Michigan.

The doctor walked through all the kinds of contraceptives with me, and I asked, "Which ones don't kill babies?"

She looked at me as if I had climbed out of a bunker. Fumbling over her words, she explained that birth control pills *prevent* pregnancy, not end it.

When I started taking the pill, I had the freedom to go to college, get a job, and begin to find my place in the world. Birth control gave me agency over my body, something I had to learn after being taught so long that my body belonged to my husband.

But this matter of choice is complicated. When I choose to stop taking the pill, my choice doesn't lead to pregnancy, conception being a somewhat infrequent occurrence under even normal conditions.

* * *

When I schedule an appointment with my OB-GYN after six months of trying to become pregnant, she tells me I need to start taking fertility medication right away because of my age. My shame about my body kicks in as she conducts a pelvic exam, casually asking about the scar on my knee. "A bicycle accident," I tell her. "My parents probably should have taken me to the doctor to get stitches."

"Oh, you're fine," she says dismissively.

Maybe she's right. Maybe it wasn't so bad. I remember the bandages on my knee for weeks, how I'd had to quit swimming lessons, how the raised purple-red scarring across my kneecap has only recently started to fade.

But I don't know how to say that my family's relationship with healthcare was complicated, that me being here alone, trying to figure out how to take agency over my own body is new for me. When I was a child, my parents took me to annual checkups and to get vaccinated against measles and mumps, but I wasn't allowed to get the human papillomavirus (HPV) vaccine that would help prevent cervical cancer. My parents thought that they could control my body and my life by holding me back from college and a career, that I would never be at risk of a sexual encounter and wouldn't need such a vaccine. I'd been told I'd never need to see an OB-GYN until I was married.

The doctor asks me about my menstrual cycle, my eating and drinking habits, my sex life. And I choose to be present and answer her questions. I am choosing to try to get pregnant, which is not the same thing as choosing to be pregnant.

When we discover David also has fertility issues, we have more choices. We can choose to see a fertility specialist. We can choose treatment. We can choose intrauterine insemination (IUI) or in vitro fertilization (IVF), or we can choose not to do anything. All but the latter choice require money, of course, thousands of dollars we don't have, so perhaps they're not really choices after all.

Everything from birth control to condoms to IVF would have been immoral in the world I grew up in. They all resemble an at-

tempt to play God, to take control over our bodies, our fertility, the number of our children. Getting treatment for illnesses like cancer was morally acceptable, but a woman changing her purpose of reproduction was reprehensible. A woman who tried to control her own body was a woman who hated families, hated herself, hated God.

I don't believe any of that anymore, but when you are taught something for twenty-five years, it is difficult to get rid of the voices telling you that you are an unnatural woman for choosing college and career first before motherhood.

And now that I've let go of these beliefs, I am stuck in a place where I must determine my own ethical standards. I don't feel good about spending thousands of dollars on a procedure that may not work. I don't think I'm ready to spend my savings and perhaps years of my life chasing a biological child who may never exist.

* * *

I wonder, if I were a mother, how would I be different? Would I be more anxious than I already am? Is that even possible?

All I know is that if I had a child, I would baptize them in love, affirm their personhood, give them a home to grow in, to feel loved in. I would want to protect them from harm. I would be careful not to unwittingly perpetuate the cycle of abuse I experienced and witnessed in my own family.

* * *

I believe I have mothering in my body — even when I am incapable of conceiving a child. I imagine moments — everyday ones — when I talk to my imaginary child, hold them, show them how to draw stars on the sidewalk with chalk or how to chase fireflies. When I cook dinner, I smile to think of how I would welcome having a hungry child to feed.

I did not expect infertility to be this hard. Perhaps because I never really thought it would happen to me. I feel shame at the selfishness of my thinking: *Haven't I suffered enough?*

My barrenness seems like another excuse for the patriarchal leaders of my past to cast judgment on me — to say that I am cursed. I did not behave as a godly woman should, and that must be why God has closed my womb. I know enough about women in the Bible — Sarah and Leah and Samuel's mother and Elizabeth — to know that being childless is interpreted as being empty. That barrenness is the lack of blessing, if not a curse. Perhaps even God thinks I am not capable of being a mother.

But not having a biological child does not mean I love less or have less. There is so much love in my heart that I ache to give because I don't know where to send it.

* * *

I can already hear the arguments of why I should not grieve: Aren't there enough humans on Earth? How can we make the future sustainable to feed more humanity? Why be sad when there are thousands of children in the foster care system, in adoption agencies, ready to be held and cared for and comforted? Why grieve over something you've never had?

I've asked myself these questions, over and over. And I don't have tidy answers. When we find out that we have a close to zero chance of conceiving naturally, we wonder if one day we will be ready and able to foster a child.

This brings me some peace, but I also know that no one will ever understand our situation, our choices, our desires. And the ethics of childbearing and childrearing are more complicated than I once realized. How do you know if an adoption agency is ethical? How do we best support children in need with the goal of reunification with their biological parents? How do we end poverty, climate change, and systemic racism? How do any of these decisions impact others? With fertility treatment, where is the line where we stop? How much medication or how many surgical procedures do we endure before we call it quits? Who do we tell?

* * *

At times I almost envy Elizabeth, the cousin of the Virgin Mary. Yes, she lived in a world where infertility robbed her of social value. But at least the answer was clear. There was nothing for her to do but continue existing. Who knows the children she mothered on the way — nieces, nephews, friends' children. We know she eventually met with Mary to help her in her pregnancy; we see that she mothered the mother of God.

And then God blessed her with a child. It was a surprise gift, a sign that God wasn't absent, only waiting. God finally showed up.

And I like to think my miracle will still show up. That one day I'll have a baby somehow through the miracle of modern medicine and will be able to laugh a little at my former anxiety. But if I'm honest, I already know my miracle is right here in front of me.

My world may be small, but I have the fire of love in my home. I may be estranged from some of my family, but not all, not even most. I have nieces and nephews whom I love. I have my work, and before it can be said that I am a working woman who just doesn't want kids enough, let me say that my work editing books and volunteering for spiritual abuse survivors has nurtured me, and I believe that it can nurture others too. When I tell stories of my pain and healing, I often hear back the stories of others living in the shadows. They send me messages, hopeful notes, to say that my words meant something to them, and I know that what I am planting on this earth is not pointless. That even if just one other survivor is helped, I can be proud. I can be a mother.

* * *

Sometimes I wish people would ask me more, "Will you have children?" They usually phrase it, "Would you *like* to have children?" which is a different question entirely. Sometimes I want my wound to be apparent — this loss of something I never had. Other times I want to hide. I want to be more assertive: *I'm choosing a child-free life; I want to focus on my career; I do not have children at this time.*

Women like me use secondary language because we do not like the word *infertility.* We'll say, "Kids aren't in the cards for us," or "It

hasn't happened yet." Buried beneath these words are the doctor appointments, the blood tests, the semen analyses, the ultrasounds, the pills, the waiting, the tracking, the peeing on sticks, the prenatal vitamins. Buried are my fluctuating feelings of despair and acceptance, frustration and hope.

* * *

I'm at a happy hour with my coworkers. It's a golden August afternoon, and I'm grateful for the chance to be outdoors, away from my computer, drinking a glass of rosé. *At least I can drink*, I think to myself.

A woman across from me, whom I've only met a couple times, has been asking questions of everyone, trying to be inclusive, to bring people into conversation. We're having a good time. But then she turns to me.

"Do you have any children?"

Everyone listens for my answer. "No."

"Would you like to have children?"

The air hits me hard. Do I smile, shrug it off, deflect? Do I lay out the devastating details in front of everyone at the table, including my boss?

"Sorry, that's something a mother would ask," she says. And that somehow makes it worse. This mother asking if I will ever be a mother.

"We'd like to. Someday. We're thinking we'd like to do fostering or adoption."

And just like that the conversation turns. One person says they know someone who chose not to have kids. Another says that their cousin is starting to foster. They all want to make a connection, make some meaning out of this awkward situation. Anything to avoid speaking it out loud: infertile.

* * *

Artist and revolutionary Frida Kahlo, who was also childless, included so much fertility imagery in her paintings that we are still wondering about how she *really* felt about children. We can create a

timeline of when she had an abortion, when she had a miscarriage. We can trace how she described her husband, Diego Rivera, as her child, herself as his mother, and we wonder if this was her redefining social norms, declaring her identity as mother the way she wanted to be, beyond the limits of her body, of her culture.

We know of the streetcar accident she survived as a child, how a metal rail pierced her spine and her vagina, likely causing infertility. We imagine the excruciating pain, the years of recovery, the ache she must have felt throughout her life.

In this place I live in West Michigan, with evangelical churches dominating street corners, women having children is often an expectation. The first question my husband and I are often asked when meeting someone for the first time is, "Do you have children?" I don't mind, yet I also know that our answer inevitably puts us into a category. We are parents, or we are childless. We are lacking.

I think of Frida Kahlo, who stayed in Michigan for a year while Diego Rivera painted his famous murals at the Detroit Institute of Arts. How she was pregnant here, dreaming of giving birth, how the American doctors told her the pregnancy wouldn't succeed, how she lay in the cold, utilitarian hospital and waited for her miscarriage to end.

I haven't had a miscarriage, but when I look at her painting *Henry Ford Hospital*, I think I understand. Frida, a mother, tied with umbilical cords to both her pain and her hope. She is lying in her own blood, tied forever to her baby, to the snail of time, to her injured spine and pelvis. She is life, and life lost, while the factories of Detroit lurk on the horizon. She is a mother, even though no one calls her one.

* * *

When *Roe v. Wade* is overturned by the Supreme Court, my body reacts as if the decision is affecting me, because it is. Now that I've worked through trauma therapy, I feel more connected to my body, and the reactions I experience are easier to interpret. I feel the pounding of adrenaline at the back of my neck, the twisting of my

gut, the racing of my thoughts. I trust my body now. It is reminding me of what it felt like to be a woman in the Christian patriarchy movement. The disempowerment of belonging to a man who made all major decisions for me. The dehumanization of being seen only as a vessel for a husband's pleasure, a womb for his children. The danger of not being able to protect myself.

I've experienced the physical and emotional costs of infertility; I can imagine that pregnancy and birth cost so much more. I think back to when I got my first period at age eleven, to how I wasn't taught about sex or consent or how I had rights to my own body. I know that it would have been devastating if I had been sexually assaulted as a child, forced to bear a pregnancy. I know now that women married in patriarchal groups often suffer marital rape, the concept of which did not exist in the framework I'd been given since wives were always to be available for their husbands.

But I know better now. I believe that everyone deserves bodily autonomy — the ability to make decisions for ourselves — something I didn't truly have until I left. And as I watch the Christian leaders I knew growing up succeed in imposing their religious beliefs on the rest of society, I know I can't be quiet anymore.

So I join a volunteer group that is petitioning to get an amendment added to our state constitution that would protect reproductive rights in Michigan. I am one of more than 750,000 people who sign the petition to get the vote on the ballot. Leading up to the election, I volunteer for an evening of cold-calling with the group. Even though the group leader has reassured us that most of the phone numbers have been confirmed to be sympathetic voters, my hands are shaking each time the automatic dialer clicks as a new person answers the phone.

"I'm talking to folks today about Proposal 3, an issue on the ballot this November that will restore the rights of Michiganders to make their own private decisions about pregnancy and abortion. Have you heard about Proposal 3?" I ask after introducing myself. If they say no, I read from the script I've been given: "The US Supreme Court took those rights away a few months ago, and now

a 1931 Michigan law that bans nearly all abortions could take effect. Yes on Proposal 3 is a common-sense middle-ground law that restores the rights we had under *Roe* in Michigan for nearly fifty years — and trusts women and their doctors to do what's best. Can we count on you to vote Yes on Proposal 3?"

I get a variety of responses: some people hang up, some people want to know more, some say they've already voted yes through an absentee ballot. One man angrily shouts, "Shame on you!" and ends the call before I can think to reply.

After that, I hang up from the dialer and sit on my carpet and focus on my breathing the way my therapist taught me. Words from this stranger triggered old feelings of being dismissed for my opinion, memories of being silenced. I sit in the discomfort as I tell myself I'm not living in the past anymore. I'm not trapped. I am in my own home. I am here. I am doing my best.

And yet, it seems as if the voices I grew up with have followed me out into the world. I tried to escape, but it is impossible to ignore the oppression of women and minorities out here on this side. It is still happening. And I'm not the only one who matters.

I sign back in to the group Zoom call and tell them what happened. They listen and commiserate, encouraging me to get back out there, saying that we are still doing good work by moving on to the next call. But I'm not sure how to keep my nervous system regulated after this.

At my next therapy session, I talk about this experience, how it was one of the most difficult things I've done since I left my family. What seemed easy for others in the group, simple phone calls to voters, had felt overwhelmingly difficult to me. I'm realizing I have limitations, that I can't do everything I want to do. After escaping the patriarchy movement, I was determined not to let anything stop me from achieving my goals and using my voice, and now I'm worried that I'm still held down by my trauma.

My therapist reminds me that we all have different limitations, different skills, and that I can still use my abilities to contribute to this cause that I've grown to care about. She asks me what I can vol-

unteer to do that doesn't trigger panic attacks. "What is something you'd be able to do given where you are today?"

After thinking about it, I reply, "I can write. I've been working on an article about reproductive rights, but I don't feel like it's enough."

She reassures me that we all have our parts to play, that none of us can be perfect or do everything that needs to be done to work toward change. I don't feel equipped to cold-call anymore, but that doesn't mean I have to be silent.

When 2.5 million Michigan residents vote in favor of our proposal, passing the amendment, I see again that I am only a small part of this; instead of feeling helpless, I know that my choices matter.

* * *

Being free from the oppression of Christian patriarchy has not meant I am unaffected by my past or immune to societal patriarchy. Every day I am reminded of my limitations. I am impacted by past trauma, shaped by my experiences. But instead of despairing, I am learning that being human is enough. Only by acknowledging where I came from — all the complexity of past love and loss and damage — only then can I grow, taking what I've learned to choose different, to break harmful cycles, to live in a new way. Even the ashes work their way into the soil, recycled into something alive, something beautiful.

* * *

On a late-autumn afternoon, David and I make our decision to stop fertility treatment. The wind of the coming winter swings around the corners of downtown Grand Rapids. As we leave the hospital after our last appointment, I feel the weight of deep knowing, and also the fear that no matter what we decide, someone else will be disappointed in some way.

My mind diverts to the urologist, and I'm thankful I will likely never have to hear any more of his grating jokes and comments. To David: "Get a bottle of wine and a couple roses, and you're in." To me: "You should have sex with him more than just when you're

ovulating." After bad news: "Some people go on vacation to Hawai'i and come back pregnant — you never know."

Sitting on a cold concrete bench, we have another version of the talk we've been having for months. *What do we feel, what should we do, what did we expect, who are we now?*

I feel the pulling in of my body, its urge to cave in, to collapse into a tight sphere. And at the same time, I feel relief, like water falling. At last, a decision, a choice to end it here. David and I are again choosing each other, choosing to be with each other in the unpredictability of the future.

I cry a little, but it's not an agonizing scream; it's not the end. It's like the small waves coming off an ocean with deep currents. The waves were already there before they surfaced on the beach.

I look out at the clouds sinking lower and remember that earlier today I met with a friend to talk about my writing and how I hope to publish my story of survival. I remember the shaking I had to overcome to speak it out loud to her, the trauma trying to rumble its way out of my body. I felt like maybe I could do something good with these words I couldn't stop writing — for me, for others — and as I sat with her, I could sense my story simultaneously wreck me and deliver me.

POSTLUDE

After ten years of varying degrees of separation, in 2022 my siblings and our partners gather at an old farmhouse in Maryland — a neutral place as we reconnect after so much time spent finding ourselves. Each of us has been affected in unique ways by Christian patriarchy. We each have our own stories to tell about our childhood home, and our stories keep moving. My two older siblings have children of their own, and I love running around the farm with them and toasting marshmallows over our campfire. We are not perfect, but we are trying to break the cycle of generational abuse and trauma.

Through everything, David has been beside me, never failing to believe in me and our future together. From the days when I was still trapped in my father's home, through the years after leaving as I worked to dismantle the bindings of abuse and trauma. From the poor days, when we weren't sure how all the bills would be paid, to when we could finally afford therapy. From our early days of codependence, to learning how to be individuals supporting each other through the terrain of life. Our Sunday-morning pancakes. Our late-summer walks in the woods. Our arguments and learning to be okay with disagreement. Our long conversations about religion and politics. Our adventures in travel and education and aging.

My joy in our relationship is only amplified when I hear from Will that he, too, has moved forward with his life, found a way to be himself. I see pictures of him and his husband, and I can't help but smile at their happiness.

If there is any meaning here, it is that change is everything. The land underneath me is in constant flux if only I could see with the eyes of the universe. And I am also in flux in the moments I am standing here, my face to the sky. I cannot stop the change.

In the rifting of my life, I learned who I really am. As humans, we hold on to memories even when we try to forget, and our experiences reside in the molecules of our bodies. But we can survive, and in the separating, we become something new, always evolving.

I have lost a lot, but I have gained autonomy and found my own voice. I have found community through writing, love through connection. Letting go of beliefs that poisoned me, of relationships that harmed me — I thought this would leave me empty. My life had been so full of grief, and now . . .

I have room to love and be loved, to explore the Earth unafraid, to pray or be silent. I am open to the wonder of living.

I lie down on my back on the ground, close my eyes. Breathe slowly. Feel the pulse of the universe, the shifting of the Earth beneath me. I am so small, almost nothing, in this grand cosmos, yet I'm here. I'm part of it.

Instead of splitting a continent, the great rift healed at the seam, scarred over. Two sides, still connected, bridged with water.

ACKNOWLEDGMENTS

Thank you to my mother and LeVar Burton for instilling in me a love of reading from an early age. My obsession with books is all your fault.

Thank you to my siblings. I know that reading this brought up difficult memories, and I'm so grateful that you all read it anyway, showing me support and love as I try to tell the whole truth. To "Allison": I'm so happy we are sisters and that we're both free to fly. To "Kyle": thank you for letting me put my head on your shoulder when I was little and for showing me that bravery sometimes looks like leaving. To "Chris": your incredible compassion for others helped me see outside of the box I lived in. You saw things so clearly before I ever could.

Thank you, always, to David, for showing me unconditional love and support from the very beginning. Thank you for constantly saying you're proud of me and for stopping me from throwing my manuscript in the trash.

Thank you to Erin McGraw for seeing me as a writer before I could even see myself as having a voice.

Thank you to R. L. Stollar for advocating for homeschooled children and for cofounding Homeschoolers Anonymous, an early resource that helped me feel less alone. Thank you to all the survi-

vors and advocates, including Julie Anne Smith, Christa Brown, Dee Parsons, and countless others — you have been a guiding light.

Thank you to all my writing teachers, especially Laura Davis De Jonge, who patiently taught me how to write an essay; Lev Raphael, who encouraged me to pursue the telling of my story; and Dr. Robin Silbergleid, whose insight and compassion helped me craft the first essays that would eventually become this book.

Thank you to Laura Julier for mentoring me in college. Your invaluable wisdom and teaching were instrumental in helping me become the editor and writer I am today. Your early review of this book made all the difference.

Thank you, Jennifer Mathieu, for showing compassion for a stranger, for writing a character I could see myself in.

Thank you to Trinity McFadden — the friend who believed me from the very beginning and who has championed this book as my agent. I can never thank you enough.

Thank you to Kristin Kobes Du Mez — your grace, compassion, and wisdom astound me. I'm so grateful that you set aside time to read the early drafts of this book.

Thank you to Kelly Sundberg for writing about domestic abuse with such nuance and boldness and for taking the time to read and endorse this book before it had even found a publishing home.

Thank you to Eric Schuemann for sharing your expertise in geology — please forgive me for any overly creative interpretations of scientific fact.

Thank you to Katherine Spearing for your friendship. Our similar upbringings may have brought us together, but our shared passion for writing and advocacy has brought us close.

Thank you to Dawn Burns, Bex Miller, Mary Catherine Harper, and everyone at SwampFire. You all are the most supportive writing group I could ever ask for.

Thank you to Sarah Clark for your insight and feedback on the chapter "Origins." Your perspective was invaluable, and I greatly appreciate you.

Thank you to the Lenape Nation of Pennsylvania for welcoming me to the River Journey treaty signing and end-of-journey festival. I was so honored to witness and participate in your sacred work. Thank you especially to Chief Adam Waterbear DePaul for reviewing and fact-checking the chapter "Origins" — I hope this book honors you and the story of your people.

Thank you to my therapist for helping me heal and giving me the support I needed while writing this book.

Thank you to everyone at Wm. B. Eerdmans Publishing: Anita Eerdmans, James Ernest, Jenny Hoffman, Shane White, Jason Pearson, Caroline Jansen, Kristine Nelson, William Hearn, Claire McColley, and especially Lisa Ann Cockrel, who believed in this story and who helped me shape my scattered pieces into a cohesive narrative.

And of course, thank you, dear readers, for witnessing my story. I hope these words help you on your own journey. If nothing else, remember that you matter. Your story matters.

LAND ACKNOWLEDGMENT

I wrote this book while residing on the ancestral land of the People of the Three Fires — the Ottawa, Ojibwe, and Potawatomi tribes. I recognize the Indigenous people who live here now and those who were forcibly removed from their homes. I affirm Indigenous sovereignty, history, and experiences and endeavor to support Indigenous communities.

Part of the proceeds of this book will be given to the Lenape Nation of Pennsylvania, the Ute Land Trust, the Hawai'i Land Trust, and the Native Justice Coalition, in gratitude for the land and her caretakers, and in an effort to make reparations to acknowledge past harm and contribute to a future of healing and restoration.

Lenape Nation of Pennsylvania: www.lenape-nation.org/donate
Ute Land Trust: www.utelandtrust.org/donate
Hawai'i Land Trust: www.hilt.org/donate
Native Justice Coalition: www.nativejustice.org/donate

NOTES

1. Jacqueline Kehoe, "How to Explore a Billion-Year-Old Volcanic Mystery along Lake Superior," *National Geographic*, February 23, 2023, https://tinyurl.com/3xcpfmfj.

2. Julia Franz and Alexa Lim, "The Midcontinent Rift Could Have Split North America Apart a Billion Years Ago. Why Didn't It?," *World*, November 14, 2016, https://tinyurl.com/yc2ypdwt.

3. Philip H. Lancaster, "Beyond the Vagabond Family," *Patriarch* 32 (January 2000): 11.

4. Philip H. Lancaster, "Getting to Know the Arch-Patriarch," *Patriarch* 41 (August 2002): 6.

5. Lancaster, "Beyond the Vagabond Family," 9.

6. Lancaster, "Beyond the Vagabond Family," 12.

7. John W. Thompson, "God's Design for Scriptural Romance, Part 5," *Patriarch* 32 (January 2000): 13.

8. *Patriarch* 32 (January 2000): 34; *Patriarch* 33 (April 2000): 31; *Patriarch* 42 (October 2002): 34.

9. Mary Bagley, "Cambrian Period: Facts & Information," Live Science, May 27, 2016, https://tinyurl.com/xbds834b.

10. "Stromatolites," Shark Bay World Heritage, accessed June 30, 2023, https://tinyurl.com/4kb3ucrv.

11. National Geographic, "Rockies Thrust Up," YouTube video, February 7, 2008, https://tinyurl.com/ycxrpu9r.

12. "Geology," Red Rocks Park, accessed June 30, 2023, https://tinyurl.com/3hhw7j5p.

13. Igpcolorado, "A Brief History of Colorado through Time (Geology of Colorado)," Interactive Geology Project Colorado, YouTube video, November 2, 2015, https://tinyurl.com/3jt27f5z.

14. "The Ute and Pikes Peak," Pikes Peak Region Attractions, https://tinyurl.com/3wb39xh2.

15. Ruthie Markwardt, "A Tribute to Pike's Peak, the 'Sun Mountain,'" Catalyst, March 12, 2014, https://tinyurl.com/y39x58jn.

16. John Ingold, "Decade after Hayman Fire, Questions Linger about Fire's Start," Denver Post, June 2, 2012, https://tinyurl.com/2kwhy4sk.

17. Martha Finley, Elsie Dinsmore (Shallotte, NC: Sovereign Grace, 1993), 282, https://tinyurl.com/5n6ezpwa.

18. Avi, The True Confessions of Charlotte Doyle (New York: Avon, 1990), 212.

19. Avi, True Confessions of Charlotte Doyle, 222.

20. Jane Austen, Sense and Sensibility (New York: Penguin, 2003), 101.

21. Kevin Swanson, "Raising Our Girls according to God's Design," sermon, March 20, 2005, https://tinyurl.com/mr2zsedh.

22. Oliver Gettell, "Conservative Radio Hosts: 'Frozen' Promotes Gay Agenda, Bestiality," March 12, 2014, https://tinyurl.com/ksrk5ws7.

23. Kevin Swanson, "The Rod and Reproof," sermon, February 22, 2004, timestamp 20:30 cont., https://tinyurl.com/w6jb7vpd.

24. William Cowper, "The Contrite Heart," Olney Hymns (1779), public domain, https://tinyurl.com/35ums6pz.

25. J. C. Ryle, Holiness (Shallotte, NC: Sovereign Grace, 2001), 22, https://tinyurl.com/3zsmt6z4.

26. Anna Sofia Botkin and Elizabeth Botkin, So Much More (San Antonio, TX: Vision Forum, 2005), 42.

27. Katie Young Yamanaka, "Pele, Goddess of Fire and Volcanoes," Hawaii, https://tinyurl.com/2p847k9u; see also https://tinyurl.com/yfm8edwb.

28. "America's Most Dangerous Volcano Is Erupting Again," VICE News, YouTube, 17:55, https://tinyurl.com/46vm9su9.

29. David McCormack, "Leader of Christian Ministry Followed by the Duggar family from TLC's *19 Kids and Counting* Is Accused of Using Teenage Girl as 'Personal Sex Slave' in $1m Lawsuit," *Daily Mail*, April 16, 2014, https://tinyurl.com/4xfmfmdn.

30. *The Return of the Daughters*, Vision Forum, Western Conservatory of the Arts and Sciences, 2007, https://tinyurl.com/4cu54wut.

31. John W. Thompson, *Pathway to Christian Marriage*, Reformation Today Series (Pensacola, FL: Chapel Library, 2007), 2. Page references from this book are given in parentheses in the main text.

32. William Shakespeare, *Hamlet*, Open Source Shakespeare, Act 3, Scene 1, lines 1846–1852, https://tinyurl.com/277vchme.

33. The article I read at the time had a similar definition to this one written by Ann Pietrangelo and Crystal Raypole, "How to Recognize the Signs of Emotional Abuse," Healthline, January 28, 2022, https://tinyurl.com/ywmrmwse.

34. Edna Ferber, *So Big* (New York: Perennial, 2000), 112.

35. John C. Green, "The Lake Superior Basin's Fiery Beginning," *Lake Superior Magazine*, June 1, 2002, https://tinyurl.com/338zs87f; "Why Is the Big Lake Called 'Gitche Gumee'?," *Lake Superior Magazine*, January 1, 2006, https://tinyurl.com/55mth2rz; and Heather Bot, "Top 10 Facts about Lake Superior," *Northern Ontario Travel*, November 3, 2022, https://tinyurl.com/4urscwwe.

36. Jennifer Mathieu, *Devoted* (New York: Roaring Brook Press, 2015), 313.

37. Phil Lancaster, "The Tenets of Biblical Patriarchy," Vision Forum Ministries, https://tinyurl.com/mutnht7s.

38. Douglas Wilson, *Her Hand in Marriage* (Moscow, ID: Canon, 1997), 13.

39. Nancy Campbell, Facebook, November 6, 2022, https://tinyurl.com/ypzu78af.

40. Rebekah Merkle, *Eve in Exile* (Moscow, ID: Canon, 2016), 129, https://tinyurl.com/ypd9f2y6.

41. Voddie Baucham Jr., *What He Must Be . . . If He Wants to Marry My Daughter* (Wheaton, IL: Crossway, 2009), 41–42, https://tinyurl.com/mrthyd6w.

42. Charlotte Brontë, *Jane Eyre*, in *Life and Works of Charlotte Brontë and Her Sisters*, vol. 1 (Smith, Elder & Company, 1895), 268.

43. James Leith Macbeth Bain, "The Lord's My Shepherd," *The Great Peace: Being a New Year's Greeting* (1915), https://tinyurl.com/hcs5y42n.

44. For more information on current research on coercive control and cultic groups, see "Steven Hassan's BITE Model of Authoritarian Control," Freedom of Mind Resource Center, https://tinyurl.com/mr2buwfk; see also Hassan, "Robert Jay Lifton's Eight Criteria of Thought Reform," Freedom of Mind Resource Center, May 30, 2019, https://tinyurl.com/54dwh93m.

45. Jessica Eggert, "Republican Candidates Attend Rally Where Pastor Advocates 'Death Penalty' for Gay People," Yahoo News, November 10, 2015, https://tinyurl.com/6temryxh; see also Rachel Maddow, "Anti-Gay Pastor Event Hosts 3 GOP Candidates," MSNBC, November 9, 2015, https://tinyurl.com/3bw77yuj; and Rekha Basu, "Candidates Won't Call Out Host Citing Death for Gays," *Des Moines Register*, November 17, 2015, https://tinyurl.com/3p5ccpyp.

46. Lilla Watson, "A Contribution to Change: Cooperation out of Conflict Conference: Celebrating Difference, Embracing Equality," Uniting Church in Australia, September 21–24, 2004, https://tinyurl.com/465ab99v.

47. "Highlighting the Lenni-Lenape," Schuylkill Banks, May 18, 2021, https://tinyurl.com/5n74z672; see also "Our Tribal History," Nanticoke Lenni-Lenape, 2007, https://tinyurl.com/mwypr84n.

48. Lenape Nation of Pennsylvania, https://tinyurl.com/cy86zn3r.

49. National Humanities Center, "William Penn on the Leni Lenape (Delaware)," 2006, https://tinyurl.com/2brw3vxr, excerpts from William Penn, *A Letter from William Penn, Proprietary and Governor of Pennsylvania in America, to the Committee of the Free Society of Traders*, 1683; in Albert Cook Myers, ed., *Narratives of Early Pennsylvania, West New Jersey, and Delaware, 1630–1707* (Charles Scribner's Sons, 1912), 224, 230, 232, 235–36.

50. *Since the Beginning: History of the World in Christian Perspective* (Pensacola, FL: Abeka, 1993).

51. "The Lenni Lenape and the Revolutionary War," Native American Netroots, December 12, 2011, https://tinyurl.com/mdwh5y6r.

52. Randy Woodley, *Becoming Rooted* (Minneapolis: Broadleaf, 2022), 101–2.

53. Chief Adam Waterbear DePaul, email message to the author, October 16, 2023.

54. Lenape Nation of Pennsylvania, 2018, https://tinyurl.com/2bf4366e; see also https://tinyurl.com/2bx57r6s.

55. Chief Adam Waterbear DePaul, email message to the author, October 16, 2023.

56. James W. Brown and Rita T. Kohn, eds., *Long Journey Home: Oral Histories of Contemporary Delaware Indians* (Bloomington: Indiana University Press, 2008), xv.

57. "Neweneit Na Ahas, The Prophecy of the Fourth Crow," as told by Robert Red Hawk Ruth, translated by Shelley DePaul, https://tinyurl.com/m5wnpfbk.

58. Miranda Blue, "Swanson: Wombs of Women on Birth Control 'Embedded' with 'Dead Babies,'" Right Wing Watch, February 1, 2013, https://tinyurl.com/4c562hyu.